Parisiennes

Translated from the French by Louise Lalaurie Rogers
Design: Plume créations
Copyediting: Pippa Hurd
Proofreading: Penny Isaac
Color Separation: Les artisans du Regard, Paris

Distributed in North America
by Rizzoli International Publications, Inc.

Simultaneously published in French as *Les Parisiennes*
© Flammarion, Paris, 2007

English-language edition
© Flammarion, 2007

www.editions.flammarion.com

07 08 09 3 2 1

ISBN-13: 978-2-0803-0037-9

Dépôt légal: 09/2007

Printed in Italy by Musumeci

Parisiennes

A Celebration of French Women

Flammarion

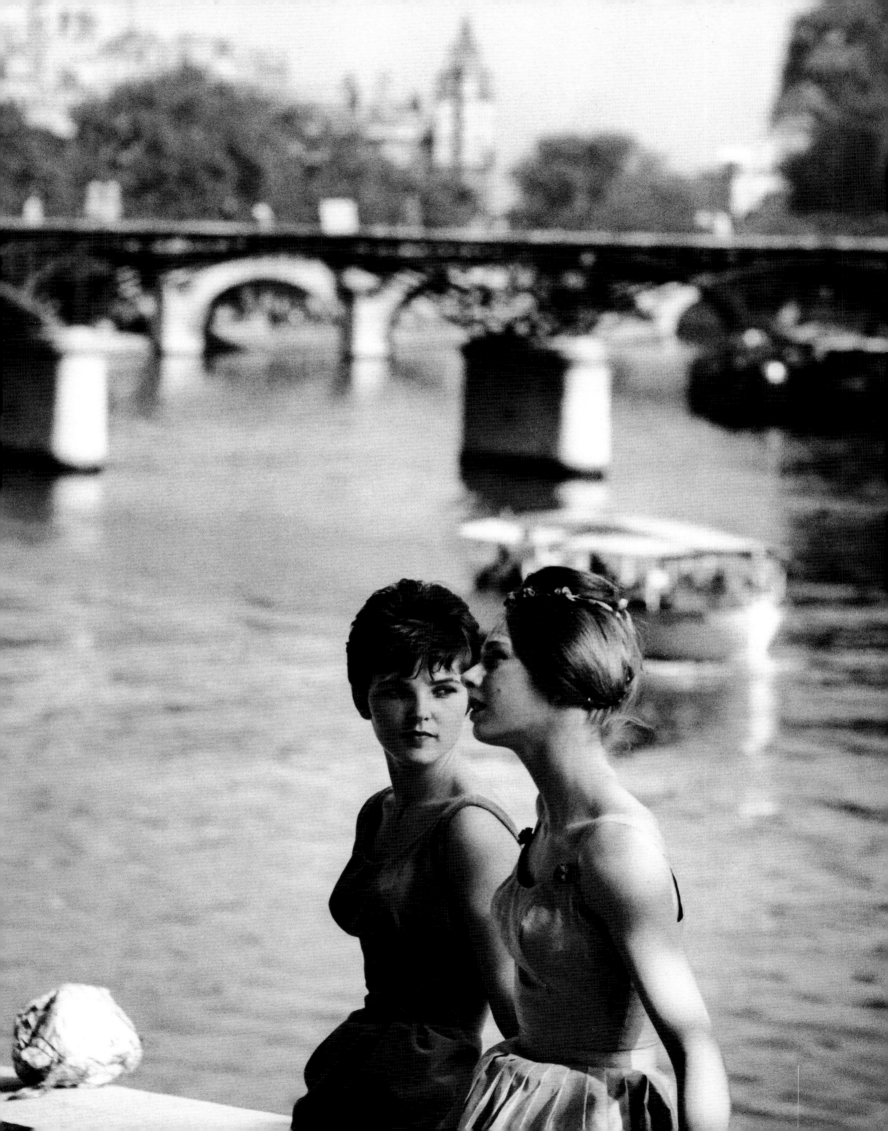

CONTENTS

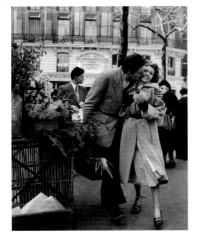
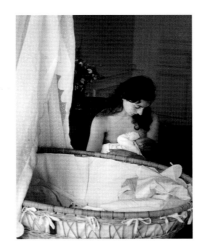
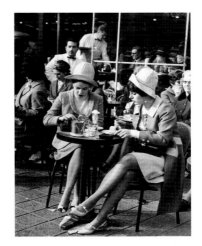
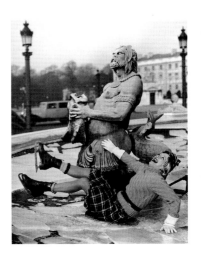

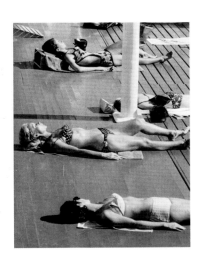
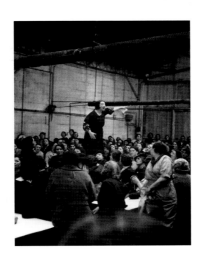
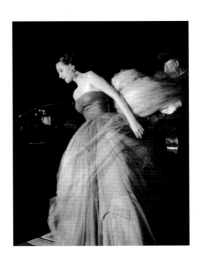
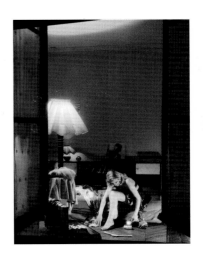

On the pont des Arts
JANINE NIEPCE, 1959

LIBERTY, EQUALITY—SORORITY?

One hundred years of the women's movement in France

Midi, time for the midday meal. *La dinette,* the local diner.... The seamstresses from the workshop nearby have come out onto the square opposite. Everyone knows them affectionately as *les midinettes*—working girls enjoying the chance to gossip and giggle over lunch. Ginette murmurs into her best friend's ear:

"I couldn't fasten my corset this morning. I'm in the family way again. I don't know what we're going to do! Three's enough. And when my husband finds out he'll stop me going out to work...." Ginette is twenty years old, the year is 1900.

Léa parks her car, ruffles her close-cropped hair, and runs down to join her friend on the *quai*, announcing with obvious relief:

"It's all over with Marc. He wanted us to get married and have kids straight away! Can you believe it? I was supposed to come off the pill when I finished my biology PhD, if not sooner...." They laugh and talk excitedly of Léa's plans when she completes her thesis. Life has never seemed so full of possibilities. Léa is twenty years old and it's the year 2000.

A single word differentiates the lives of the two women: freedom. Progress towards the emancipation of women was more spectacular and far-reaching in the twentieth century than at any other time in history. And for the women of France, two dates stand out on their road to equal status as human beings in their own right: in 1944, a date that is staggeringly late when compared to their sisters on the other side of the Atlantic, French women gained the right to vote, and in 1967 they gained the right to contraception. Two essential victories for women's freedom, and their dignity: full citizenship, and control over their own fertility. But what struggles along the way!

"FRENCH WOMEN MUST VOTE"

Russian women got the vote in 1917, British women in 1918, Luxembourgian women in 1919, American women in 1920, Turkish women (yes, Turkish women) in 1930, Spanish women in 1931. And French women? The decree granting French women the right to vote and stand for election was issued by General de Gaulle, on April 21, 1944. And yet French women had fought for this fundamental right since the Revolution itself, in 1791. Olympe de Gouge's bold Declaration of the Rights of Woman and Women Citizens declared that "Women are born free and with equal rights to men," but Olympe was guillotined and the so-called universal suffrage introduced after the Revolution of 1848 applied to just one half of the population—the male half. It took almost another century before women became French citizens in their own right.

The French suffragettes began their campaign of direct action, demonstrations, and public appeals towards the end of the nineteenth century, and the movement intensified after 1900. The

International Woman Suffrage Alliance was officially inaugurated in 1904, followed by the French Union for Woman Suffrage in 1909. In 1910, France's first large-scale suffragist meeting in Paris attracted over 1,200 people. Three leading militants—Hubertine Auclair (founder of the group Le Droit de Femmes as early as 1876), Marguerite Durand (founder and director of the feminist newspaper *La Fronde* "The Uprising"), and Madeleine Pelletier (a staunch defender of women's rights)—stood for election, illegally of course, attracting four percent of the vote and above all securing coverage for their cause in the newspapers. In 1914 France's National League for Votes for Women was created, together with a public meeting and two suffragist demonstrations. Later, in the 1930s, the supremely elegant and combative Louise Weiss led a body of women onto the racecourse at Longchamp, bearing placards with the legend *La Française doit voter* ("French women must vote"). Weiss's supporters presented gifts of socks to French parliamentarians who had expressed concern over who would take care of household mending if women worked or were elected. They held a symbolic demonstration on place de la Bastille; they made a human chain across Paris's rue Royale; they made trouble at the Senate. Why the Senate? Because while the deputies at the National Assembly, the lower house of the French parliament, voted in favor of genuinely universal suffrage (including women) no less than four times—in 1919, 1932, 1935, and 1936—the Senate refused. The generally accepted view was that the man, as head of the household (a status he retained in French law until 1970) should vote on behalf of the rest of the family. Women, who were destined "by nature and vocation" to become mothers, were homemakers and guardians of family values, but nothing more. An especially ridiculous argument was advanced by one man (of course), a certain Gustave Hervé:

> The women's vote is just, democratic, and possible. But the gesture is distasteful. And we want nothing of it. Women's hands are made to be kissed with devotion, and not for casting voting papers in urns.

French, and particularly Parisian, gallantry was also a pretext for the worst excesses of conservatism and social injustice.

"JOB-STEALERS"

And yet women's hands were already doing a great deal more than receiving men's kisses. From the beginning of the twentieth century, poetry flowed from the hands of the French writers Renée Vivien and Anna de Noailles. Isadora Duncan's hands and body created the new *danse libre* ("free dance"), while Mistinguett triumphed with her *valse renversante* ("amazing waltz"), partnered by Maurice Chevalier, at the Folies Bergère in 1911. The hands of Alice Guy, the pioneering filmmaker, operated a movie camera. And it was Madeleine Vionnet, the queen of the bias cut and flimsy dress fabrics, who caused a scandal by showing models without corsets at her boutique on avenue Montaigne in 1912, releasing women's figures at last from their starched prisons. There was Camille Claudel, who produced her finest sculptures in her studio on quai Bourbon until she was carried off to an asylum. And Lili Boulanger, celebrated composer and winner of the Prix de Rome. Suzanne Valadon, whose studio became the Musée de Montmartre, and Elise Laroche, the first woman in the world to obtain a pilot's license....

The women of the early twentieth century excelled in the arts and sports, but they were also employed at sewing and cutting, grinding sugar, bandaging wounds, carrying out housework, and writing on blackboards. Women worked. They worked as assistants in shops selling fashions and

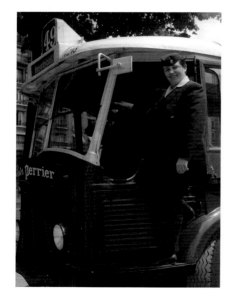

First woman bus conductor
ANONYMOUS, 1961

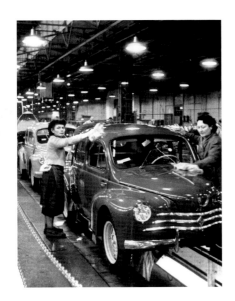

Renault factory
ANONYMOUS, 1950

novelties, smiling and serviceable, subjugated by their male employers, on their feet for ten hours a day. A woman's dream at the beginning of the twentieth century? The chance to sit down from time to time. Shop girls were granted a legal right to seats with the so-called *loi des sièges* of 1900. But there was little time for resting on the job, since many of them were paid nothing but a percentage of their sales. Women in the post offices and telephone exchanges were able to sit down, but they worked at a furious pace, with long hours, and for a paltry wage. When, in 1909, the women of the Paris central post office took action to improve their working conditions, two of them were arrested and 805 were dismissed.

In 1906, women accounted for thirty-eight percent of the working population in France—some eight million strong. In the "modern" city of Paris, some even became coach-drivers in 1907, and taxi drivers in 1908. In 1909, the wearing of trousers was no longer a punishable offense for women, provided they were riding a bicycle or a horse. Conditions for women factory workers were so harsh that they sparked a workers' revolt in 1914, during which women strikers marched singing through the streets of Paris. Even when women were confined to so-called "feminine" work, their male colleagues resented their presence. The male-dominated unions took a dim view of these *voleuses d'emploi* ("female job-stealers") who accepted significantly lower wages (as if they had any choice in the matter), and undermined their male colleagues' demands. The male world, from the political classes downwards, and many women too, believed that a woman's proper role was as a mother and housewife. This was her nature, her destiny.

"IL EST PARTI SOLDAT!"—"HE'S GONE FOR A SOLDIER!" (EDITH PIAF)

The two world wars disrupted the relationship between the sexes, for a time. During World War I, those fragile creatures with delicate constitutions and soft hands made helmets for the boys at the Front, twelve hours a day, and strapped up 120-millimeter shells in armaments factories. The French newspaper *J'ai vu* could scarcely contain its admiration:

> To the call of the fatherland in times of danger, the women of the Great War have answered with all their strength. Dressed in workers' overalls, we have seen them in the factories, turning shells on lathes, smelting steel for the cannons, manufacturing explosives. And in this atmosphere of death, carrying out men's labor with their slender arms, they have retained their femininity and grace.

This new generation of working girls earned themselves a new nickname—the *munitionettes*, to rhyme with *midinettes*.... France's transport workers, the *cheminots*, were replaced during the war by female *cheminottes*, punching tickets on the metro, or driving trams. And there were female slaughterers in the abattoirs, postwomen, policewomen, too. At the Citroën factory, sixty percent of the workforce were women. In 1917, the *obusières*—female munitions workers—even had the audacity to call a strike. But not all women answered the call to join the "holy alliance," fighting and working for victory over the enemy; some feminists remained resolutely pacifist. Addressing a Conseil de Guerre on March 29, 1918, the primary schoolteacher Hélène Brion declared that "war is the triumph of brute force" and was promptly incarcerated at Saint-Lazare women's prison. Women working in the armaments factories were above all attracted by the high salaries; they could buy luxuries such as silk stockings and oranges, provoking widespread scandal. What really shocked the public was, as ever, the spectacle of women with earning-power, the "unnatural" prospect of women at work. In truth,

hostility towards women in the traditional male workplace was as great as ever. With the armistice signed, women factory workers were sent home as quickly as possible.

Almost exactly the same scenario unfolded during World War II. The situation was worse, if anything, because the ideologies propounded by the Nazis, and by Marshal Pétain in the "free" zone of southern France, confined women solely to the role of mothers and housewives. Women's labor was, it seemed, only good as an emergency stopgap, when all else failed. In February 1940, a decree was issued for the organized recruitment of women to work in the armaments factories. In June of the same year, they were dismissed en masse. In 1942, they proved useful once again when Hitler was badly in need of "manpower." Pétain was reluctant to send women to work in Germany, but they could be put to the service of the Reich equally well in French factories. The Service du Travail Obligatoire or STO deprived the French economy of some 1.5 million men, who were forced to contribute to the Nazi war effort in German labor camps. Back at home, their places were taken by women—in post offices, on the railways, and in schools. Needs must when the devil drives....

French women played a vital role throughout World War II, in the daily struggle to feed their children and families. They queued for food vouchers, and queued again outside shops that were often all but empty. By kicking against the daily challenges of life under occupation, French women began to revolt. Danielle Casanova (who died in Auschwitz in 1943) organized women's committees to protest against high prices, and laws passed by Pétain's Vichy régime. In the Paris markets on rue de Buci and rue Daguerre, women's voices cried out, "We want potatoes!" and "Down with the Bosch!" In 1942, the couture house run by a certain Madame Grès was closed by the Germans following the launch of her new collection, in the blue, white, and red of the French tricolor flag.

Taking things a step further, many women joined the Resistance. Their role was absolutely crucial: they kept the supply lines open for food, and provided nursing care (the traditional feminine tasks), as well as producing counterfeit papers, and typing documents and newspapers (often written by their male counterparts). They carried messages and information, liaised with agents, acted as escorts, and sheltered men on the run. A few of them, but only a few, are still celebrated today, such as Bertie Albrecht and Marie-Claude Vaillant-Couturier. Lucie Aubrac pulled off an extraordinary tour de force while pregnant and the mother of a small baby: Aubrac served as an armed escort, delivering her husband and thirteen other resistants from the hands of the Gestapo, and accompanying them to London, where she gave birth four days later. As a rule, however, the Resistance's most daring exploits were the preserve of the men, who were happy for their female comrades to transport and hide caches of arms, but not to use them.

Madeleine Riffaud was one of very few women in the Resistance to take part in actual fighting. A poet, Riffaud was in prison awaiting the firing squad when she wrote: *L'homme qui tirait l'autre nuit, c'était moi* ("The man shooting the other night was me"). Of ten thousand uniformed agents belonging to the AFAT (the armed forces of the Resistance) only one, the chemist Jeanne Bohec succeeded—by sheer determination—in getting herself parachuted behind enemy lines, to serve as a sabotage instructor. When the Liberation came, women were sidelined from the fighting divisions of the FFI (the united Resistance force known as the Forces Françaises de l'Intérieur or French Forces of the Interior), with the exception of Lucie Aubrac who played a strategic role in the subsequent decision-making process.

In spite of Aubrac's declaration that "without women, the Resistance could do nothing," women resistants remained comparatively unrecognized. French women were left to the happy task

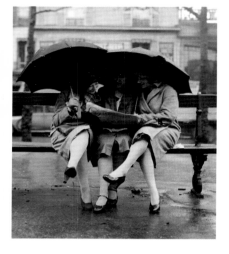

ANONYMOUS, 1928

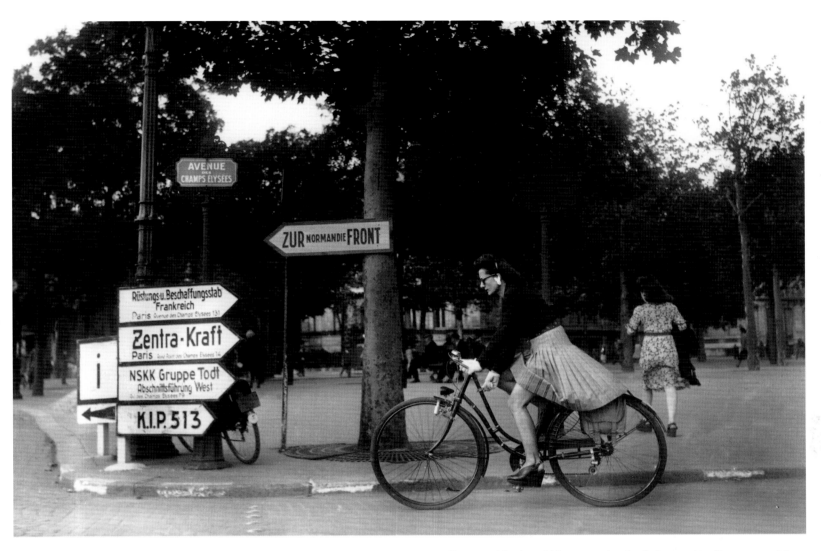

Paris street signs in German
during the Occupation
ANONYMOUS, 1944

of kissing American soldiers on the Champs-Elysées. Women who had slept with German soldiers during the war, on the other hand, were accused of "horizontal collaboration." Many were shamed by having their heads shaved—a thoroughly sexist punishment denounced by Jean-Paul Sartre as "medieval and sadistic." Marguerite Duras, herself an active member of the Resistance, was horrified and revolted to see her neighbor shorn, man-handled, and paraded through the streets, a spectacle she remembered when she wrote the screenplay for the 1959 film *Hiroshima, mon amour*, in which Emmanuelle Riva plays a French actress looking back on a wartime affair with a German soldier. She observed: "My heart belongs to France, but my body is my own."

BOBBED HAIR AND *GARÇONNES*

The active involvement of French women in two world wars may not have contributed much to their emancipation in real terms, but it did at least earn them (in addition to the right to vote) a certain freedom of behavior. For example, they began to take part in sport—for generations the closely guarded preserve of the male sex. In the face of public ridicule, women began to ride bicycles, swim, play tennis.

In the 1920s, women metamorphosed, adopting straight, knee-length dresses in lightweight, floating fabrics that skimmed past the waistline and ignored feminine curves. Coco Chanel wanted her clients to feel comfortable, to move with ease. She threw out "feminine" frills, creating knitted sweaters, and elegant dresses in black wool jersey. Women hit the headlines by cutting their long hair, earning themselves the nickname *garçonnes* ("tomboys")—the title of a 1922 novel by Victor

Playing tennis on
the place de la Concorde
ANONYMOUS, 1932

Marguerite, read by twenty percent of French people in the Roaring Twenties. Short hair was a sign of women's independence. Men grumbled that they were losing their exquisite femininity. They were behaving like men, "living their own lives," they were "*garces*" (even more tomboyish and unpredictable than *garçonnes*).

Women were free to engage in sport, and to dance. They wore cloche hats to dance the Charleston, and later huge, swirling skirts and petticoats to jive to rock and roll. In the 1950s, narrow waists were in, but hats and corsets were definitely out. While the vast majority of French women got on with the housework and attended Mass on Sundays, two figureheads propounded the myth of female liberation: Brigitte Bardot, with her exuberant, shameless performances on the silver screen (every woman wanted to wear their hair in an artless, piled-up *chignon choucroute* like hers), and writer Françoise Sagan, whose motto was "drive fast, drink whisky and live at night." And—both might have added—change your man whenever you feel like it. But the dream of independence seemed very far from everyday reality. A few years earlier, on April 11, 1946, Marthe Richard, a municipal councilor in Paris, proposed a law to close France's *maisons de tolérance* (officially tolerated brothels) out of pity for the prostitutes. In fact, the girls stood their ground, and the brothels were not officially closed until as late as 1960—an act, however, which did very little to curb prostitution.

The problem was addressed, together with every other aspect of the condition of womankind, in Simone de Beauvoir's 1949 book *The Second Sex*, a virulent feminist critique contained in a weighty tome, hurled like a French Revolutionary cobblestone into the unruffled waters of the masculine conscience. Among much else, the book brought to light the tragedy of clandestine abortions. Modern women may have had polyester skirts that didn't need ironing, Moulinex appliances designed to "set the housewife free," seamless nylon stockings, and curling tongs that transformed them into "the belle of the ball." But what use were these when women were denied that most fundamental of all rights, to do as they wished with their own bodies?

OUR BELLIES ARE OUR OWN

Throughout most of the twentieth century, most French people—men and women alike—remained convinced that women's natural destiny was to have babies, bring up children, and carry out domestic chores. French women continued to embrace their role as homemakers and mothers, in spite of the atrocious agony of childbirth to which they submitted as if this were an unavoidable fait accompli. Epidurals were first tried in the 1940s, but only became more generally available in France in the 1970s, and then with great discretion, as if the relief of such pain was a luxury to be shunned. From 1945 onwards, women could give birth in hospital, and their costs were reimbursed by social security. And, in 1947, the first Prénatal boutique opened in Paris, offering wraparound dresses and sailor shirts that didn't necessarily set out to disguise the fact that their wearers were pregnant. (There would even come a day when stars would parade their naked pregnant bellies triumphantly on the front pages of magazines.)

But the mothers of the postwar generation were timid in their demands, requesting the bare minimum of rights and protection: the right to return to their old job after the birth of their child, for example. A law passed in 1909 granted French women the right—in principle—to return to their jobs. And in 1913, the so-called *loi Strauss* officially granted four weeks' leave before childbirth, to be taken at the mothers' discretion, plus postnatal leave, which was compulsory, and qualified women for

financial compensation. This was motivated more by the desire to protect the child's well-being than that of the mother, it must be said. World War I and after saw a growing movement for the promotion of children's health. Mothers, overwhelmed with advice, became the frontline troops of the doctors and hygienists. How could any mother have the heart to abandon her baby and work outside the home, leaving it to be fed from the dreaded, possibly fatal bottle rather than at the breast? (In the 1940s, on the other hand, bottle-feeding was seen as chic and ultra-hygienic.)

A law passed in 1917 provided for the creation of breast-feeding rooms in factories. In 1932, state allowances for families were made universally available, and in 1935 the Syndicat Professionnel de la Femme au Foyer (Professional Union of Housewives) vaunted the status of the "woman indoors," whose "valuable social role ensures harmonious family life, healthy children, personal happiness, and the prosperity of the nation." Marshal Pétain had little trouble officializing the *Fête des Mères* (Mothers' Day) in 1941, glorifying motherhood as the only true feminine value.

In the same year, the Pétain régime declared that abortion "struck against the French people and national unity." A law passed in 1920 had outlawed contraception and abortion, branding them both as equally reprehensible. But Pétain took the repression of women a stage further. On February 15, 1942, abortion was declared a crime against the State, punishable by death. The first executions followed soon after: on July 30, 1943 Marie-Louise Giraud was found guilty of having acted to bring about abortions in 26 women. She was sentenced and guillotined in the prison courtyard at La Roquette. In fact, tens of thousands of women used the services of France's clandestine abortionists, the so-called *faiseuses d'anges* ("angel makers"), or performed abortions upon themselves by penetrating the cervix with knitting needles, hat-pins, or corset stays. Even in the 1970s, at least one French women died every day as a result of these interventions, and many were left sterile or disabled. They were prepared to risk death, either because they could not continue a pregnancy that would brand them as "single mothers," or because they were simply unable to feed a fifth, or an eighth child, even if they were married. This daily tragedy was due to the fact that, before the late 1960s, no reliable form of contraception was available to women—even though France's equivalent of Planned Parenthood, launched in 1956 under the official title *Maternité Heureuse* ("Happy Motherhood") distributed diaphragms in secret. In late 1967, the French deputy Lucian Neuwirth succeeded by sheer courage and obstinacy in passing a law authorizing contraception in certain circumstances. But the reactionary misogyny of France's male-dominated political class was such that the final decree implementing Neuwirth's reform was only passed in 1972. The Pill was finally made available to adult women (over the age of 21) and reimbursable through social security in 1975. Meanwhile, France experienced the explosive revolt of May 1968, in which young women played an active, passionate role. But this time, they didn't go home again afterwards; they decided to unite, share their experiences, and organize to express their demands. On August 26, 1970, women laid a wreath beneath the Arc de Triomphe on the tomb of France's unknown soldier, in honor of "the soldier's unknown wife." The act marked the start of the official Mouvement de Libération des Femmes, which went on to organize a number of spectacular, far-reaching demonstrations, mobilizing tens of thousands of women protesting for the right to abortion. In 1971, a testimony signed by 343 women (including several well-known names) was published in the news magazine *Le Nouvel Observateur*. The signatories testified that they had all had abortions, provoking a media storm. In the following year, the lawyer Gisèle Halimi used her defense of a young girl who had been raped, and who had aborted the

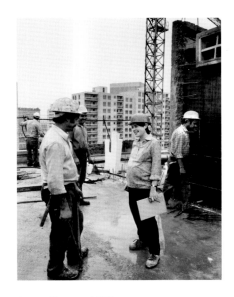

JANINE NIEPCE, 1982

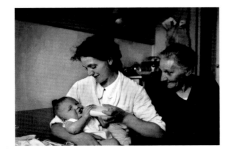

Maurice Thorez's wife, son, and mother-in-law
ANOYMOUS, 1936

resulting pregnancy, to launch a strident denunciation of the injustice of repressive laws which affected the poorest and most vulnerable women. In 1973, the Mouvement pour la Liberté de l'Avortement et de la Contraception openly offered abortions on demand using the newly discovered suction method of abortion, a relatively simple, harmless operation compared with the agonizing curettage carried out until then on unanaesthetized patients. The situation became explosive. In 1975, Simone Veil was appointed France's Minister of Health and took a stand against the powerful lobbies of the Catholic Church and the Ordre des Médecins (France's professional medical association). She extended her attack to the crass vulgarity, unbridled sexism, and unhealthy misogyny of so many French deputies, and finally voted for the law that bears her name today: the voluntary termination of pregnancy was henceforth authorized for women in distress as a result of their condition. The *loi Veil*—a far more progressive piece of legislation than that seen in many other European countries at the time—granted each woman the freedom to make her own decision.

Simone Veil—one of France's greatest stateswomen—also made social security benefits universally available to all French citizens, and extended the period of maternity leave. Prudently, she passed the initial law authorizing abortion as a provisional measure. Five years later, in 1979, when it was seen that French women still wanted to have babies (babies they truly wanted), the law entered the statute books for good. Women's support for the law was plain and plentiful: fifty thousand women demonstrated on the streets of Paris on October 6, 1979. And in 1982 Yvette Roudy made abortion reimbursable through social security. Contraceptive advertising was finally allowed in France in 1991 (chiefly as a response to the growing AIDS epidemic). The *loi Neiertz* of 1993 made it a criminal offense to impede the implementation of the law authorizing voluntary terminations, in response to attacks by pro-life campaigners on hospitals and private clinics. Finally, in 1999, at the very end of the twentieth century, the morning-after pill could be bought over the counter in pharmacies, and through school nurses who were authorized to give it to pupils.

For the first time ever, French women were completely free to take their own decisions about their fertility: Free to give birth only to children they had chosen to have, and to dissociate sex from procreation. A veritable revolution, flying in the face of thousands of years of male domination.

Women in Parliament

So were women now truly the equals of men? Not so fast.… True, Léon Blum had appointed three women under-secretaries of state in 1936, in the heady days of the Front Populaire: Suzanne Lacore (a former primary-school teacher) at the Ministry of Health; the radical activist Cécile Brunschvicg at the Ministry of Education, and Irène Joliot-Curie (a member of the Communist Party) as Minister for Scientific Research. Joliot-Curie was a distinguished chemist, and the winner (together with her husband) of the Nobel Prize for Chemistry in 1935. Her mother Marie Curie had won two Nobel Prizes, for physics in 1903, and chemistry in 1911. Two extraordinary women, dedicated to science and the well-being of others. Shining examples—if such were needed—of feminine intellect and excellence.

French women voted for the first time in municipal elections on April 29, 1945 (thirty-five women councilors were elected). On October 22 of the same year, they voted in elections for the National Assembly, to which thirty-three women were elected. But women still didn't enjoy equal civil, social, and political rights. The constitution of France's Fifth Republic, established in 1958, guarantees equal status for men and women, but women were still considered "minors." The Napoleonic Code

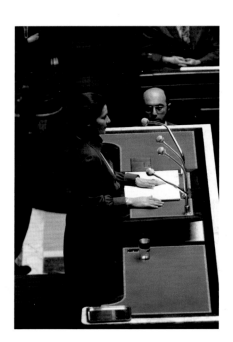

Simone Veil at the National Assembly
Uzan Gilbert, 1968

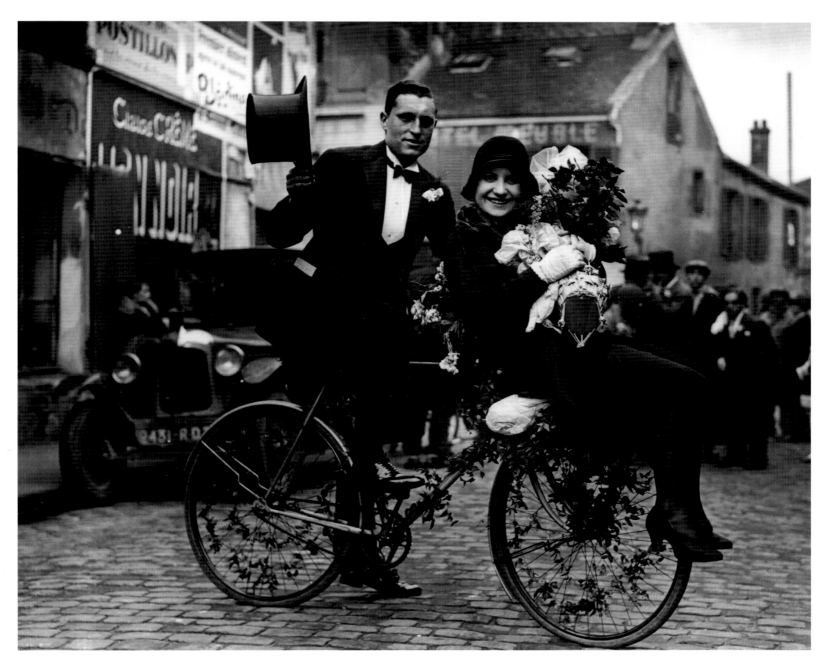

Young newly-weds
ANONYMOUS, 1930

kept them firmly in harness. As the head of the household, the French man was still empowered to dictate his family's place of residence, and to forbid his wife to go out to work. Only in 1965 were wives fully emancipated, free to manage their own goods and affairs, and to open their own bank accounts. In 1965! The year when skirts got so short you could see young girls' legs twisting the night away. In 1966, French women were granted the right to work without their husband's permission, but the notional title of "head of the family" (attributed to the man, of course) persisted until 1970. French women had to wait until 1980 to see rape classified as a crime, under a law passed by Monique Pelletier. And equality between spouses was only formally introduced (in principle) in 1985.

Equality of the sexes depends, inevitably, on equality between boys and girls. Both sexes were taught identical programs in French secondary schools from 1924 onwards, but it was 1965 before equal numbers of girls and boys passed the national *baccalauréat* examination at age 17 or 18. The girls quickly caught up, outstripping the boys, so that in 1991, fifty-five percent of successful candidates for the "*bac*" were girls. Girls tended to take liberal arts subjects at university, but some dared break down the doors of noted all-male bastions, and beat the men at their own game. In

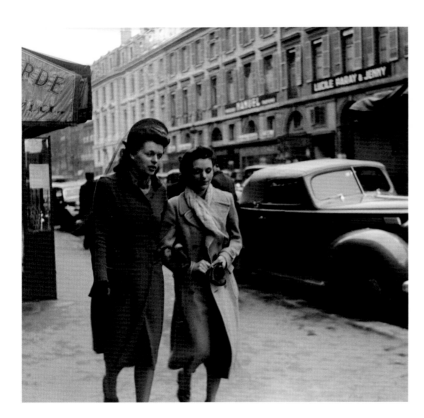

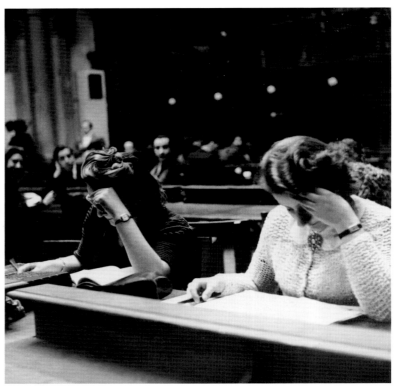

Shopgirls
ANONYMOUS, 1939

Reading room, Law Faculty, Paris
ANONYMOUS, 1940

1969, Françoise Chandernagor was the first woman to graduate top of her class from the École National de l'Administration (ENA), the prestigious postgraduate school that has trained the French political class since 1945. In 1972, Anne Chopinet became the first woman to do the same at the École Polytechnique, France's national military academy, which had traditionally and famously been closed to women.

Women began to make their presence felt outside the traditional "feminine" professions, becoming firefighters (and captains), police commissioners, and presiding over France's departmental law tribunals. There have been women prefects (representing the Minister of the Interior in each of France's administrative departments), women tax-inspectors, women professors at the prestigious Collège de France. There has been a woman vice-president of the National Assembly. France today has seen women auctioneers, women police officers, civil engineers, composers, business leaders, and even women members of the previously resoundingly male Académie Française (the first woman to be elected was the writer Marguerite Yourcenar, in 1980).

Little by little, French women have shown themselves capable of taking on positions of authority, or jobs requiring great physical strength—qualities which they were traditionally seen as lacking. And yet men are still firmly entrenched on the upper side of the pay divide, earning on average thirty percent more than women. The rate of unemployment for women is fifty percent higher than for men. There is still a tendency in France—even among some women—to see a wife's salary as a useful contribution rather than the bedrock of a household's income. French men still participate very little in housework and childrearing, ensuring that women are able to devote less time to their careers. The old rallying cry of the Mouvement de Libération des Femmes in the 1970s—*double travail, demi salaire* ("twice the work, half the pay")—is still not completely obsolete at the beginning of the twenty-first century.

And what of women in government? Progress has been slow but sure. France's first woman minister was Germaine Poinso-Chapuis, in the Schuman government of 1947. As Minister for Public

Health and Population, her portfolio covered a number of traditionally "feminine" spheres: the fight against prostitution and alcoholism, and above all the defense of childhood and the family. France's second woman minister (Simone Veil) was elected in 1974, after a 27-year gap. In the same year, the celebrated journalist Françoise Giroud was appointed Secretary of State for the Condition of Women, a new post created by President Valéry Giscard-d'Estaing. Giroud did her best to end discrimination against women, but achieved little concrete success, due to lack of resources.

Women ministers came to real prominence in the Mitterrand government of 1981, with Yvette Roudy as Minister of Women's Rights, an effective feminist committed to providing equal opportunities for every French woman. Edith Cresson became Minister for Agriculture, and Huguette Bouchardeau became Minister for the Environment, together with their colleagues Georgina Dufoix, Catherine Lalumière, and Nicole Questiaux. Women were at last recognized for their competence and ability to govern. But a decade later, when Mitterrand appointed Edith Cresson as France's first woman prime minister, she remained in power for just ten months, despite being surrounded by no less than five other woman ministers: Edwige Alice, Elizabeth Guigou, Catherine Tasca, Frédérique Bredin, and Martine Aubry—all women of substance and ability. Politics aside, Edith Cresson was subjected to an incessant barrage of sexist taunts that were impossible to ignore.

In 1995, the year in which a woman, Nicole Notat, became the first woman head of a French trade union, Prime Minister Alain Juppé appointed twelve women ministers—a new record, but one which was short-lived…. Two-thirds of the so-called *Juppettes* were off-loaded in one reshuffle. In 1997, one-third of Lionel Jospin's ministerial appointments were women, among them/Martine Aubry (Employment), Ségolène Royal (Education), Elizabeth Guigou (Keeper of the Seals), and Marie-George Buffet (the Ministry of Youth and Sport)—an unprecedented line-up.

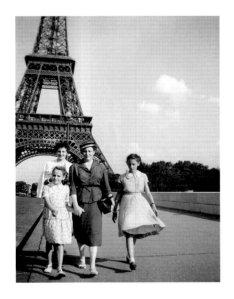

Xavière Gauthier (back, left) with her mother and sisters in front of the Eiffel tower, 1955

It was Jospin, too—with the support of President Chirac and in response to pressure from women's associations—who (in a 1998 reform) proposed a revision of the Constitution to ensure equal political representation for men and women. The State had been searching for a solution to the problem of equality of representation for some time. An initial suggestion, in favor of quotas, was put forward by Monique Pelletier in 1980. Women still accounted for less than eleven percent of deputies at the National Assembly. Quotas would operate as in some other countries, guaranteeing (for example) a third of the Assembly's seats for women. But why not half, to reflect the population as a whole? The concept of absolute parity was introduced, but remains far from a reality today, with the various parties reluctant to respect the "male–female balance." Turning the question on its head, one might also venture to ask (in the words of a group of leading French women politicians in 1992): "Why do 81 percent of members of the European parliament have to shave every morning?"

"Go into politics!" urged French *Elle* in 2000. Back in 1947, the same magazine explained: "Today, many married women earn a living, too. But this is not their main role. The greater part of their time and energy is devoted to their home, their husband, their children." We may smile now, at such old-fashioned views. Or may we? As I write these words, in 2007, for the first time in the history of France, a woman has just been beaten in her attempt to become president of the Republic. Early reaction to Ségolène Royal's candidacy included this question, posed by one of her (male) political colleagues: "But who's going to look after the children?" (She has four). Women's lib? Watch this space….

Xavière Gauthier

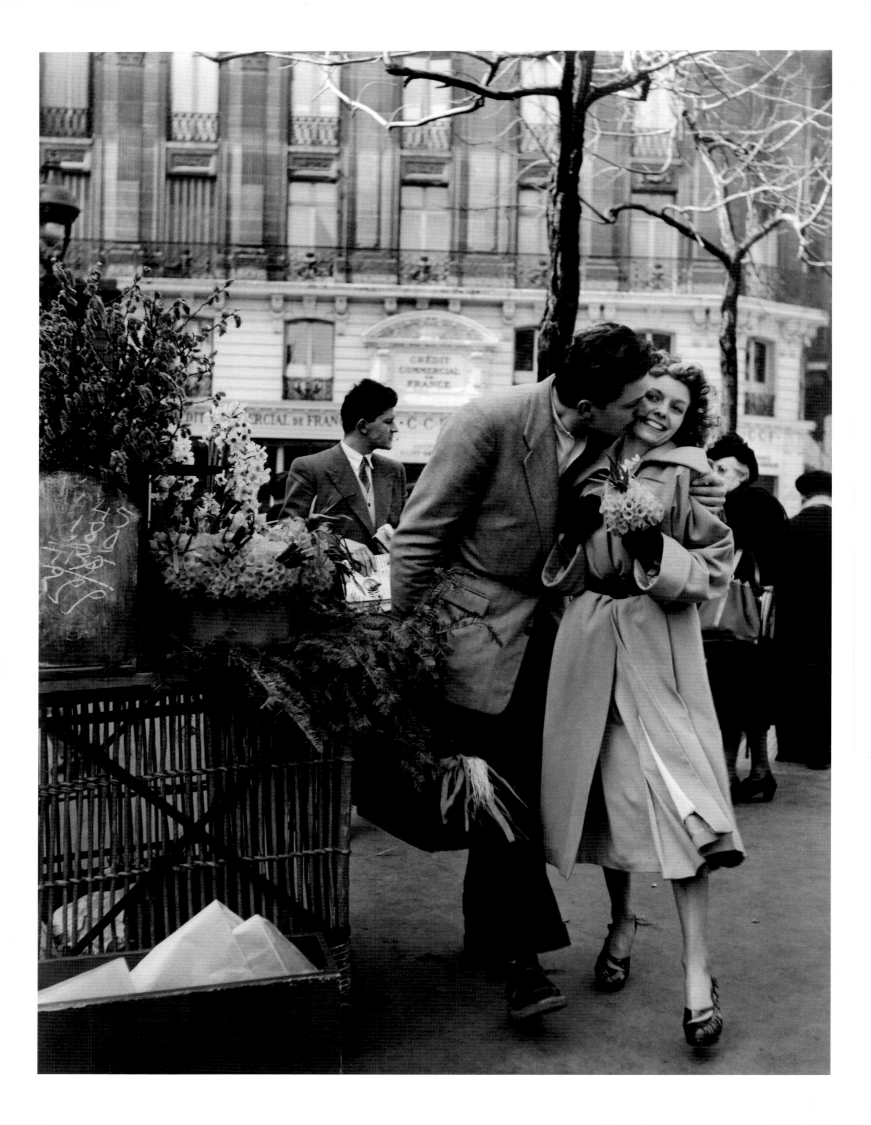

LOVE

Place de la Concorde, the *quais* down by the Seine, cafés on the "Boul' Mich'"—the true Parisienne plans a lovers' rendez-vous with care. Not just any old meeting-place, but legendary settings revealed by great photographers, transformed into post-cards, elevated to mythical status. Parisiennes know full well what they're about. They dress for the occasion, and their reputation for elegance is undimmed: a flattering fur collar, a charming flared coat. The hem is always just so: eight inches lower than it was at the prime of Saint-Germain-des-Près. So much more graceful for dancing, *ma chérie*. They have studied the allure of Simone Signoret and the little-girl pout of Brigitte Bardot. Love elevates them to the status of cinematic heroines, and they play their role to perfection.

Because it would be naïve to think that when a girl's fancy turns to thoughts of love, all else is forgotten. Being in love doesn't just mean giving yourself to another, it means putting on an accomplished show for the benefit of passers-by. It means loving the fact that everyone can see you're in love. Running to a lovers' tryst allows the Parisienne to exhibit a spirited pair of legs slipped neatly into elegant pumps, the suggestive outline of the body beneath a tight-fitting skirt. When the weather turns warm, out comes the little print dress. And even when a girl disappears beneath the welcoming embrace of a well-built man, she can still enfold him with a perfectly poised arm, dangling a couture hand-bag. In short, the Parisienne acts the part.

And if, like the city where she lives, the Parisienne has become a legend, it is not because she is the most beautiful of women, nor because Nature has granted her a finer figure. No, it is because she knows that however real your feelings, falling in love is also the performance of a lifetime, a bite at the stuff that dreams are made of.

CATHERINE MILLET

Lovers with leeks
ROBERT DOISNEAU, 1950.

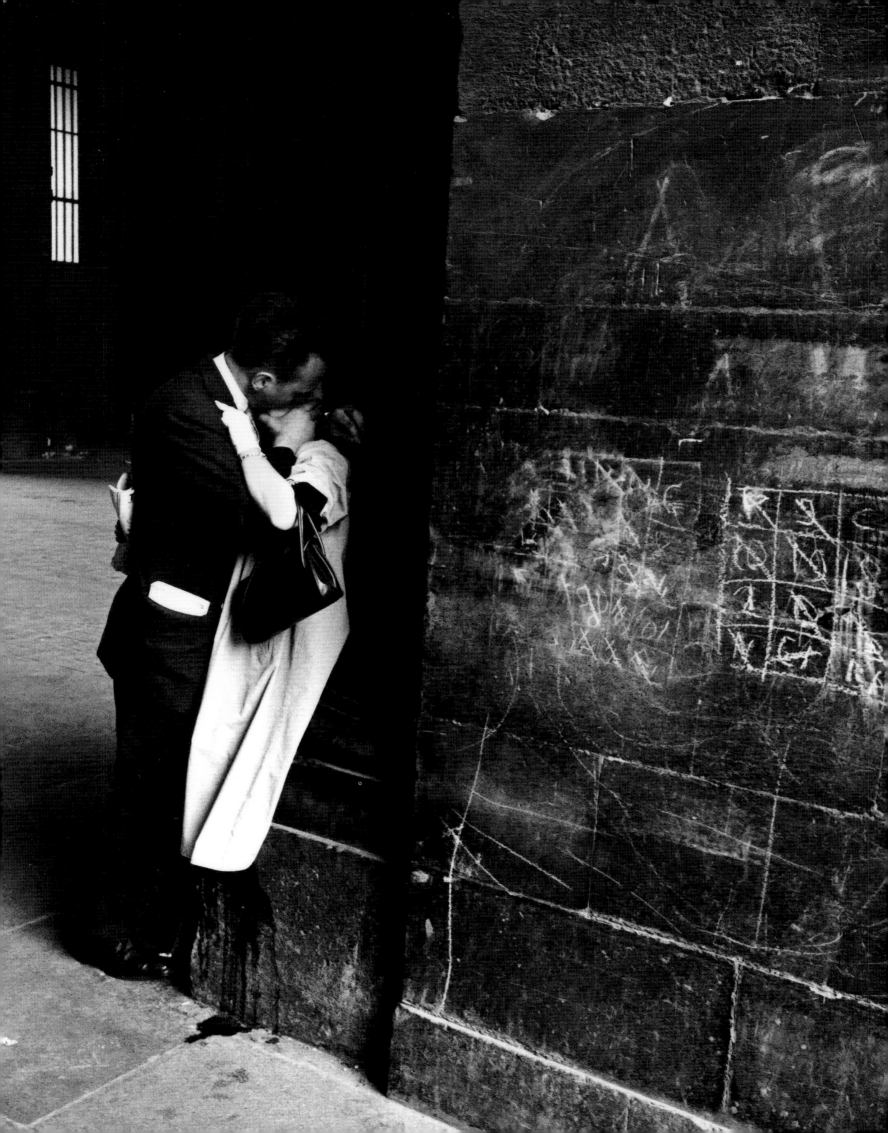

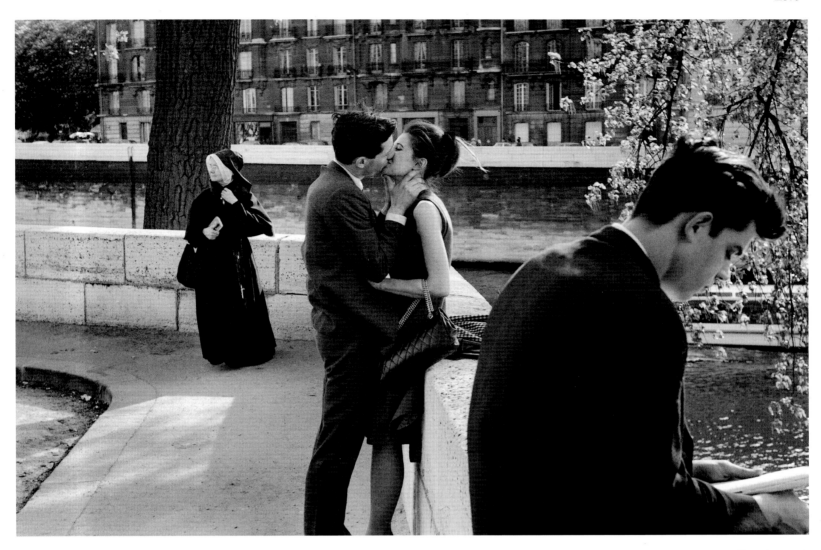

Île Saint-Louis
ÉDOUARD BOUBAT, 1975

" A legally permitted kiss will never equal a stolen kiss. "

GUY DE MAUPASSANT, *A Wife's Confession*

ÉDOUARD BOUBAT, 1950

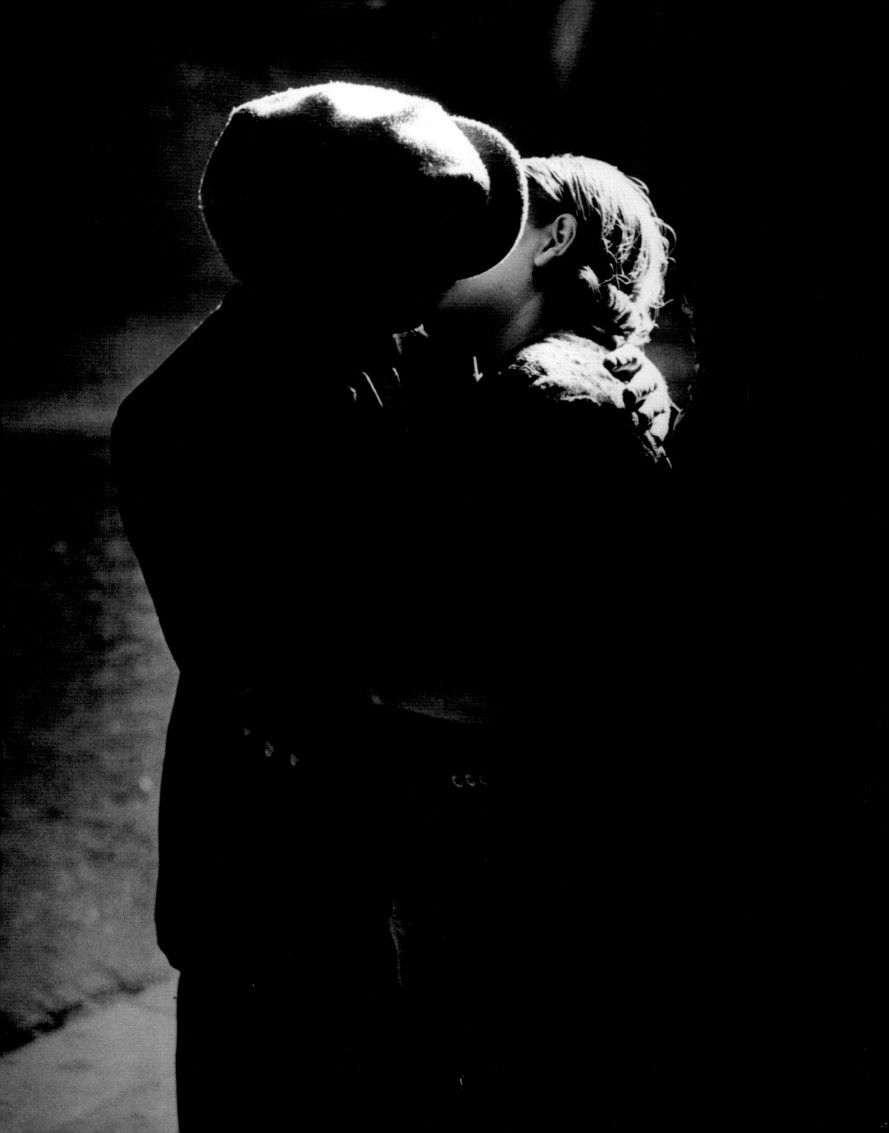

"What is a kiss? —

A shift off course. Everything capsizes."

ANDRÉ BRETON, *La Révolution surréaliste*
("The Surrealist Revolution")

A kiss
BRASSAÏ, C. 1932

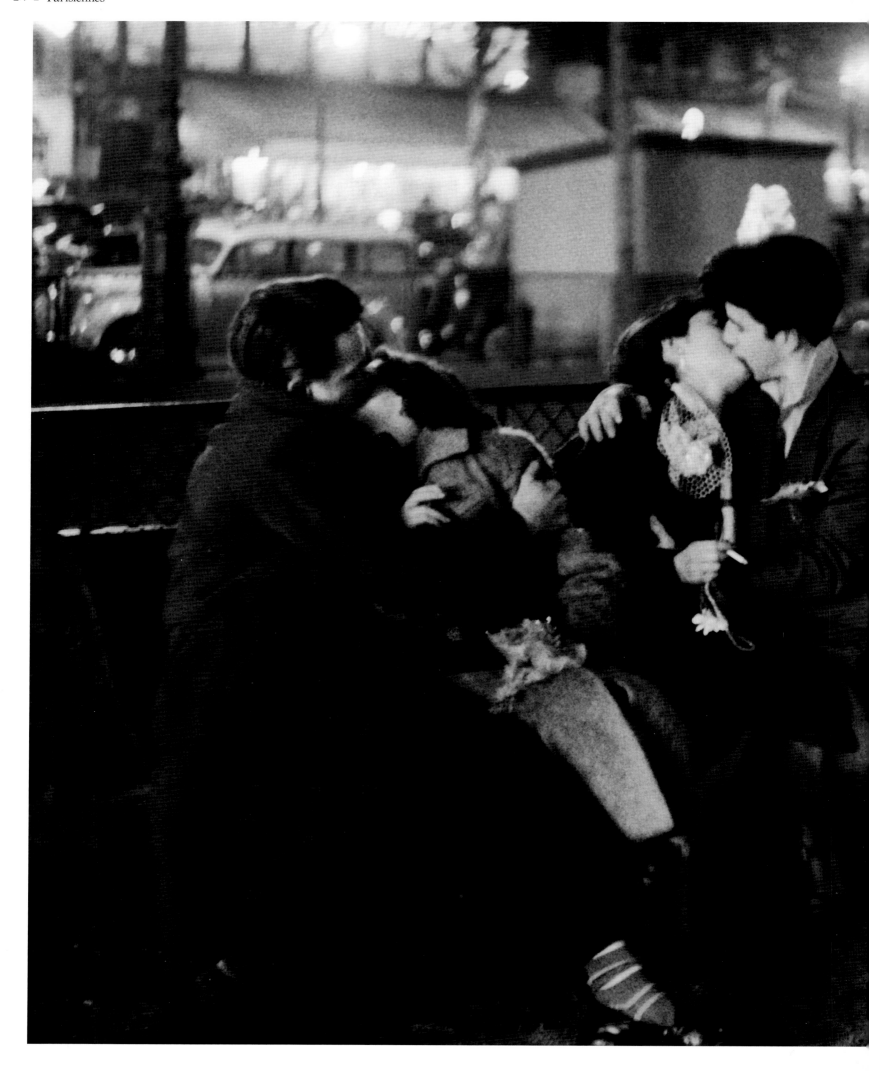

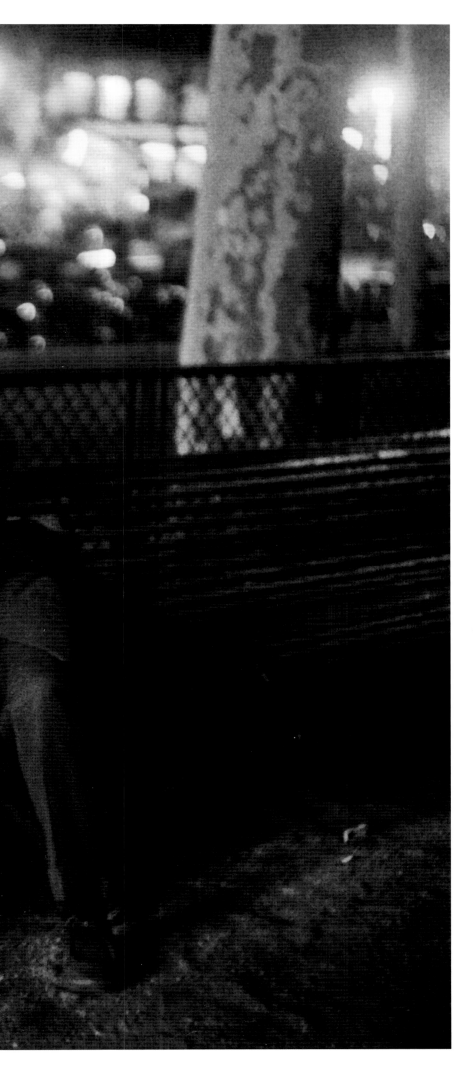

Lovers on a public bench,
place de la République
SABINE WEISS, 1955

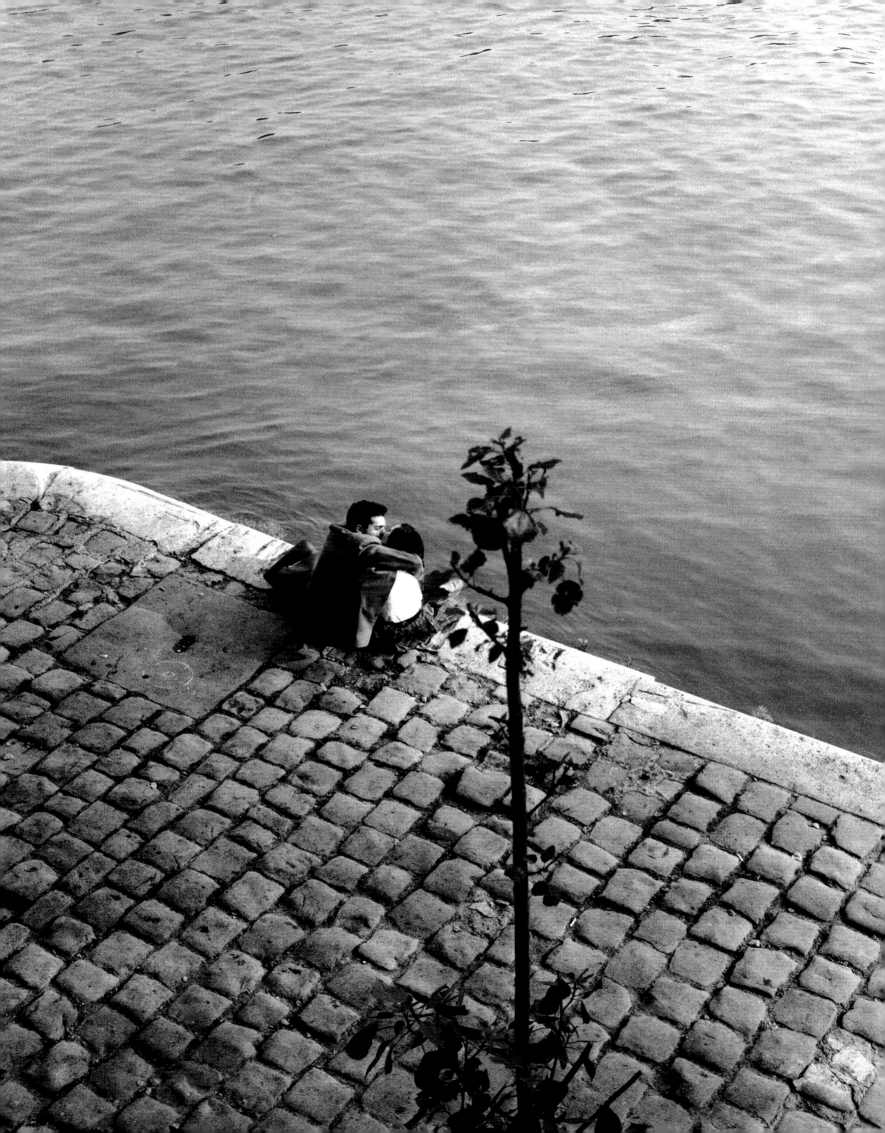

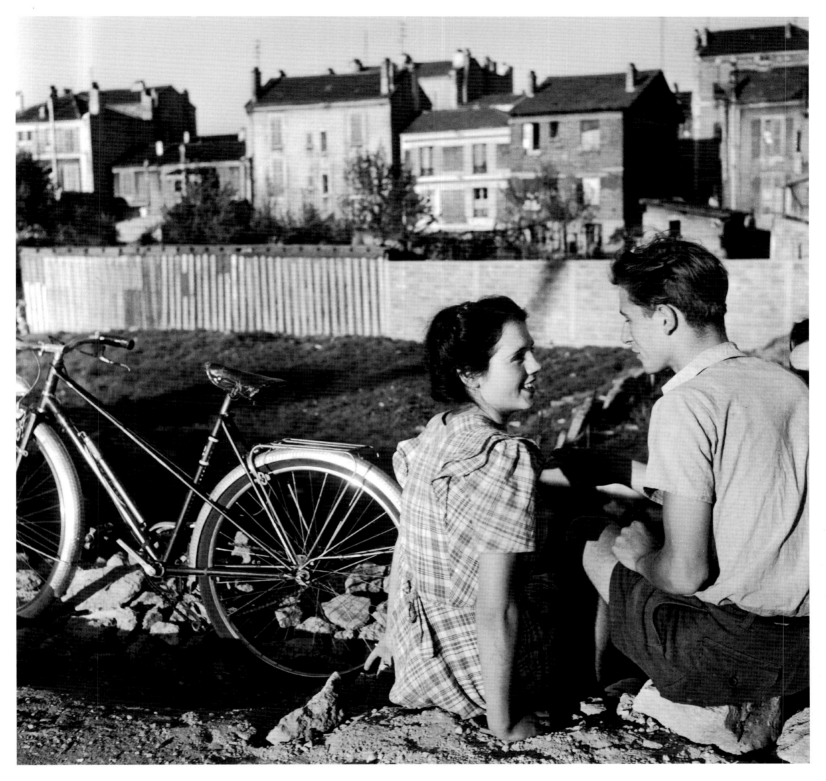

A bicycle in spring
ROBERT DOISNEAU, 1954

Quai du Louvre
WILLY RONIS, 1953

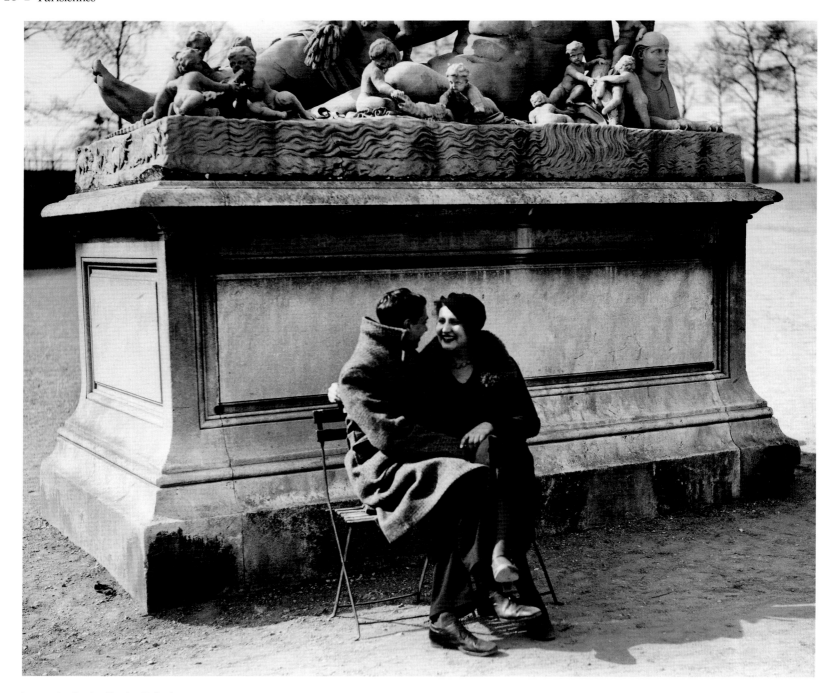

Lovers in the Jardin des Tuileries
ANONYMOUS, 1932

" Paris is the world capital of the mind-flirt: people
worry a great deal about what people say, but
what's said is of no importance whatsoever. "
ALAIN SCHIFRES, *Les Parisiens*

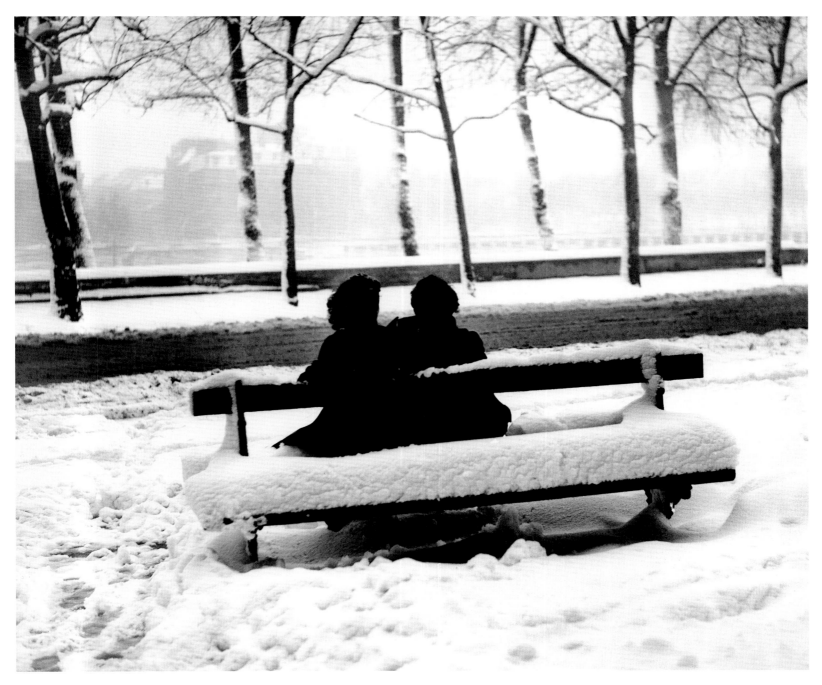

Lovers in the snow
ANONYMOUS, 1946

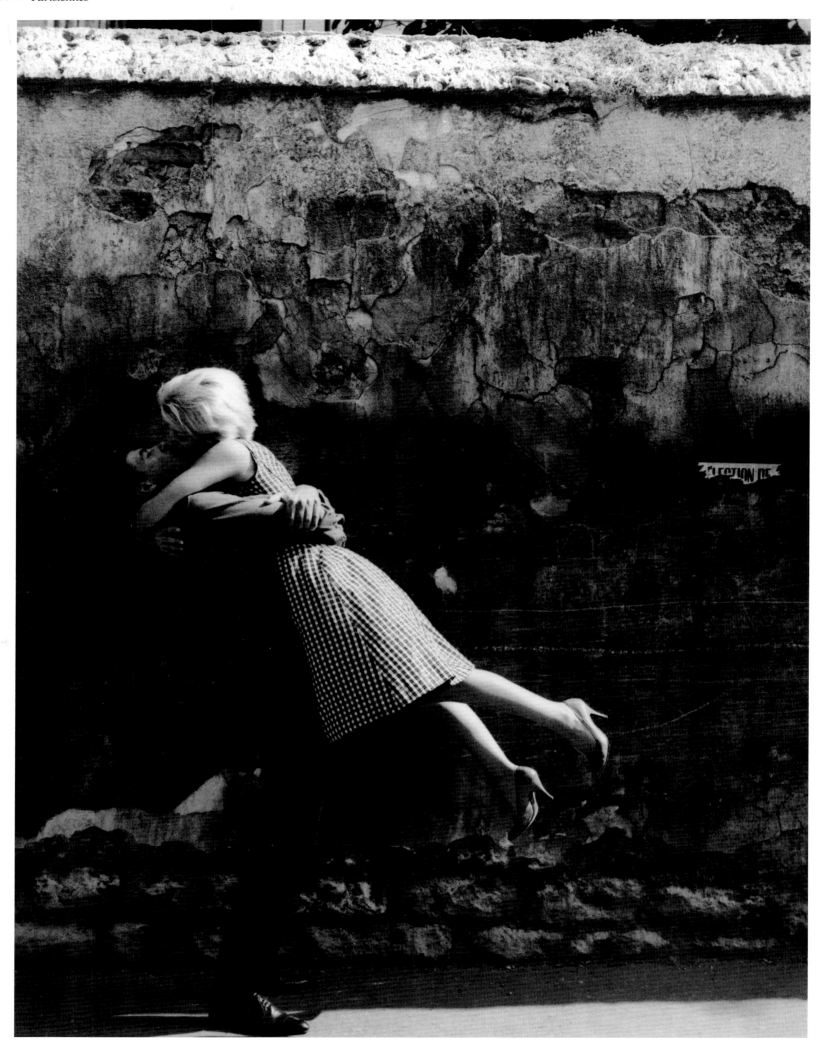

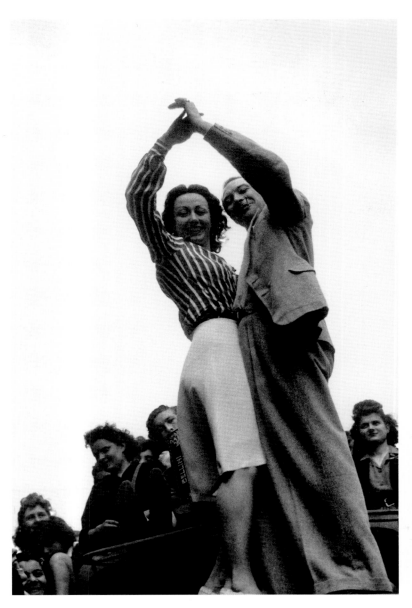

May 8, 1945
JEAN-PHILIPPE CHARBONNIER, 1945

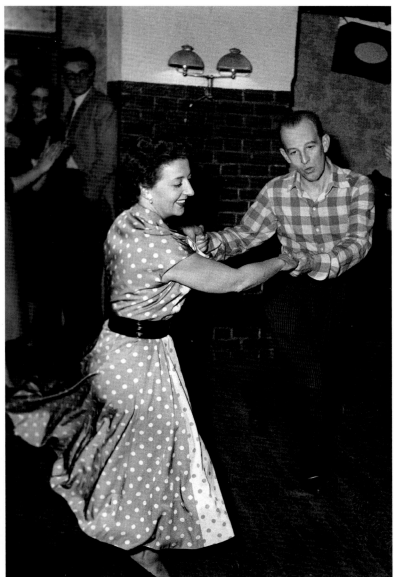

Dancers at the Crazy Horse
ANONYMOUS, 1951

Couple embracing
ÉDOUARD BOUBAT, 1959

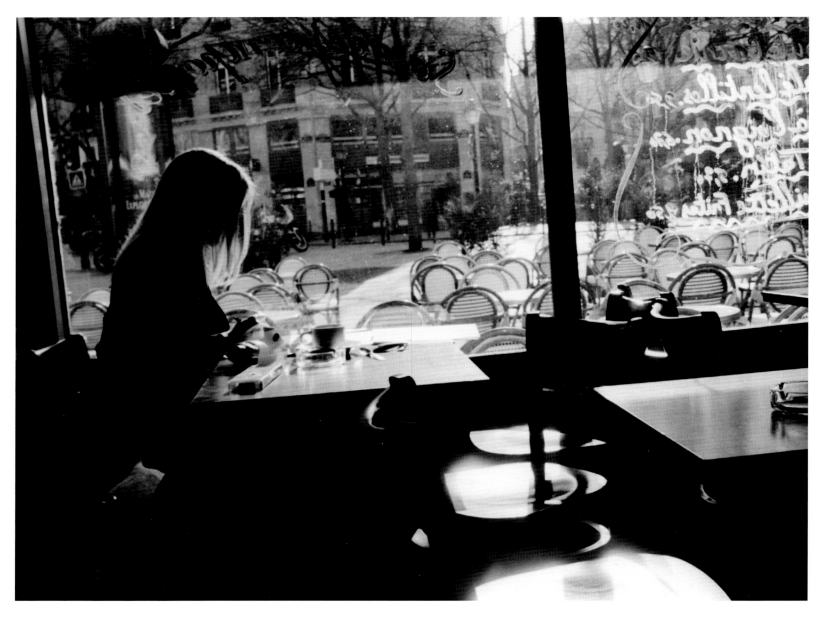

Young woman in a café on place Saint-Michel
ELISE HARDY, 1990

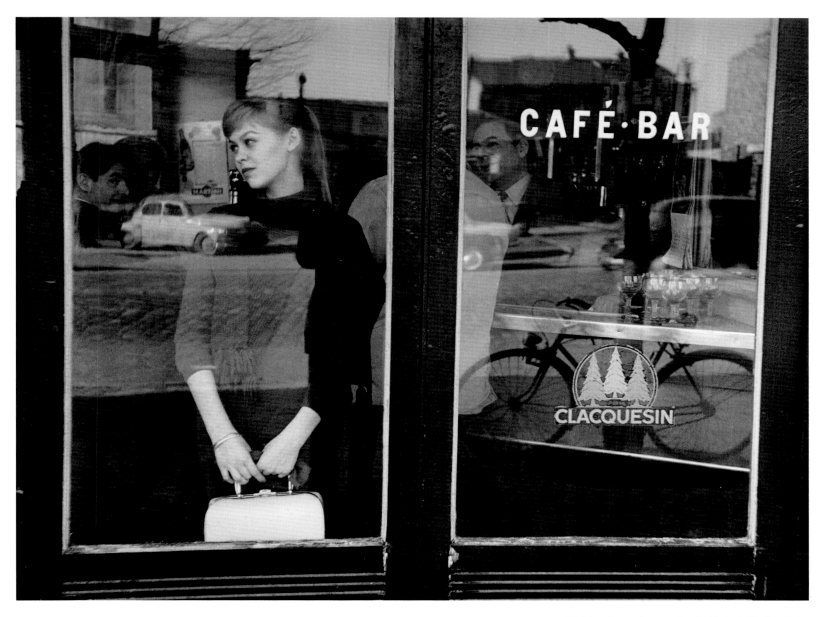

Waiting for a date at the Café de la Vache Noire
ÉDOUARD BOUBAT, 1957

" How tiresome to wait even an hour for the one we love. "

PIERRE CORNEILLE, *The Maidservant*

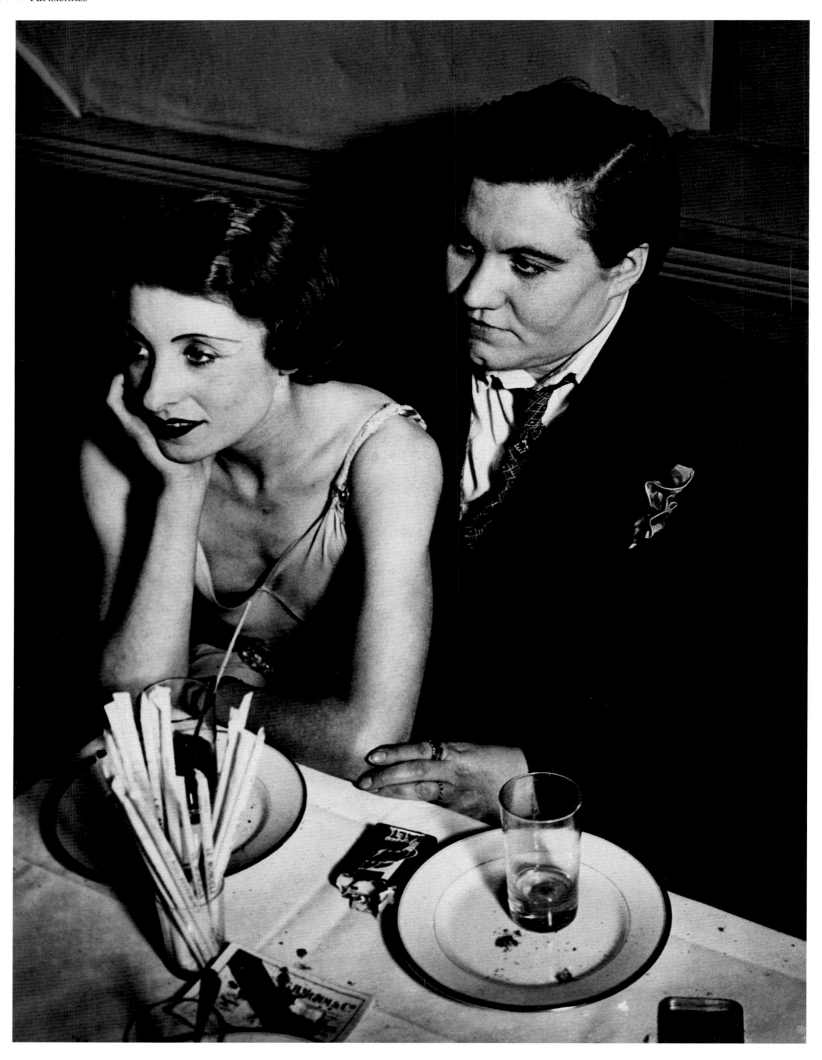

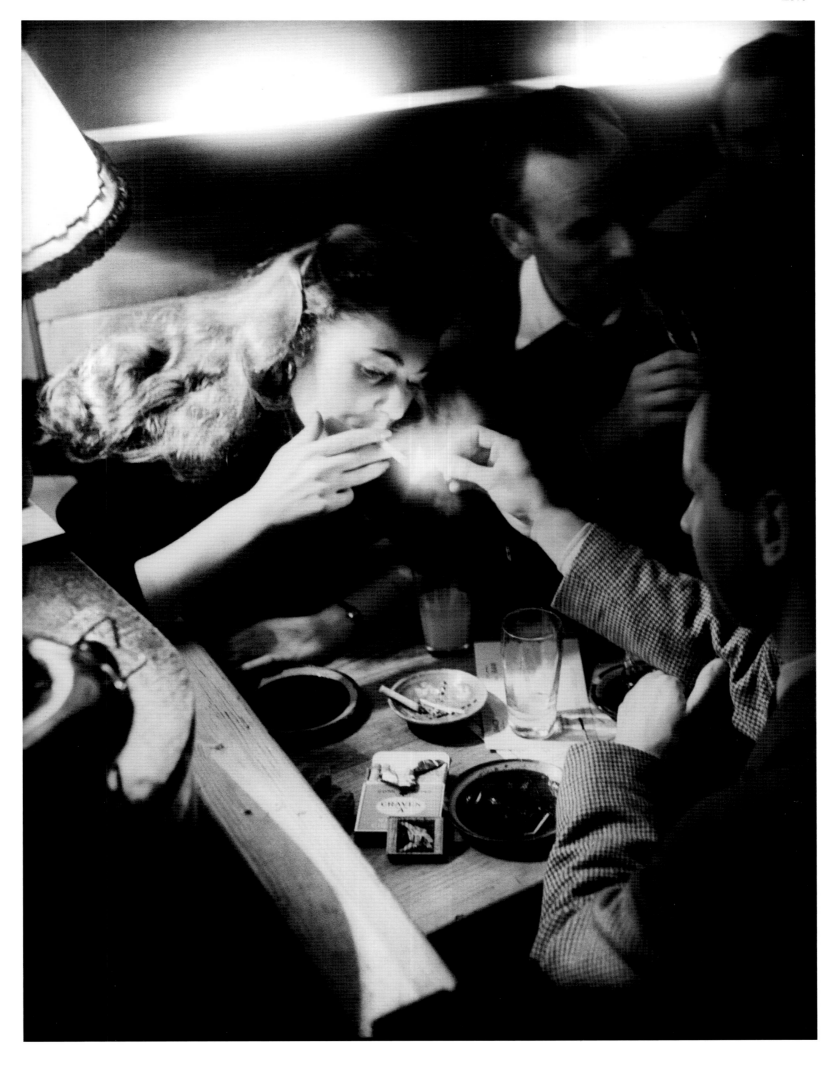

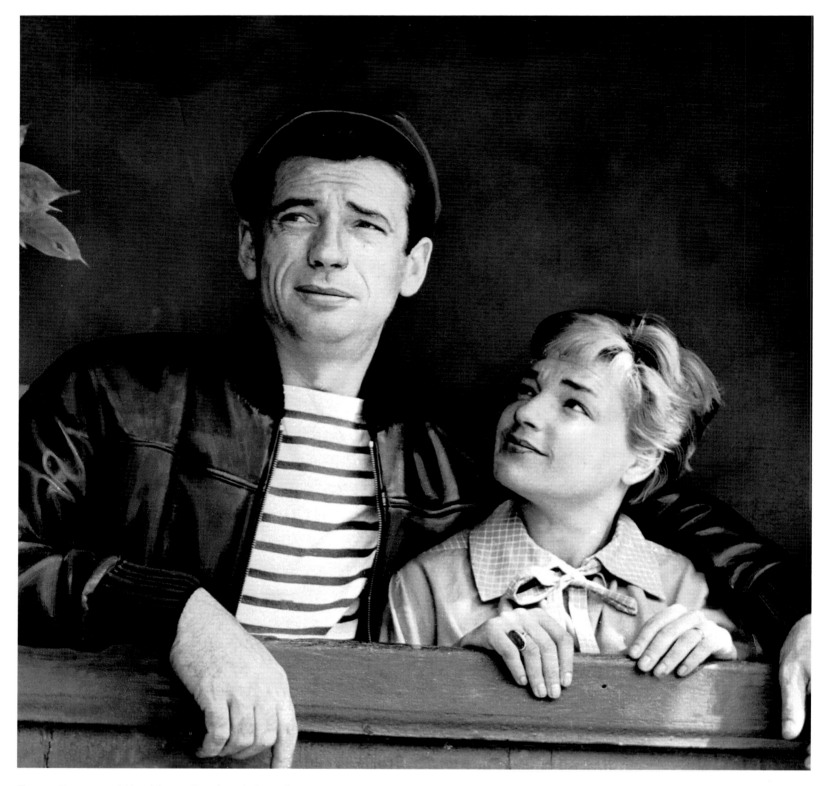

Simone Signoret and Yves Montand at the window of
their apartment on place Dauphine
ANONYMOUS, 1951

PAGE 34
"Grosse Claude" and her girlfriend at the
Monocle club
BRASSAÏ, C. 1932

PAGE 35
Nightclub
WILLY RONIS, 1952

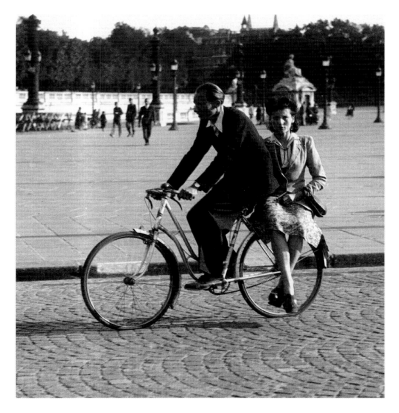

Couple on a bicycle, place de la Concorde
ANONYMOUS, 1943

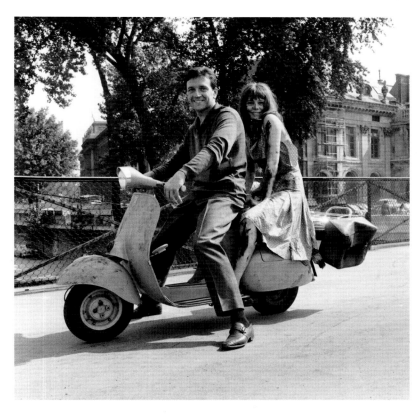

Jean-Pierre Cassel and
Françoise Dorléac on
a Vespa on the Pont des Arts
ANONYMOUS, 1961

" What's the point of emotions you keep all to yourself? "

ANNA GAVALDA, *Hunting and Gathering*

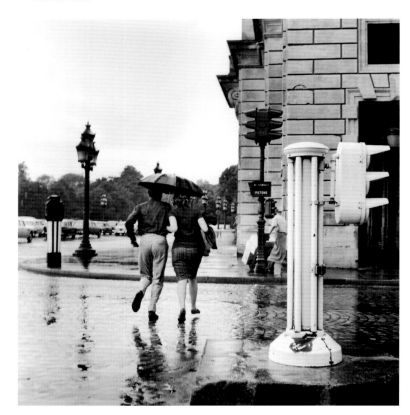

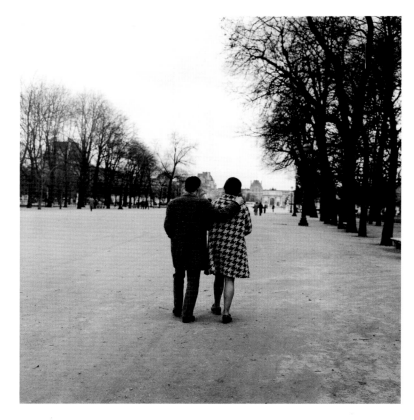

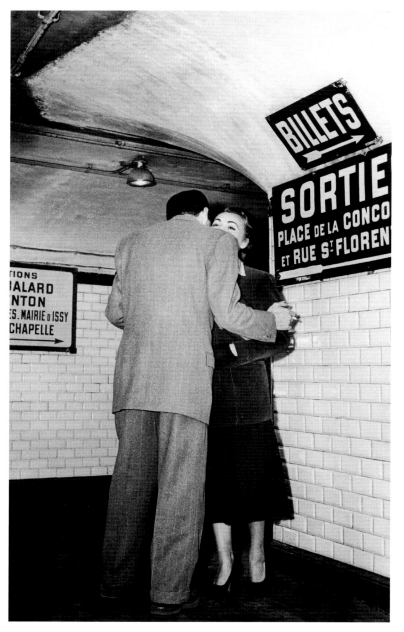

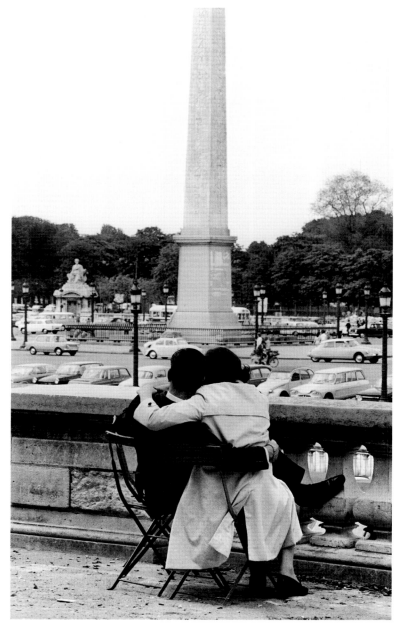

"To be loved is to be consumed in the flame. To love is to glow with inexhaustible light. To be loved is to pass over; to love is to last forever."

RAINER MARIA RILKE,
The Notebooks of Malte Laurids Brigge

ABOVE, LEFT TO RIGHT
Summer rain on rue Royale
ANONYMOUS, 1963

Lovers in the Jardin des
Tuileries, walking towards
the Louvre
ANONYMOUS, 1968

BELOW, LEFT TO RIGHT
Couple embracing in the
Louvre metro station
ANONYMOUS, 1950

Lovers in the Jardin des
Tuileries, overlooking place
de la Concorde
ANONYMOUS, 1967

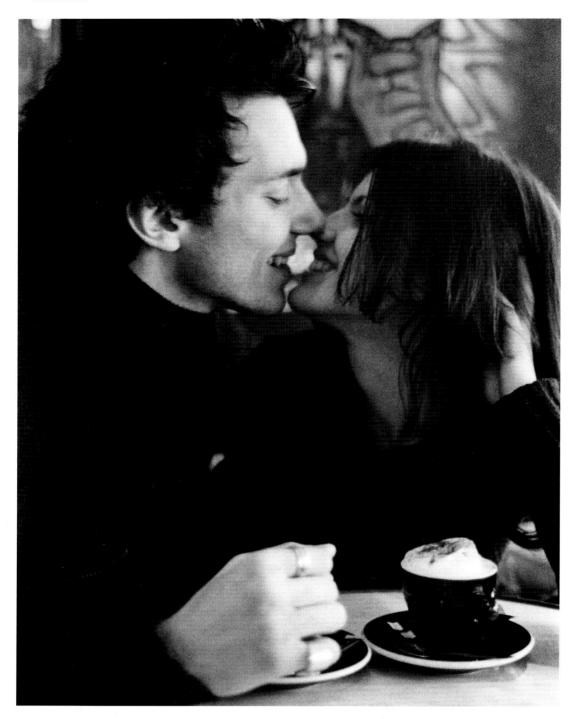

Couple drinking coffee
ELISE HARDY, 1980

"A kiss assuages hunger. You can sleep in a kiss, inhabit it, find oblivion."

JACQUES AUDIBERTI, *La Poupée* ("The Doll")

Couple embracing
ELISE HARDY, 1980

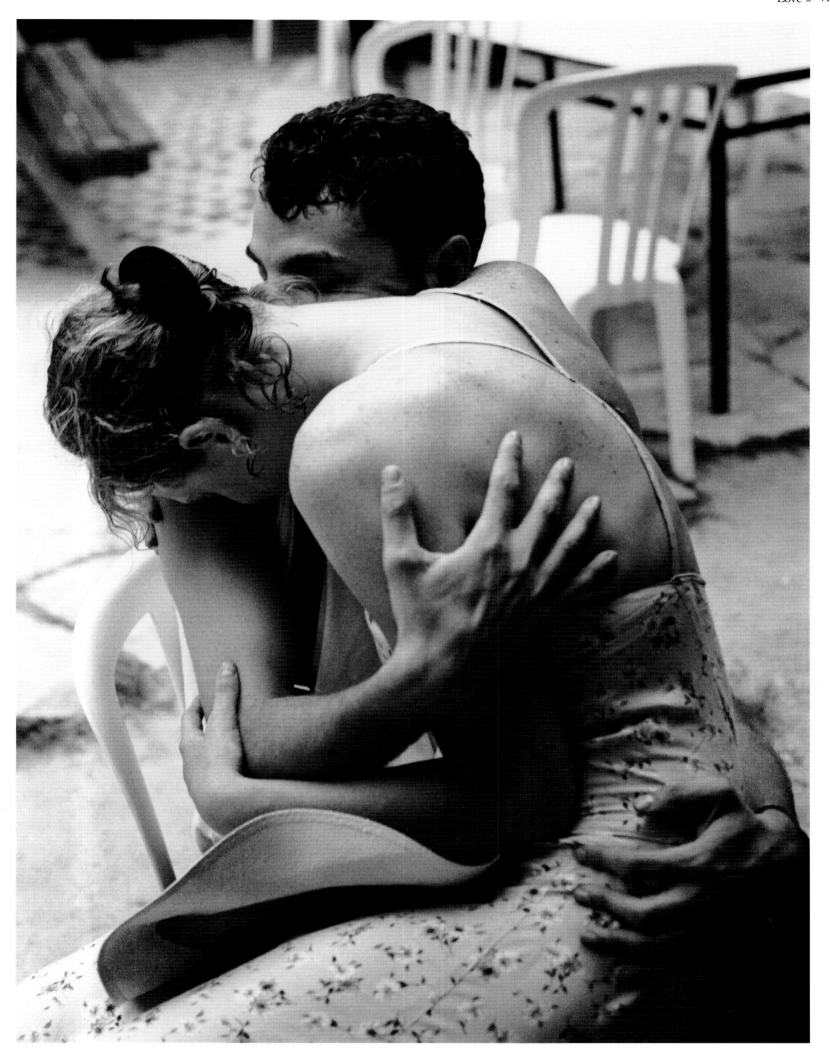

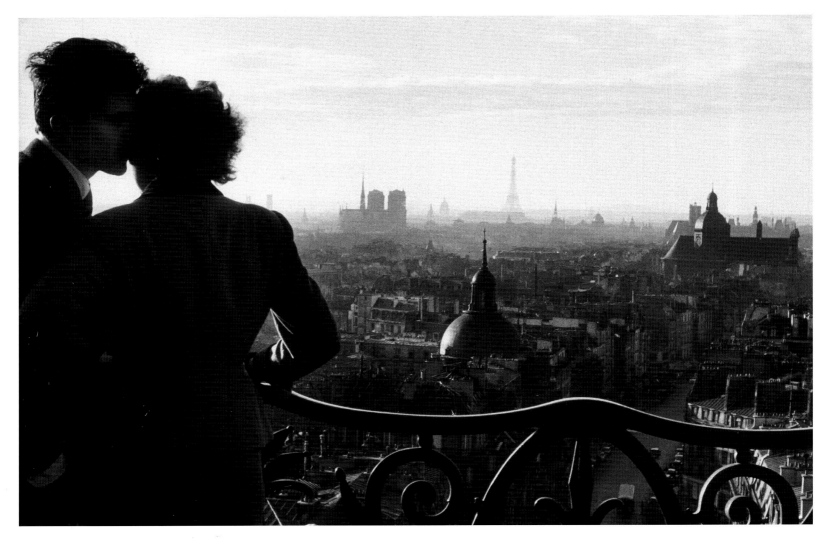

Lovers on top of the July Column, place de la Bastille
WILLY RONIS, 1957

"And then he told her. Told her that it was as before, that he still loved her, that he could never stop loving her, that he'd love her until death."

MARGUERITE DURAS, *The Lover*

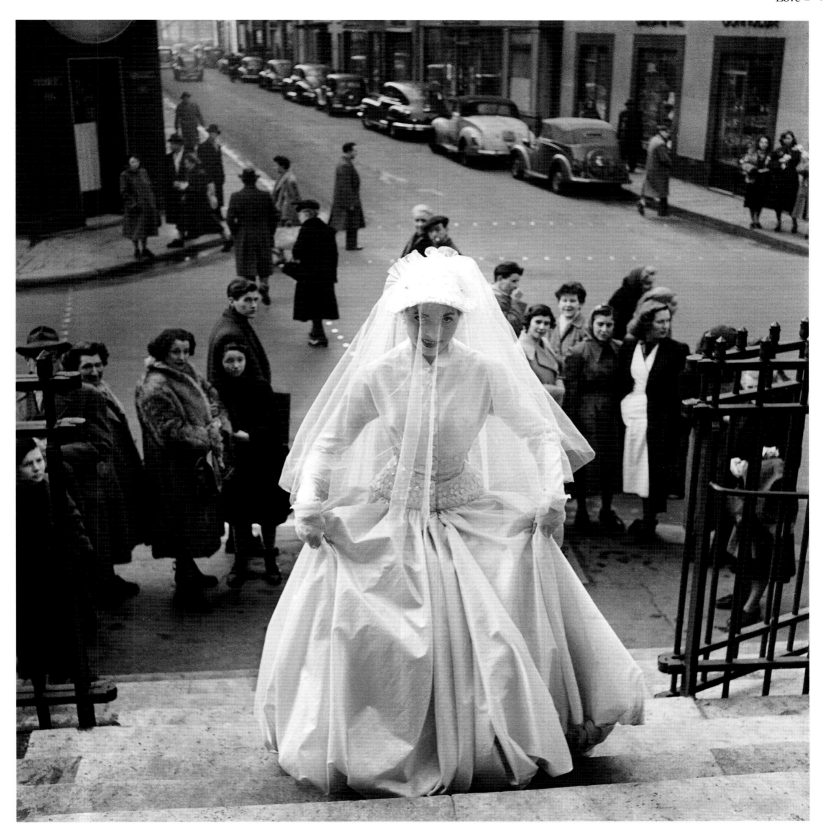

Church of Saint-Roch
ÉDOUARD BOUBAT, 1952

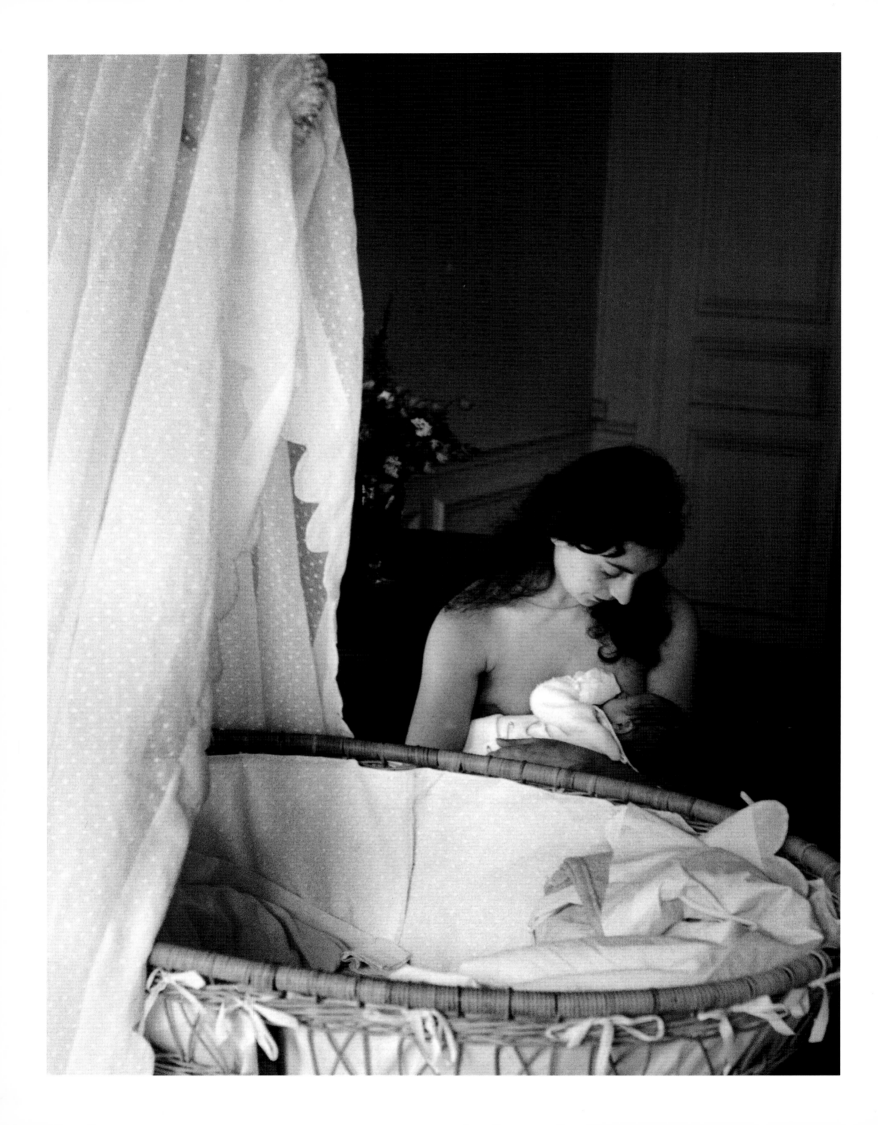

MOTHERHOOD

Mothers are not always impeccably behaved. Mothers leave, they suffer, and they work, too; like mine, in the 1960s; like my grandmothers, one a hat-maker and one a mender of fishing nets, in the 1930s. Mothers are not always patient. Sometimes, at bath-time, they feel like striking out for the open sea. Sometimes—just sometimes—when it's time for hugs, they find the stocks are low.

Virgil celebrated their smiles, but there are mothers who never smile at all. And some whose smiles flash sporadically, among moments of impatience, or preoccupation, almost lost among the myriad demands of daily life. There are mothers who love joyfully, passionately, unreservedly, and there are mothers who love distantly, who perhaps don't know how to love. There also mothers who love so much they suffocate. And surely a father's love is "equal to no other" too? There are several mothers in me, some good and some bad. I often get bored pushing a swing. I confess I'm happy when school starts again on Mondays, and I sometimes dread the holidays. I bless my parents for being such good grandparents, my partner for being such a good father, and baby-sitters for just existing. I write, and I take good care of my children: there's no contradiction between these different creative acts, just, sometimes, overwhelming exhaustion. Better, then, to admit defeat, to have a siesta than a game of "horsey." And better to loosen your children's reins than to be always on their backs.

But sometimes life does imitate art, and our life resembles the idyllic images in this chapter. I've got a little balcony, and the sun shines for me, too. And just like the photo of the mother taken in the 1930s, I've filled up a bathtub in the stifling heat of summer, the water sparkling and splashing. I've turned my balcony into a day at the beach for my children. I've played with watering cans and buckets beneath a burning sky, pretending we're at the seashore. I've fed my baby a bottle, and chosen school bags, just like these photos of an ideal world. And I've been lucky enough to do these things in the modern world, where childhood illnesses are less severe, where childbirth takes a lesser toll, where women are freer. And so I, too, have lost myself in games and bubble-blowing with my two small children. And when we're full of the energy of those happy times, when our elation hasn't turned to vertigo, we store up these mental snapshots for the gray days, the empty days, and we feel we're the best mother ever, the only mother possible, for our children.

Sophie and Bernard
ÉDOUARD BOUBAT, 1958.

MARIE DARRIEUSSECQ

"The natural protectiveness, the skilled care, the delicate motherly gesture— the privilege of woman."

COLETTE, *The Vagabond*

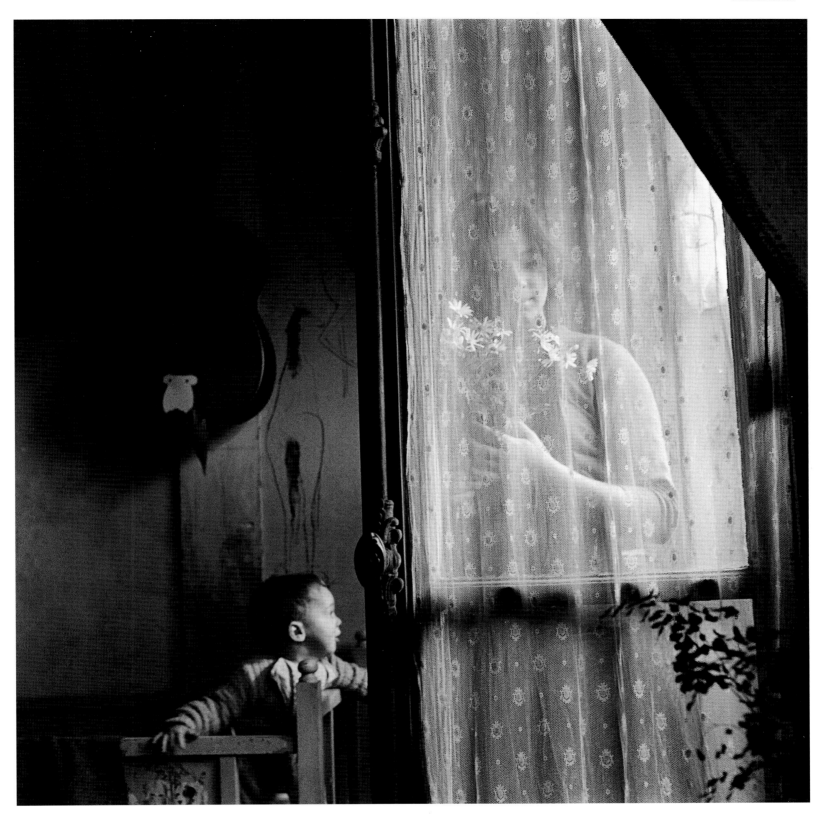

Mother and son
ÉDOUARD BOUBAT, 1951

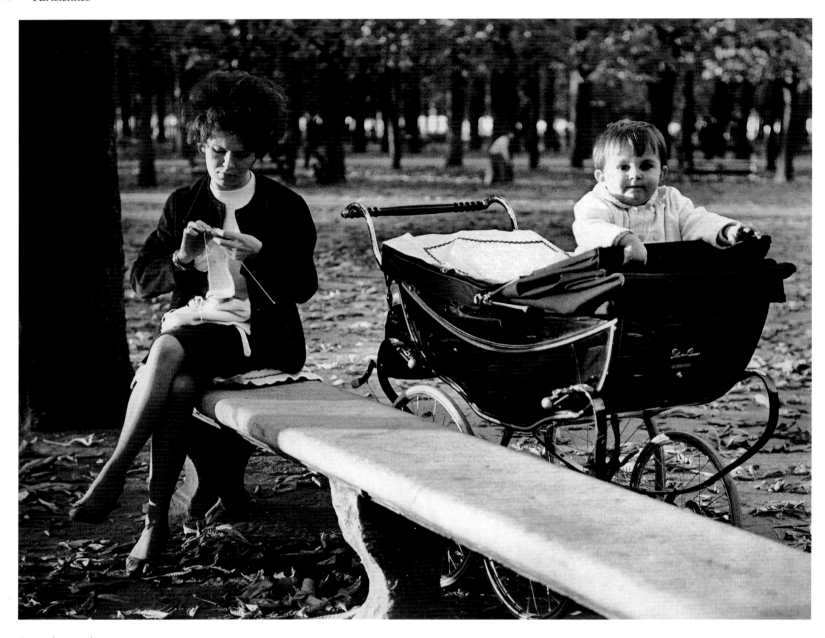

An outing to the
Jardin des Tuileries
ANONYMOUS, 1960s

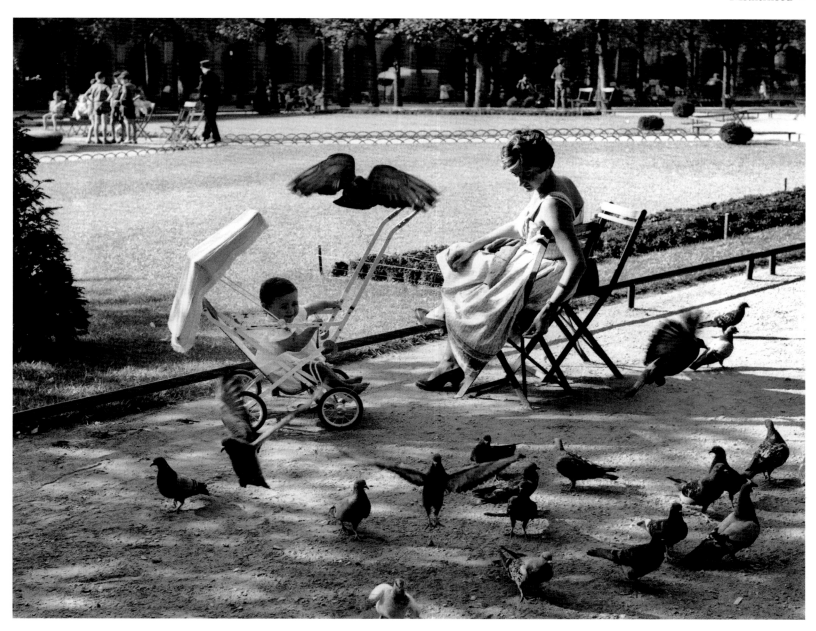

Mother and child in the gardens
of the Palais royal
ÉDOUARD BOUBAT, 1950s

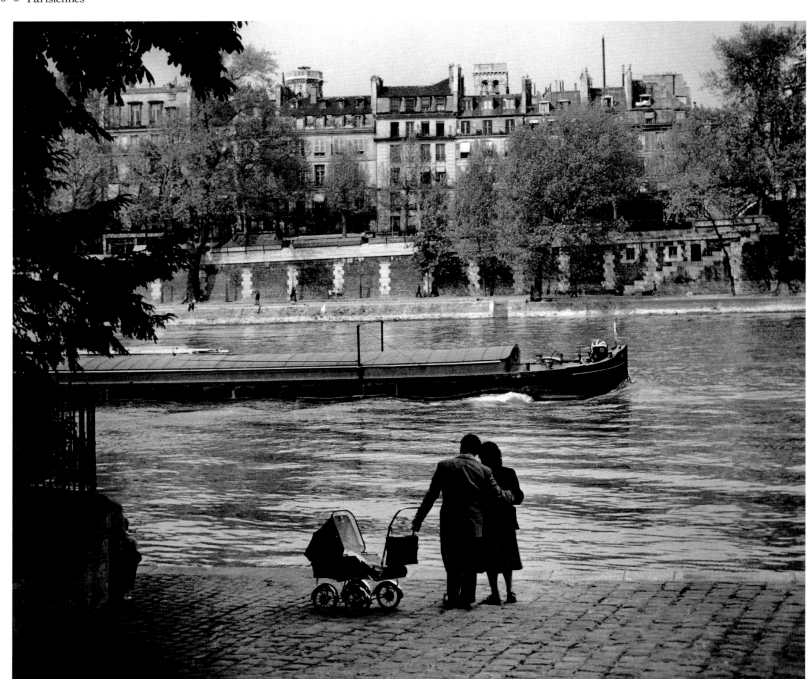

In the square du Vert Galant,
Ile de la Cité
WILLY RONIS, 1953

" A mother knows love: this is all her art. "

CHARLES HUBERT MILLEVOIE,
L'Amour maternel ("Maternal Love")

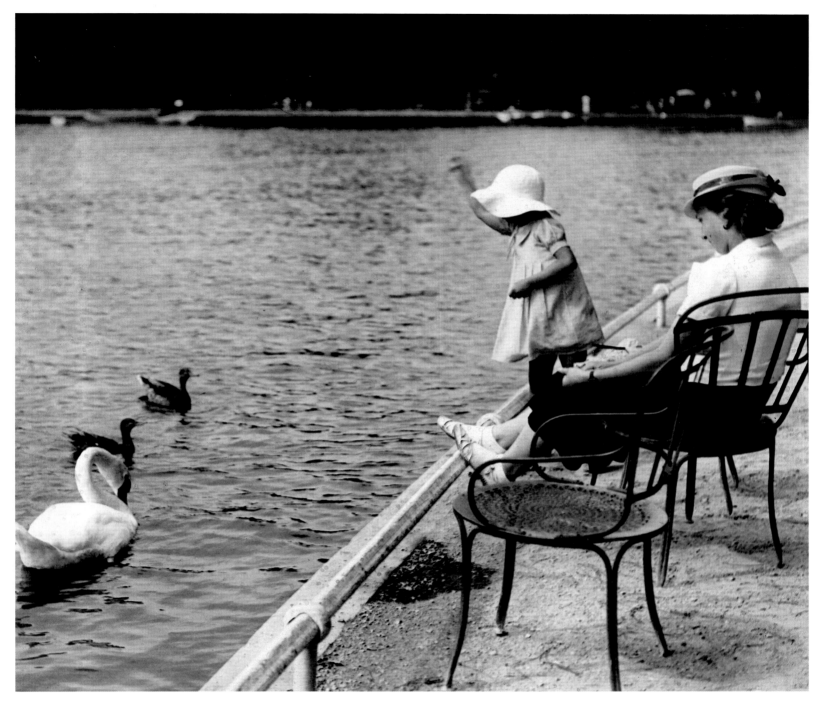

A little girl feeding a swan and
ducks on the lake
in the Bois de Boulogne
ANONYMOUS, 1930

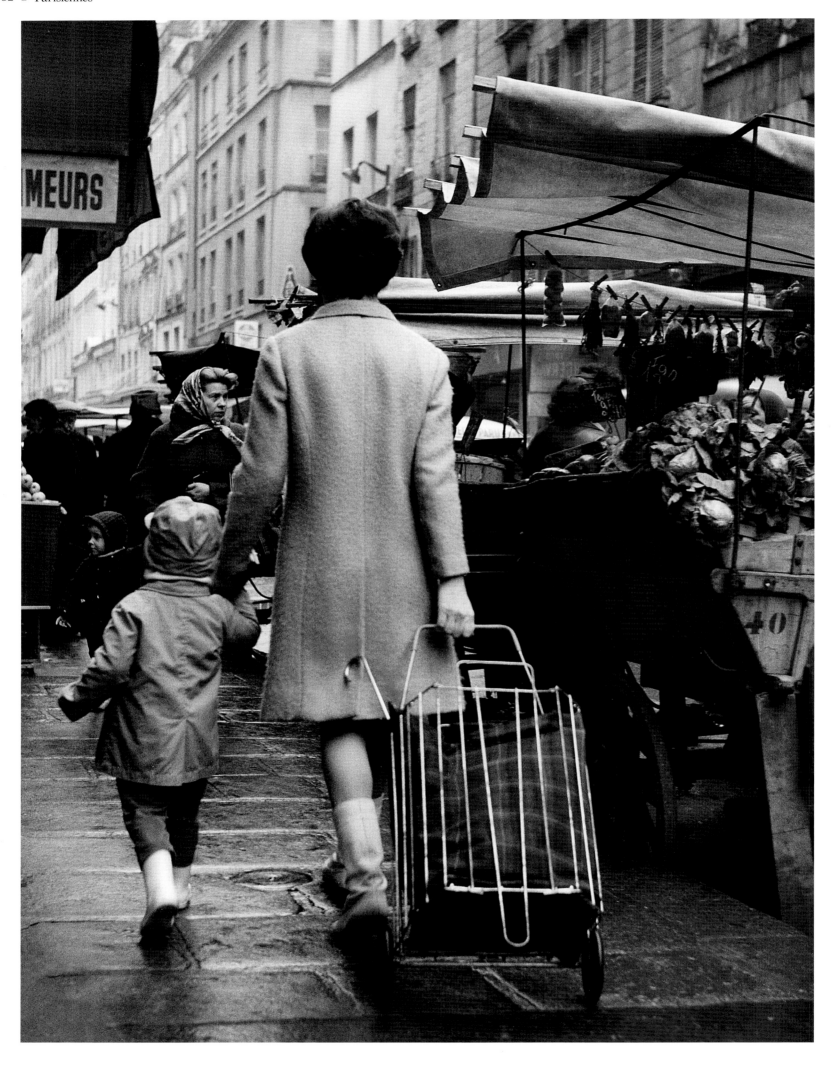

> **❝** Our mothers' love, equal to no other. **❞**

ALBERT COHEN,
Le Livre de ma mère ("The Book of My Mother")

Mothers and children
shopping in the market
ANONYMOUS, 1968

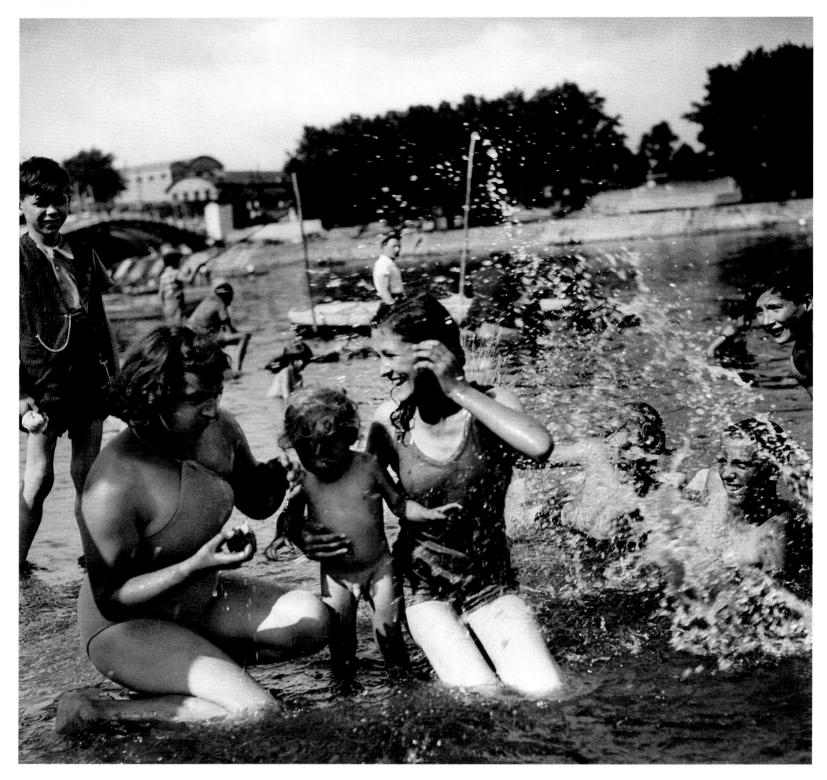

Playing and swimming
in the Seine
ANONYMOUS, 1938

" The infant knows its mother by her smile. "

VIRGIL, *Eclogues*

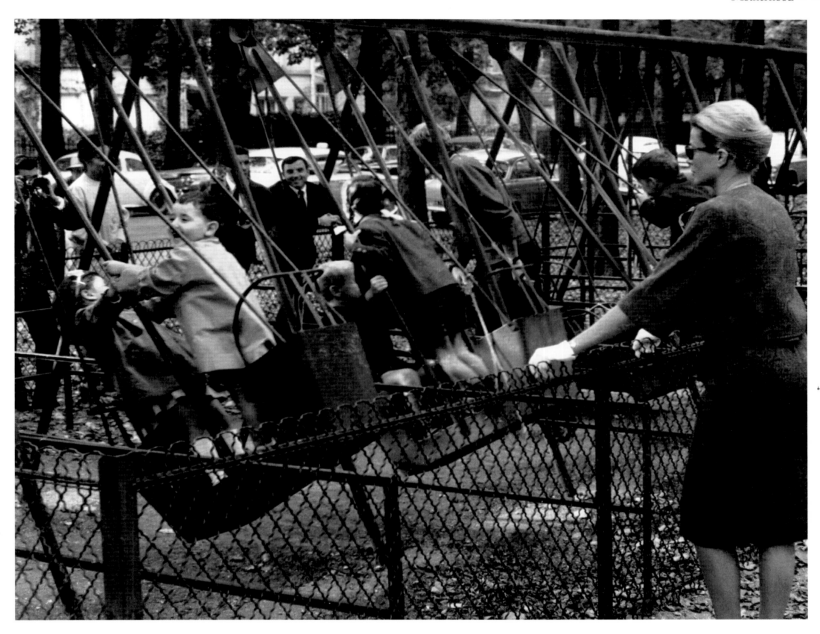

Princess Grace of Monaco watching
her children play on the swings in
the Jardin du Luxembourg
ANONYMOUS, 1962

" My mother's love for me

was so great that I have

worked hard to justify it. **"**

MARC CHAGALL

A mother pours water
over her children, splashing
in a bath on a balcony
ANONYMOUS, 1937

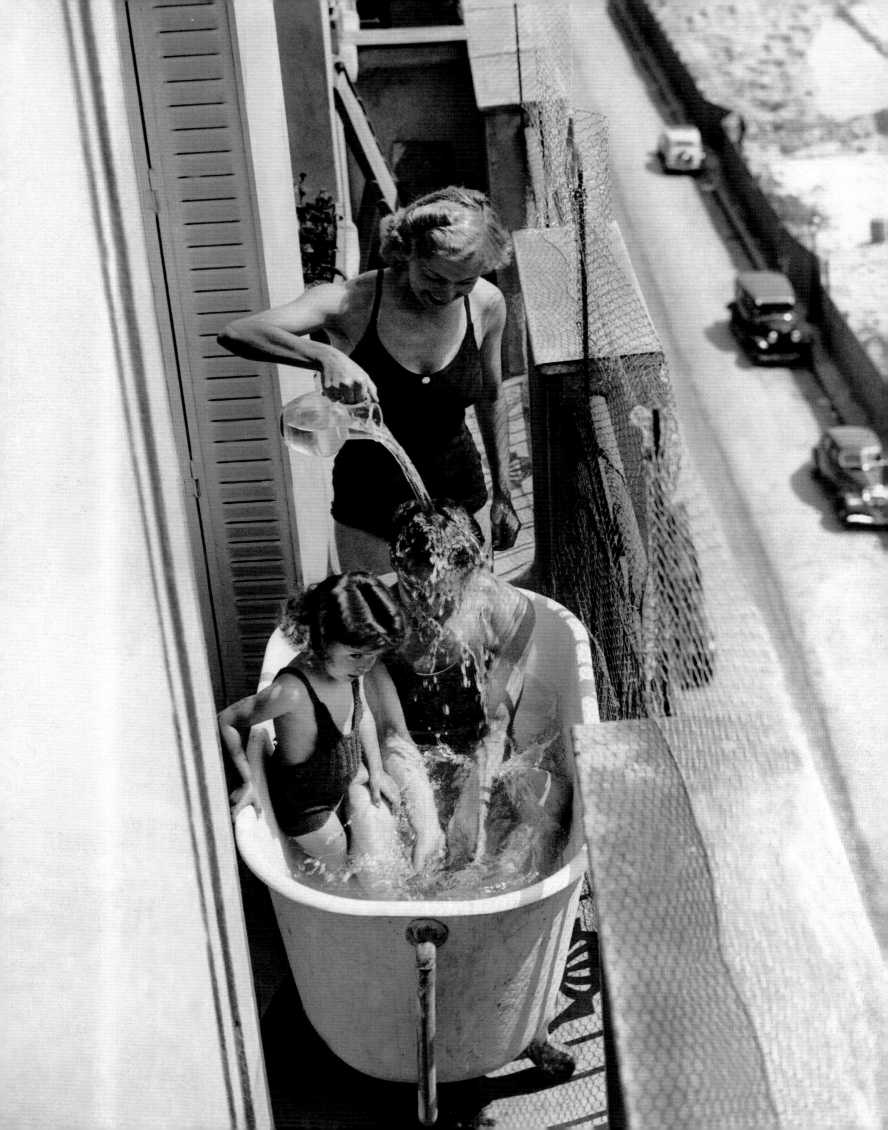

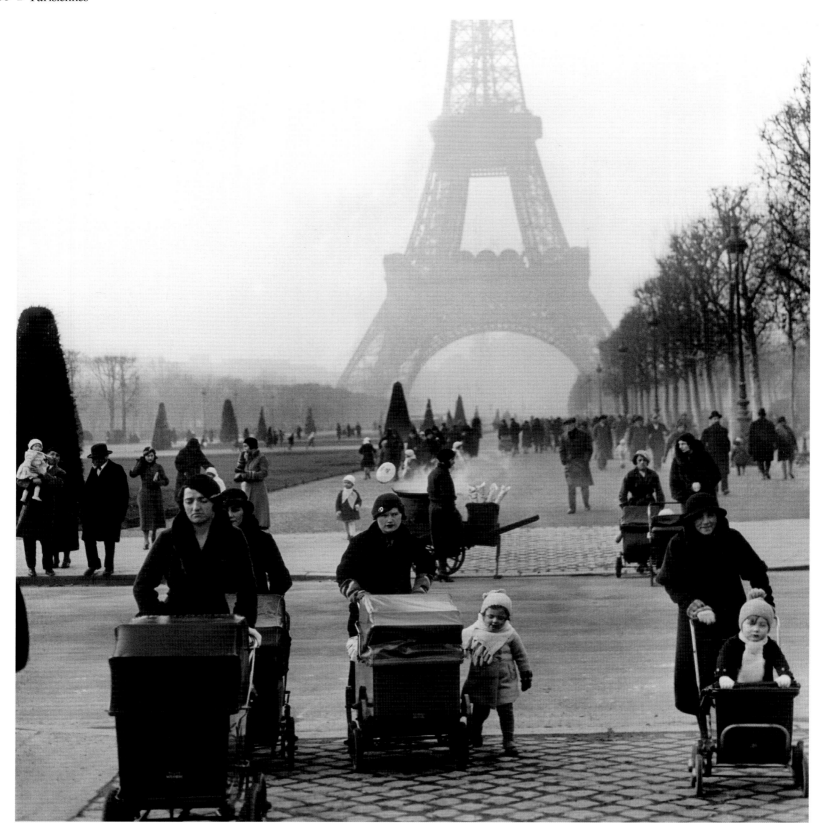

A walk in the
gardens of the
Champ de Mars
Anonymous, 1934

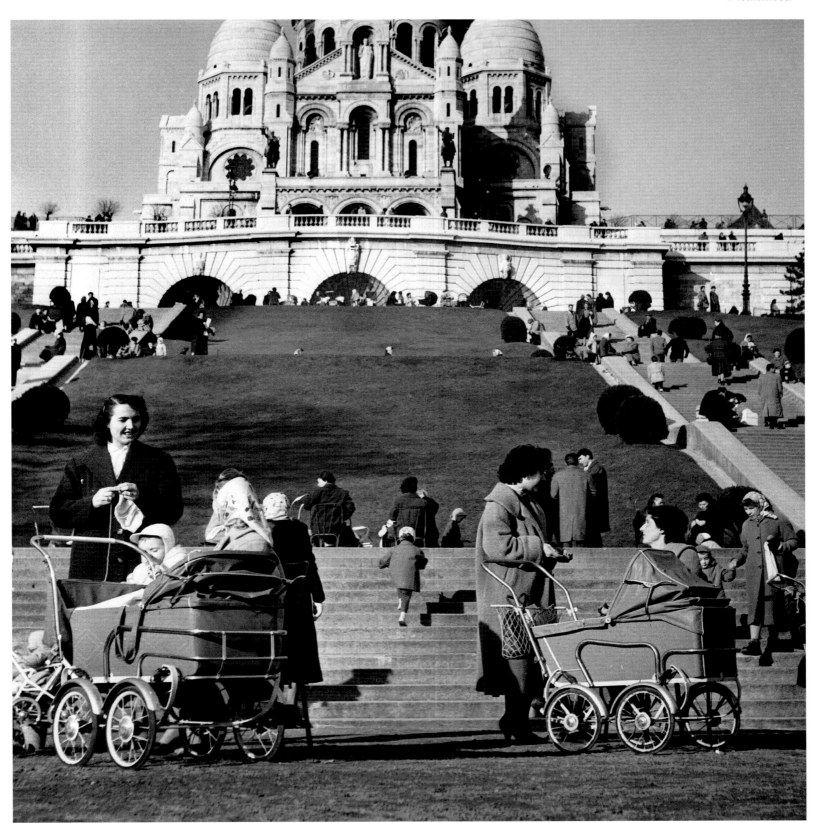

Chatting beneath Sacré Cœur
ANONYMOUS, 1958

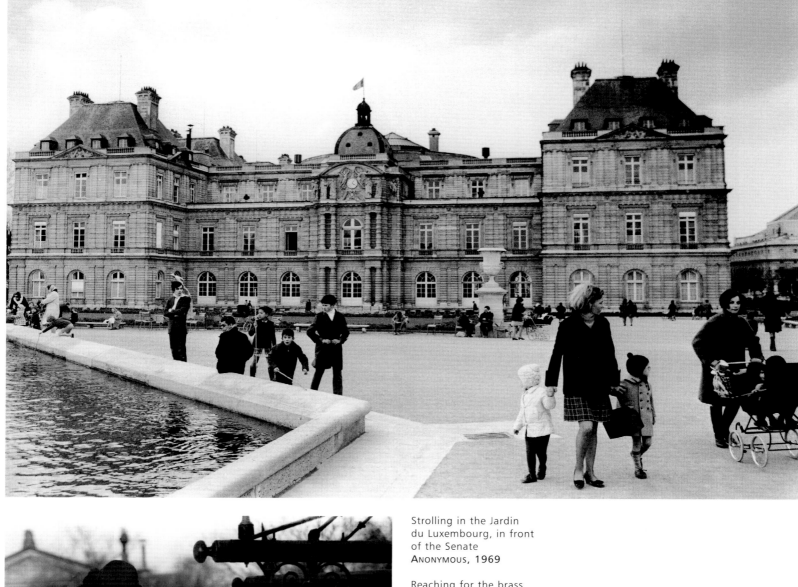

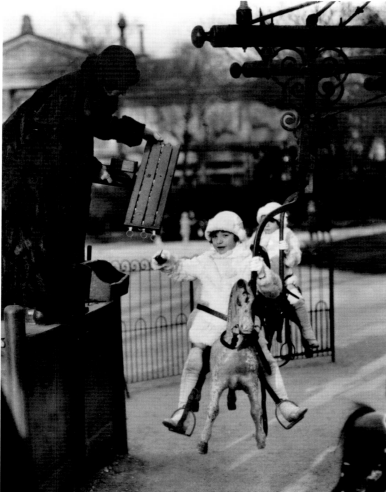

Strolling in the Jardin
du Luxembourg, in front
of the Senate
ANONYMOUS, 1969

Reaching for the brass
ring on the carrousel
ANONYMOUS, 1957

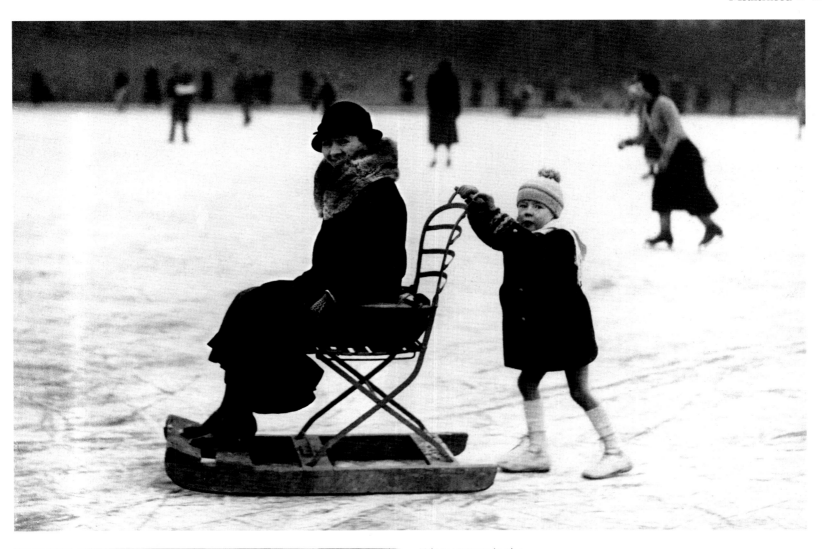

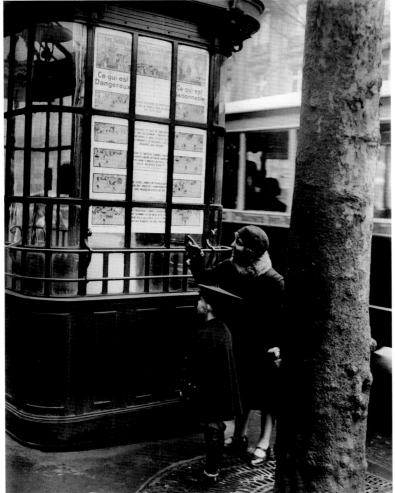

Winter games in the
Bois de Boulogne
ANONYMOUS, 1933

Mother and child reading
a poster at a tram-stop
ANONYMOUS, 1931

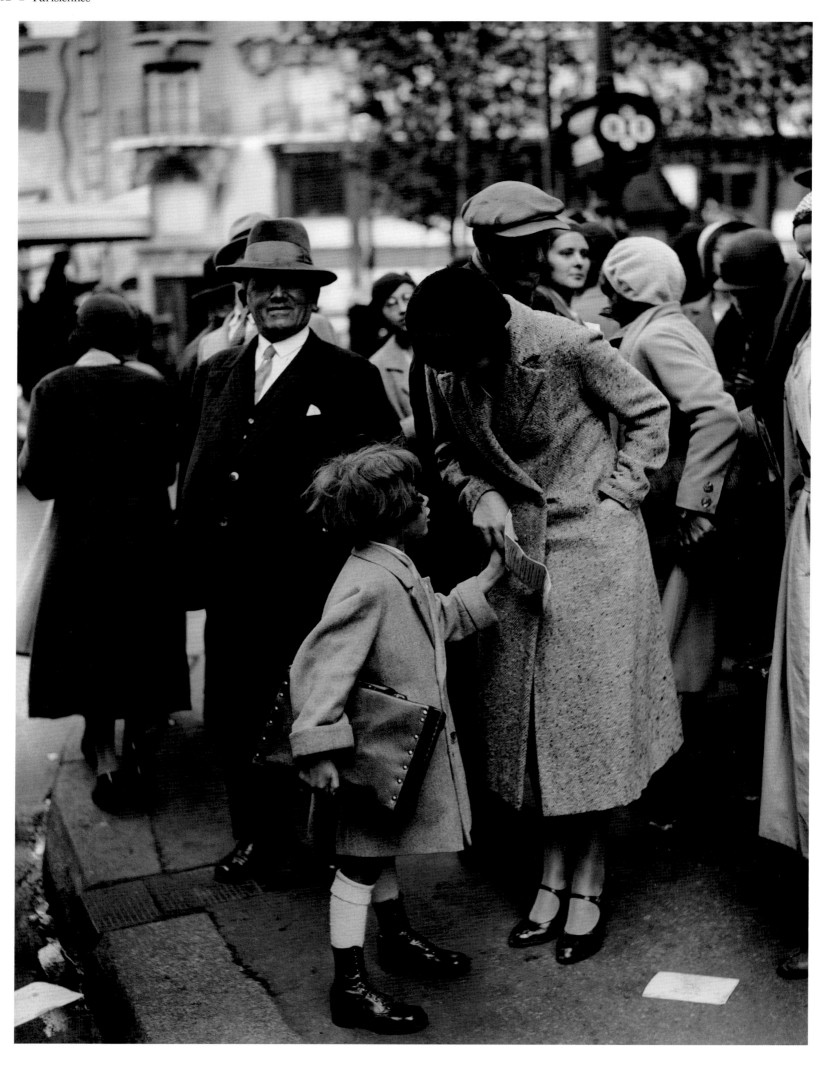

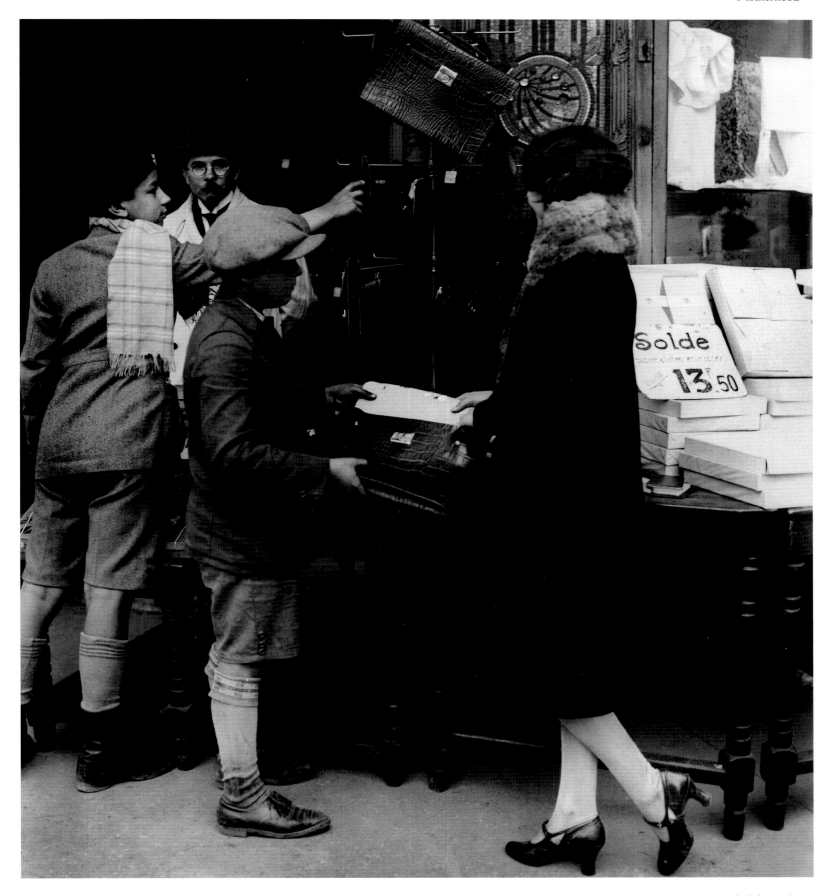

Buying a satchel: last-minute
shopping before school
ANONYMOUS, 1930

Back to school
ANONYMOUS, 1931

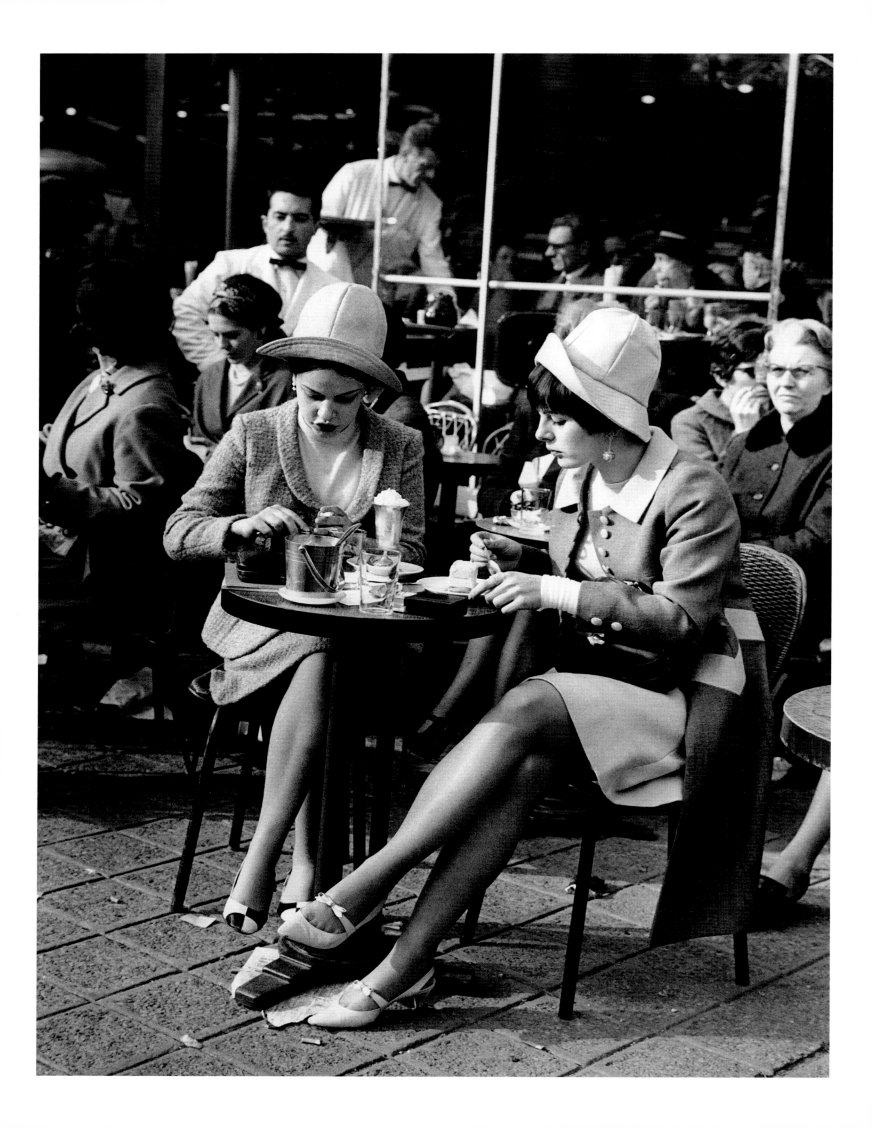

APPETITE

Photographs may be frozen moments in time, but these glorious celebrations of women enjoying food and drink are very much alive. They are reenacted daily, and what memories they evoke in any woman who has spent time in Paris. They capture us. It is easy to see ourselves in these photos (although perhaps without the hats). I have looked through so many windows of pastry shops; read the menus posted at so many cafés and restaurants; wined, dined, and laughed at tables of all kinds. I am the French woman in the photos, perfectly captured on film. Breakfast, lunch, and dinner are my favorite pastimes. Eating and drinking is about pleasure, but sitting down at the table is much, much more: with that comes conversation, communication, sharing, relaxing, dreaming, and laughing. It's about conviviality, which sometimes seems to be an art that's disappearing, although not so for the Parisienne. These timeless photographs prompt memories of *moments gourmands* I've had in Paris—wonderful meals with friends and relatives—but more precisely of my mother's visits to Paris once or twice a year: *Les deux p'tites gourmandes,* that's what our family called us. When mother returned to our family home after a couple of days with me, she had to give full report of all the *plaisirs gourmands* she had shared with me.

Still so fresh in my mind is a lunch at Le Grand Véfour, the celebrated restaurant in the Palais Royal where just drinking in the beauty and history of the dining room made our spines tingle. I remember how we were often the last ones to leave a restaurant as my mother and the chef would share a few culinary secrets on the doorstep. But these were grand and rare events indeed. And only she and I could taste the subtle changes next time she made her *pigeon rôti.*

These photos capture the everyday gourmandise that is the tell-tale cultural trait of Paris, and sets it apart from other world capitals. I have shared many an afternoon with women like those in the photographs, sitting out on the terrace of Café Flore or one of its many cousins, sipping a *citron pressé* or a *crème,* or sharing a delicious fruit tart—and most of all enjoying the moment. We could stay a whole afternoon doing nothing and not feeling guilty. Sometimes, after hours of walking the city, ice creams at Berthillon were another refreshing indulgence. And, ever hungry for life, dinner at a small bistro always beckoned, again to be shared with mother or a girlfriend or boyfriend (now husband), possibly at Le Voltaire where famous actors and personalities would sit nearby and remind us that the pleasures of the table are for all of us, and romance and friendship are just a few more ingredients in the experience of *joie de vivre* and *art de vivre.*

Café terrace on the Champs-Elysées.
ANONYMOUS, 1960

MIREILLE GUILIANO

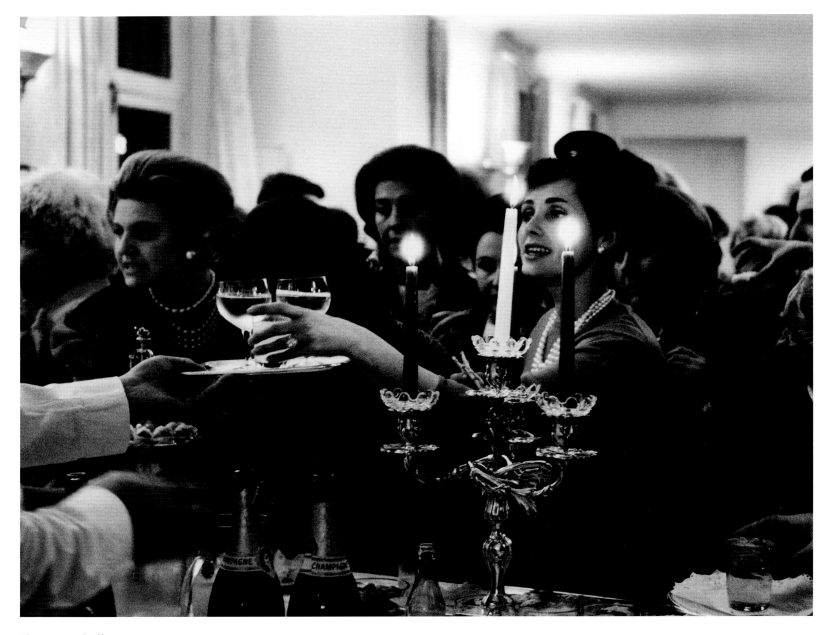

Champagne buffet
JANINE NIEPCE, 1963

“I entered the world of wine with
no professional training beyond a
decided enjoyment of a decent bottle.”

COLETTE

Lanvin employees celebrating
Saint Catherine''s Day
(a traditional Parisian festival for
unmarried working women)
JANINE NIEPCE, 1959

Three women at the bar in a bistrot,
rue de Lappe
BRASSAÏ, C.1932

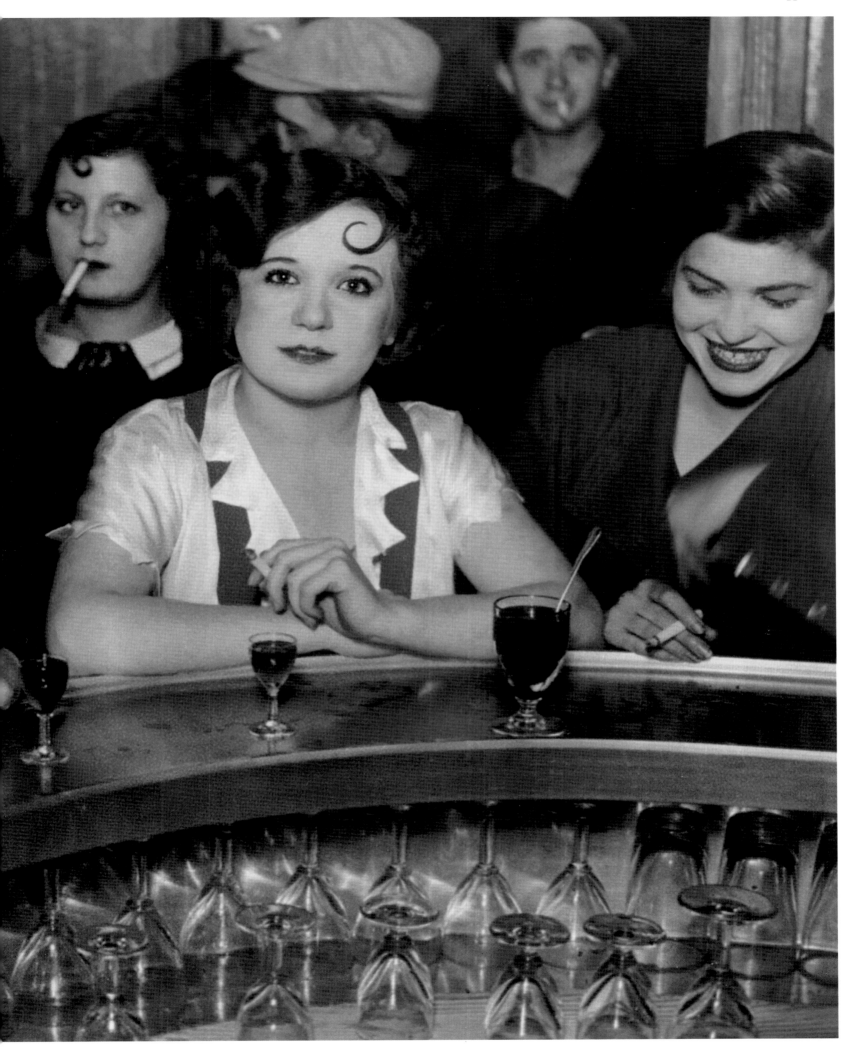

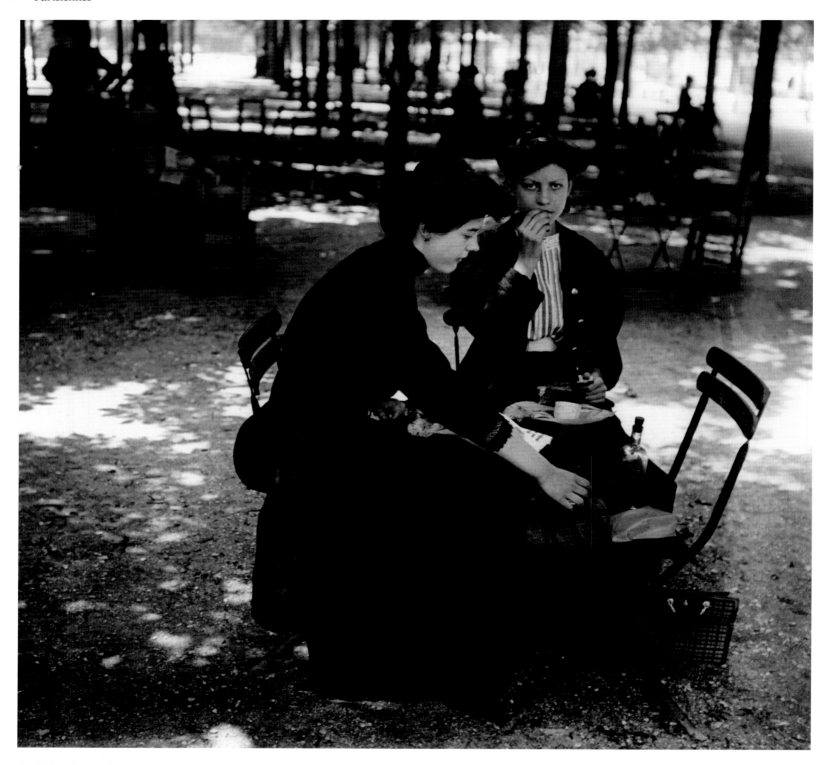

Picnicking in a park
ANONYMOUS, 1900

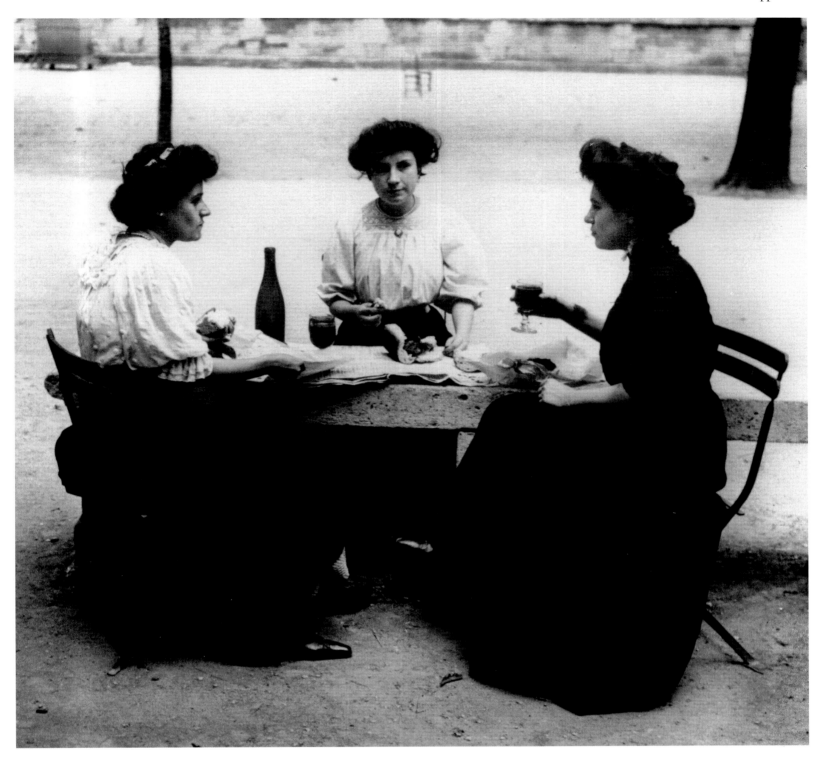

Picnicking in a park
Anonymous, 1900

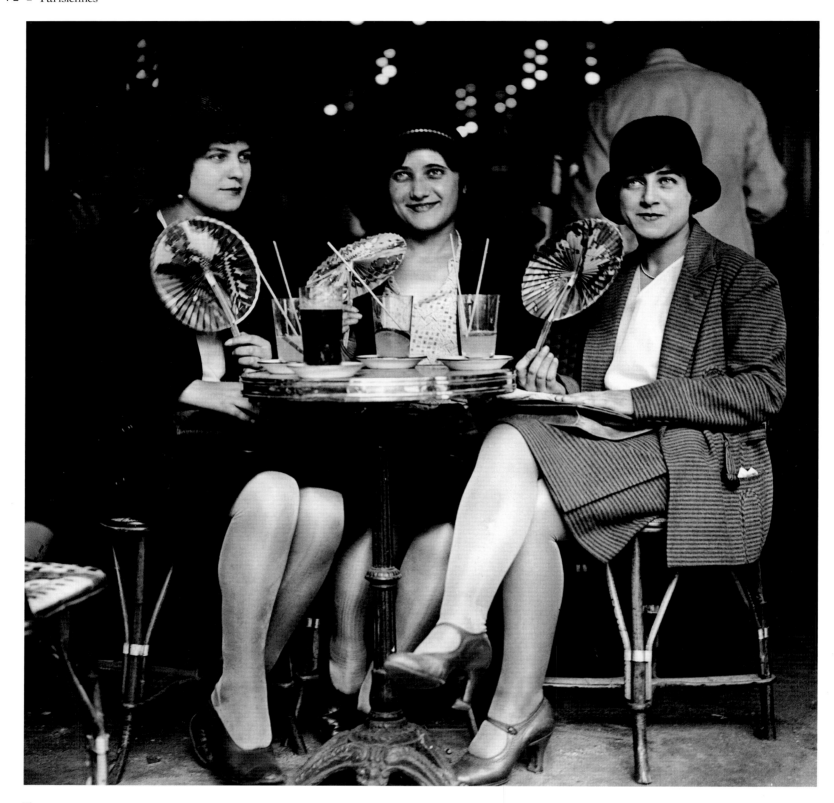

Three women
on a café terrace
Anonymous, 1929

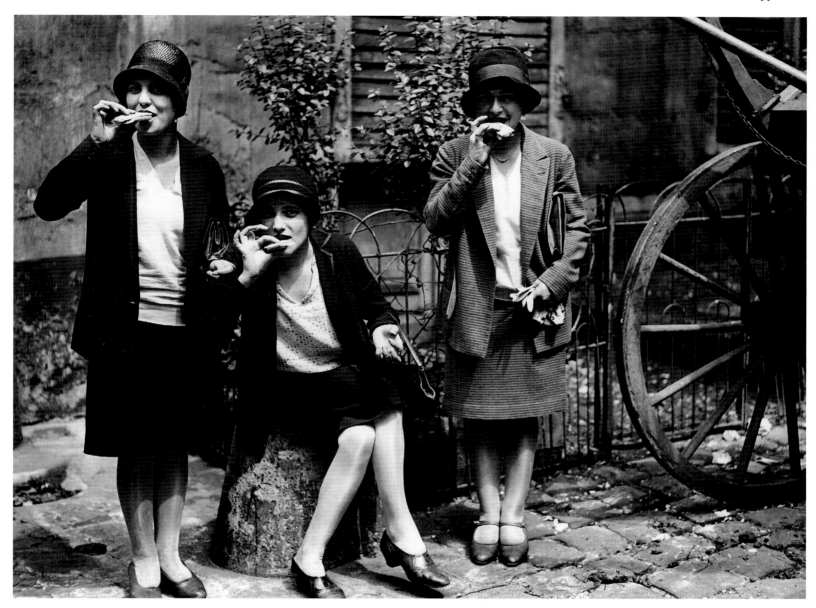

Three women eating crêpes
ANONYMOUS, 1929

"The worst outrage that may be perpetrated upon a gourmet is to interrupt him in the exercise of his jaws."

GRIMOD DE LA REYNIÈRE

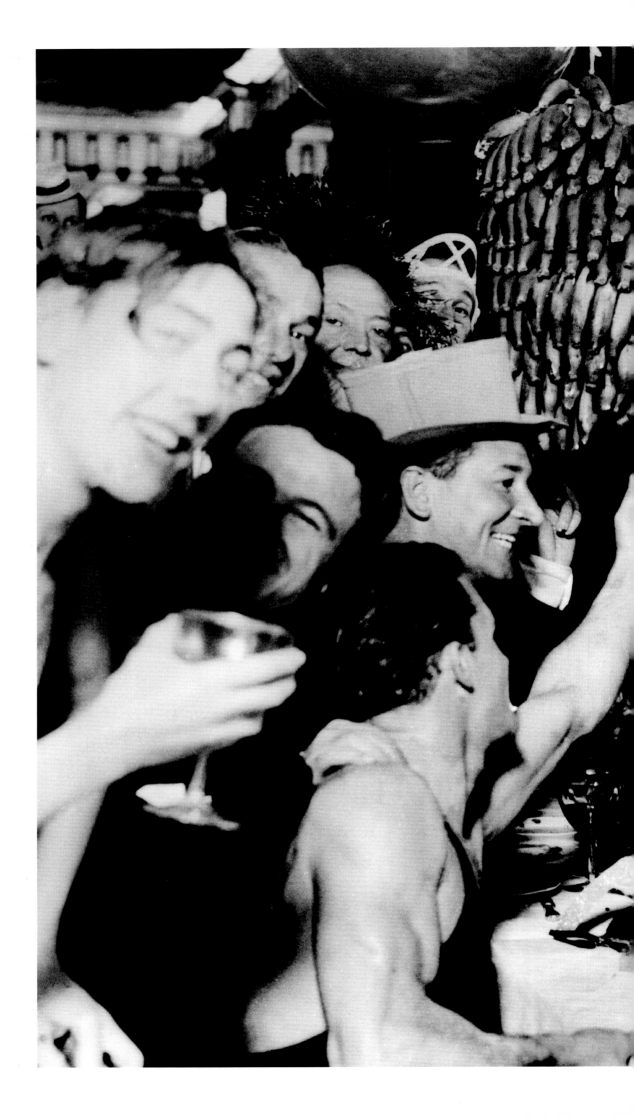

Josephine Baker celebrates
the success of her Folies
Bergère production *Un Vent
de folie*, with members of
her troupe
ANONYMOUS, 1931

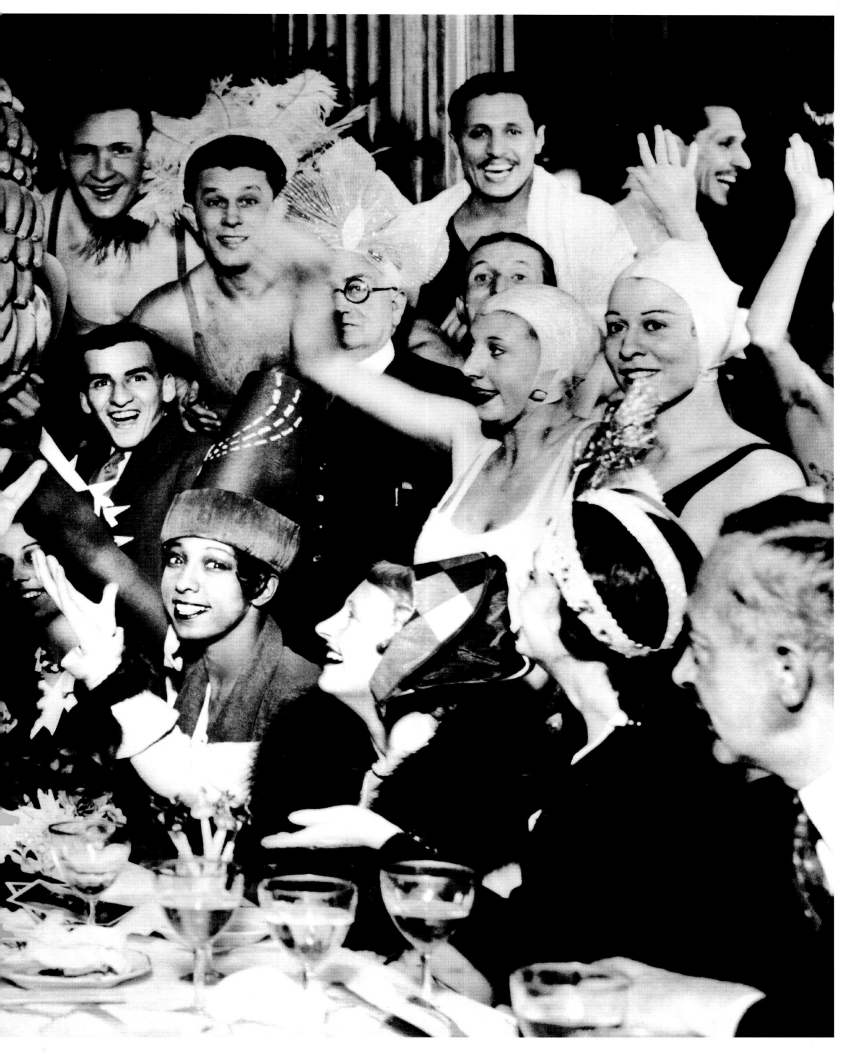

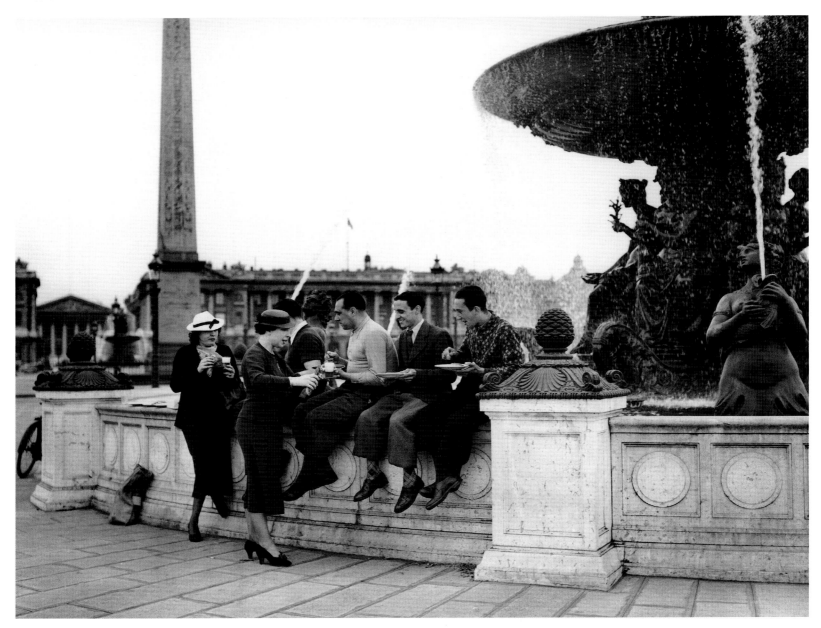

Picnic on the place de la Concorde
ANONYMOUS, 1936

❝Gourmandise begins when one is no longer hungry.❞

ALPHONSE DAUDET, *Lettres de mon moulin* ("Letters From My Mill")

Four young women eating lunch
beneath the statue of Bacchus in
the Jardin des Tuileries
ANONYMOUS, 1940

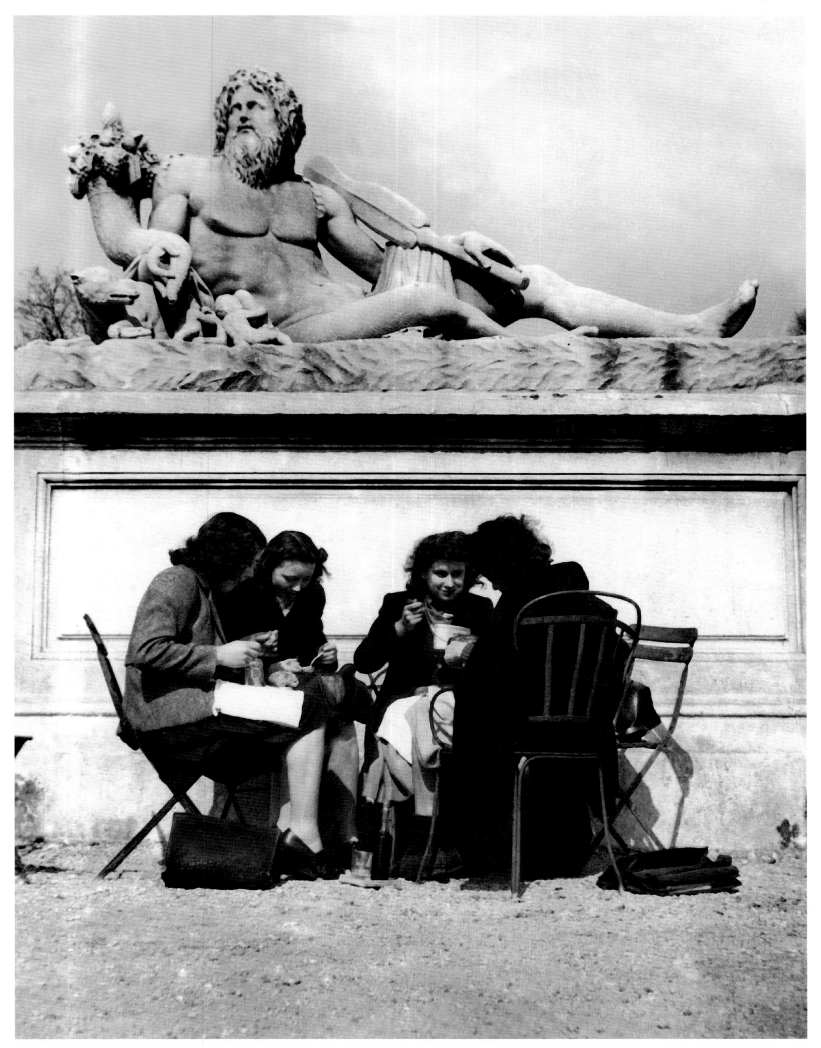

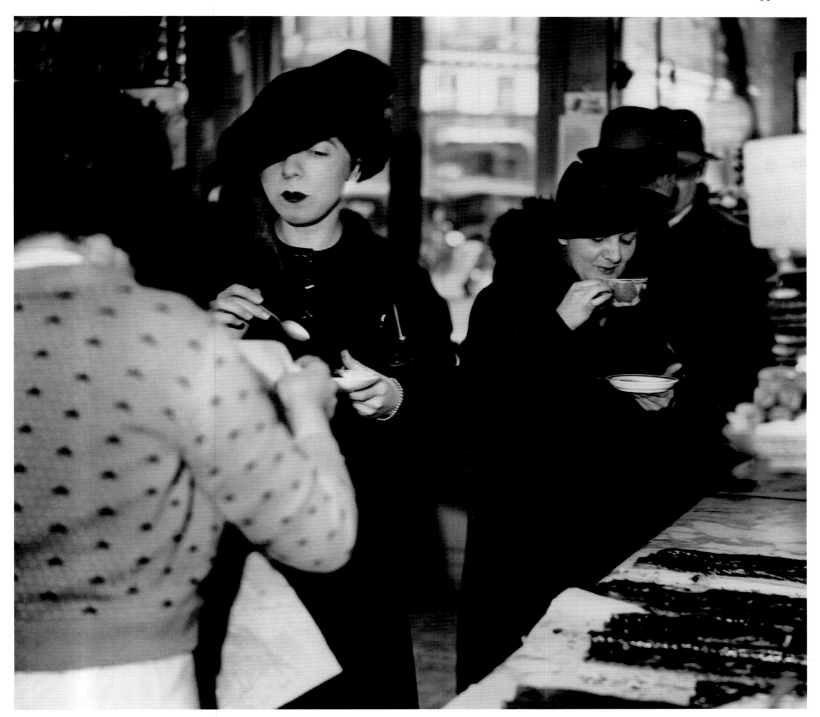

Ladies in a tearoom
ANONYMOUS, 1930

"Take chocolate: it will make the most evil company seem pleasant."

MARQUISE DE SÉVIGNÉ

Le Dupont café
ANONYMOUS, c. 1930

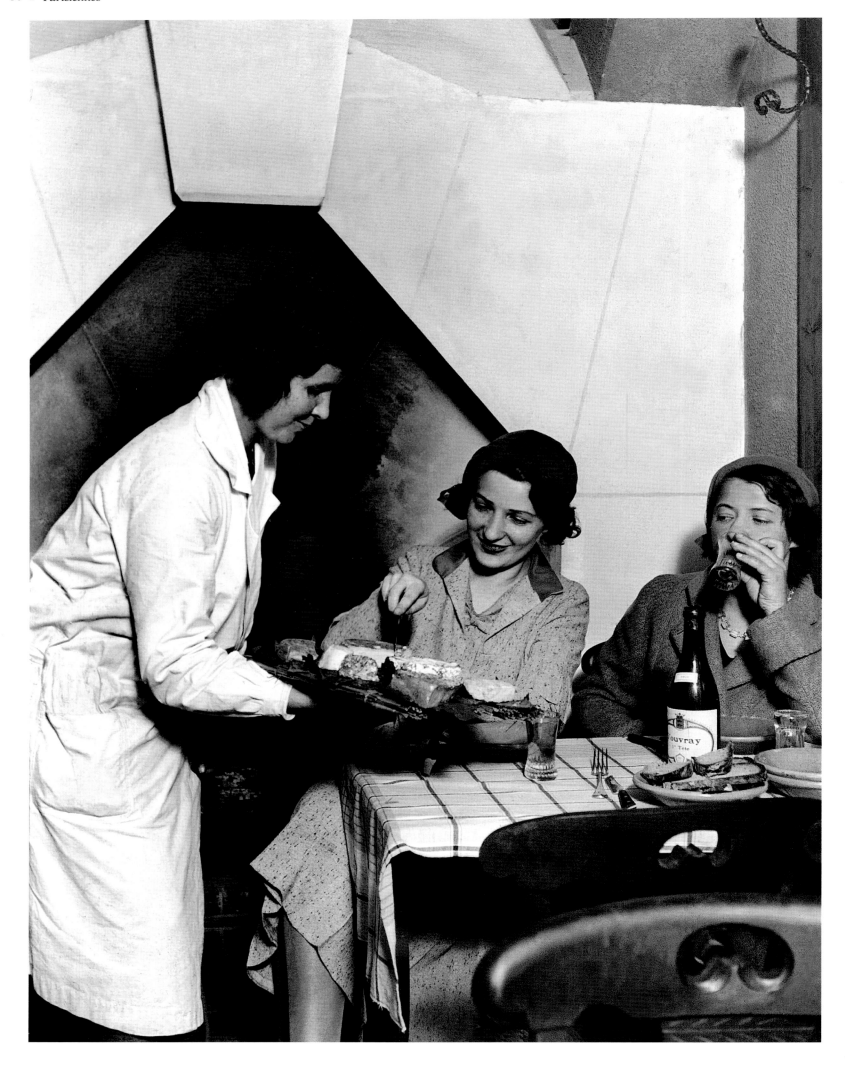

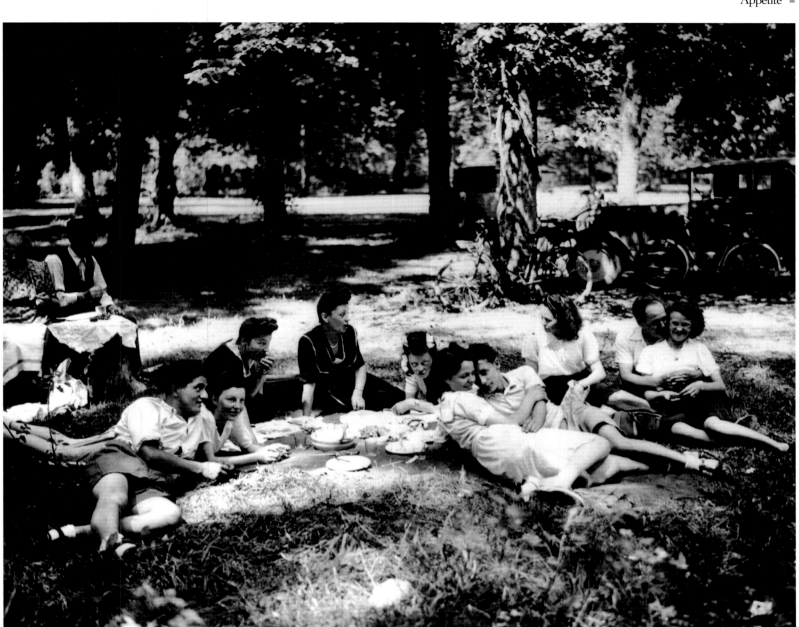

Picnic in the Bois de Boulogne
ANONYMOUS, 1949

Tasting cheese and wine at
Androuët's cheese shop
ANONYMOUS, 1936

Traditional Epiphany cakes
in a pastry shop
ANONYMOUS, 1938

"Of all the passions, gourmandise alone
seems to me to be truly respectable."

GUY DE MAUPASSANT, *Amoureux et primeurs*

Rue des Amandiers
WILLY RONIS, 1948

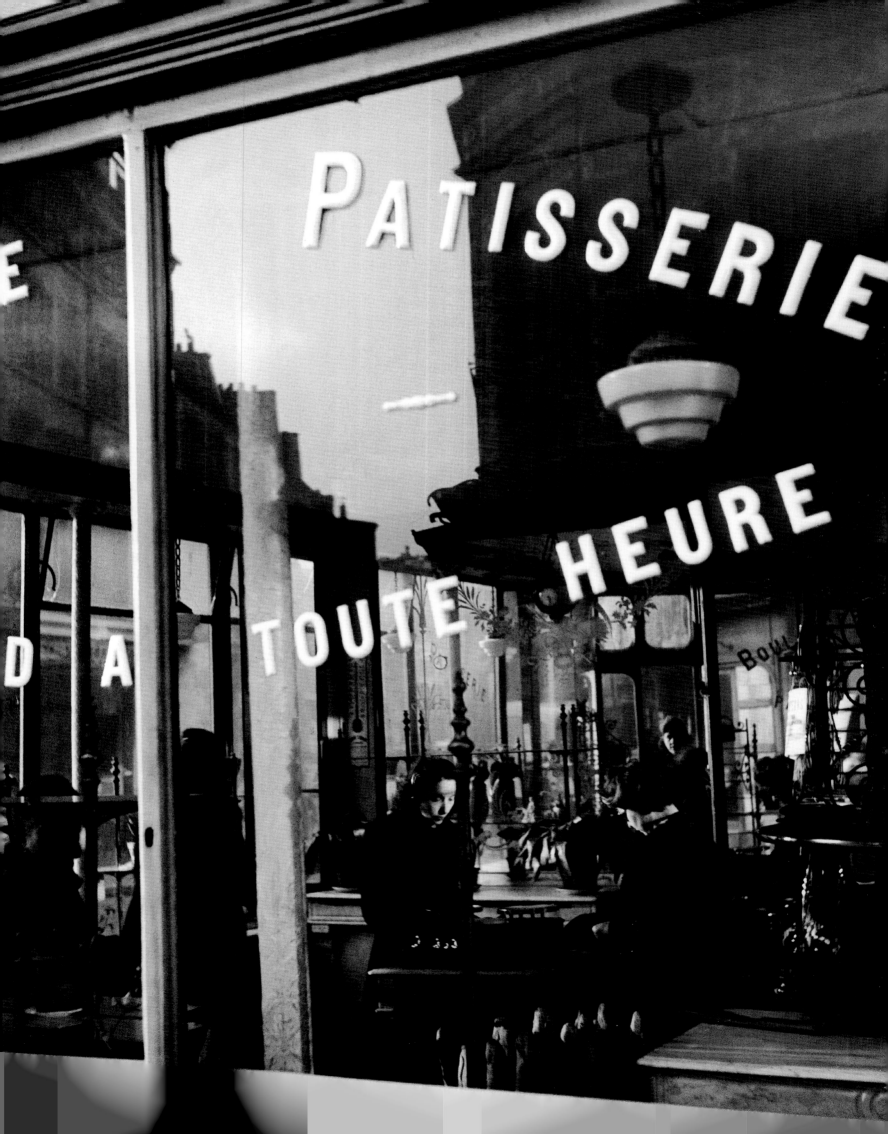

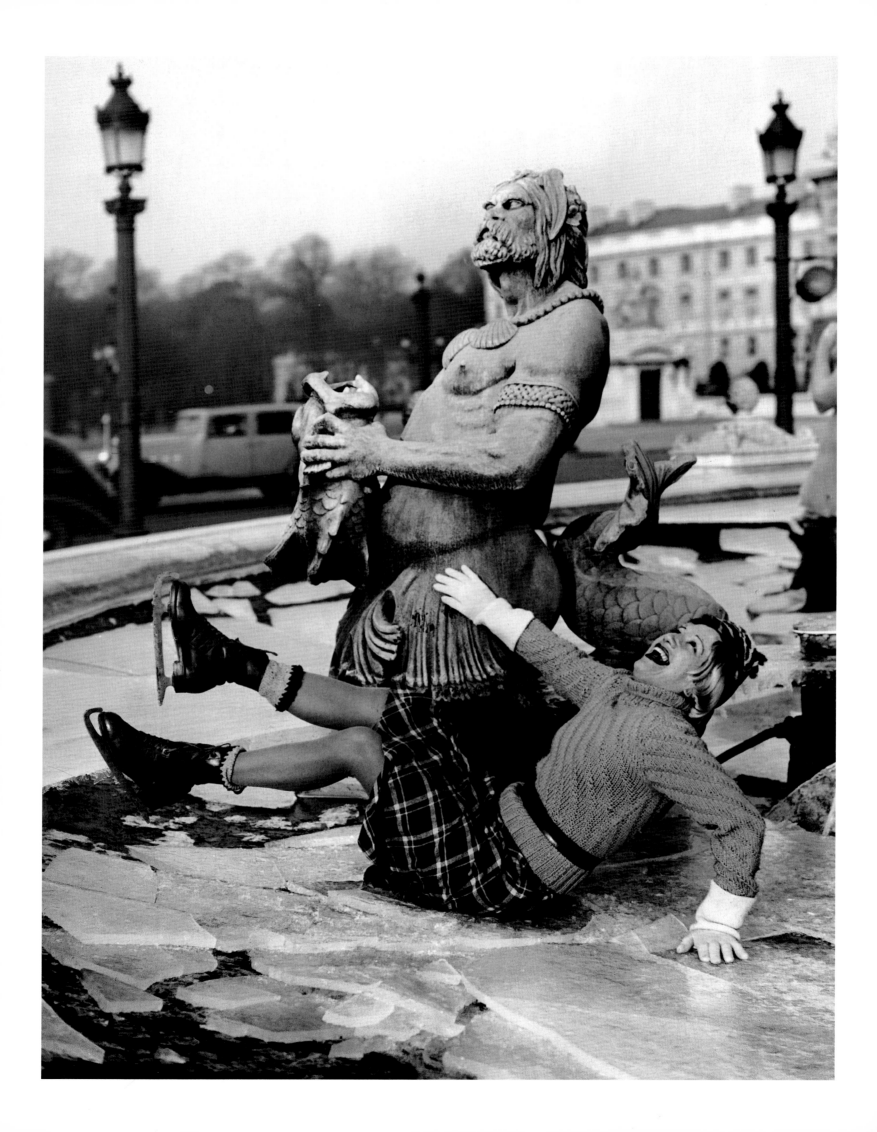

WORK AND PLAY

It was my father who made me proud to be a Parisienne. It was through him that I fell in love with the quarter he believed to be the most beautiful in all Paris, home to the Louvre, the Opéra, the Tuileries, the rue de Rivoli, place de la Concorde.... I know every last nook and cranny. My current typical Parisienne day? I get up at seven a.m., tumble down the stairs and out onto the street for my first cup of black coffee at the pavement café nearby. I listen to the day's talk, and breathe in the atmosphere. Then I climb back up the stairs for a few hours of writing. On the stroke of eleven a.m, mission accomplished, I interrupt my solitary labors for the beginning of my second day, the one with people in it.

What shall I see today to enrich my heart and soul, my daily life? For the Parisienne everything is urgent, important, joyous—provided your schedule is organized down to the last fifteen minutes! I try to organize my outings into "bouquets": a visit to the doctor on boulevard Raspail will be accompanied by a trip to the Gallimard bookshop, with an outer loop taking in the grocery department at the Bon Marché for designer sardines, rare coffees, and other delicacies.

Should I include in my account of Parisienne hyperactivity all those things I haven't yet done, and absolutely intend to do some day—a visit to the Musée Guimet, to Delacroix's workshop, to the tribal art at the Musée du Quai Branly—not forgetting all the things I'm dying to do again, such as another trip to the Picpus cemetery, the place du Tertre, the Petite Ceinture tramway, the gardens at the Musée Rodin, the Parc Montsouris....

Active life, Parisienne style, is lived at a hurried—not to say furious—pace, and quite capable of being filled to the brim with shopping, fashion houses, trips to museums and theaters, strolling and idling, outings into town, and furtive escapades to the green spaces beyond.

Paris pulls you in every direction at once, keeps you constantly on the move, whether to avoid something, admire something, buy something, or let a tiny detail pierce you to the core, so that nothing is missed in the great spectacle of a bubbling, effervescent city. Thank goodness for tomorrow, I tell myself, and the chance to make up for lost time!

MADELEINE CHAPSAL

Attempting to skate on the pond
at the place de la Concorde
ANONYMOUS, 1938

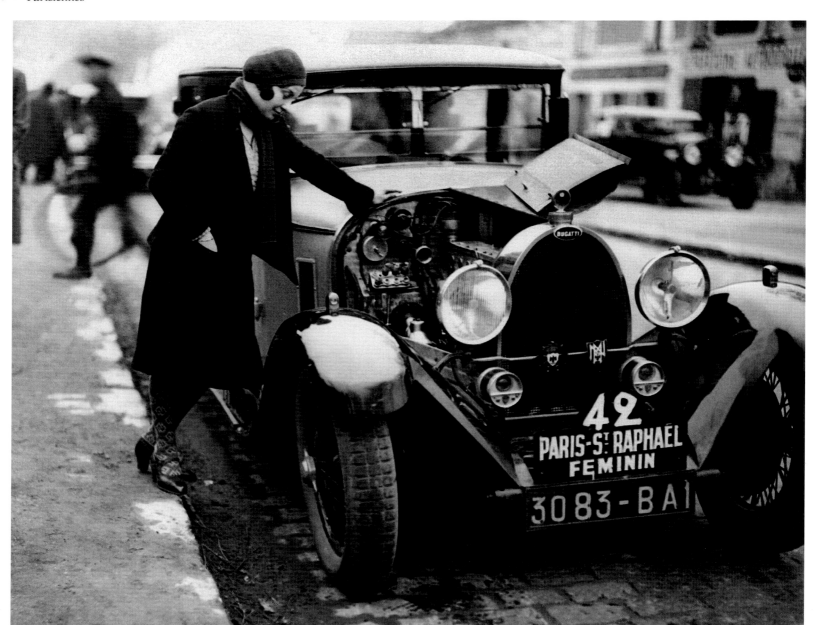

Renée Friderich, a professional
car-racing competitor, inspects
the engine of her car
Anonymous, 1932

Young woman on a motorized
bicycle asking a
Parisian driver for directions
Anonymous, 1947

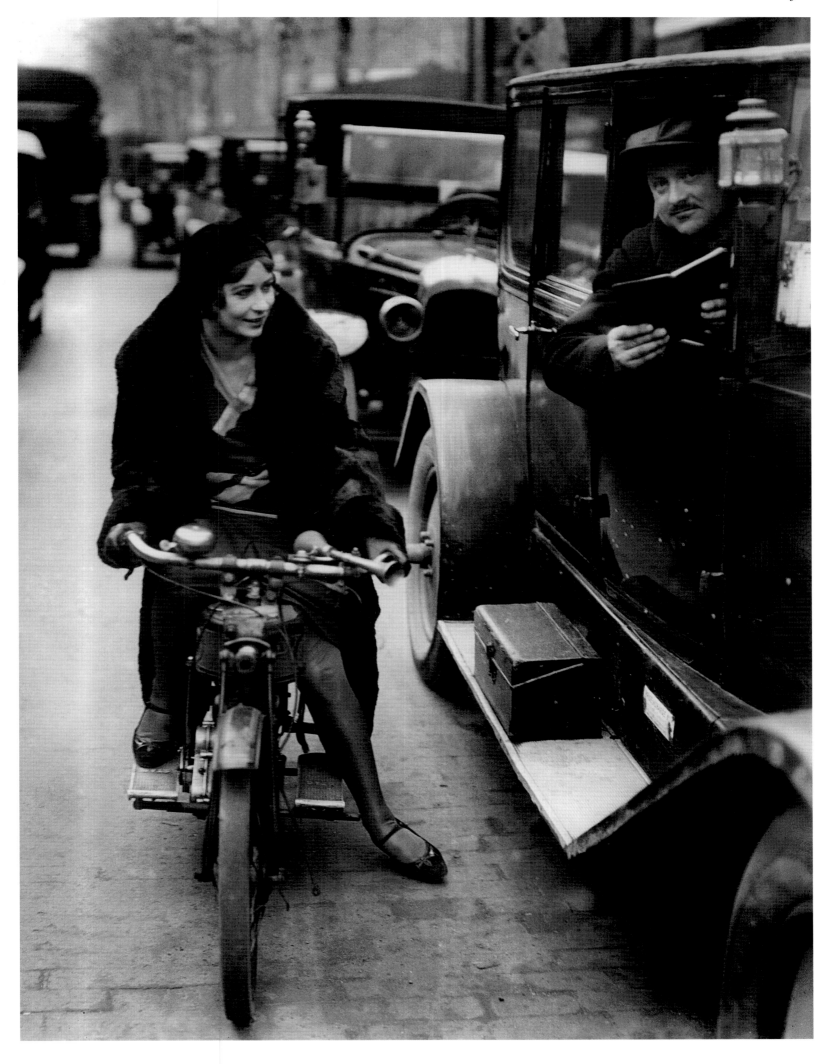

"The concierge, in the honourable tradition of the female guardians of Paris, was always in a bad mood."

ENRIQUE VILA-MATAS, *Paris Never Ends*

Concierge with spectacles
ROBERT DOISNEAU, 1949

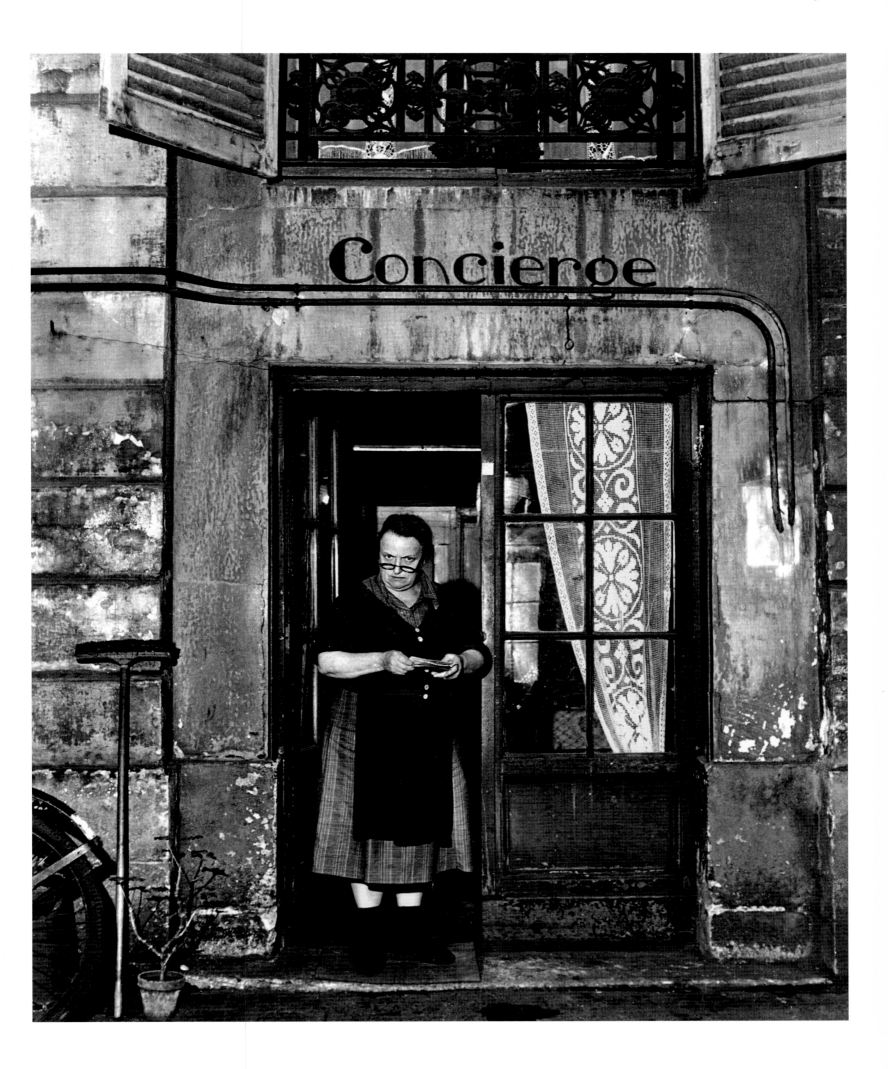

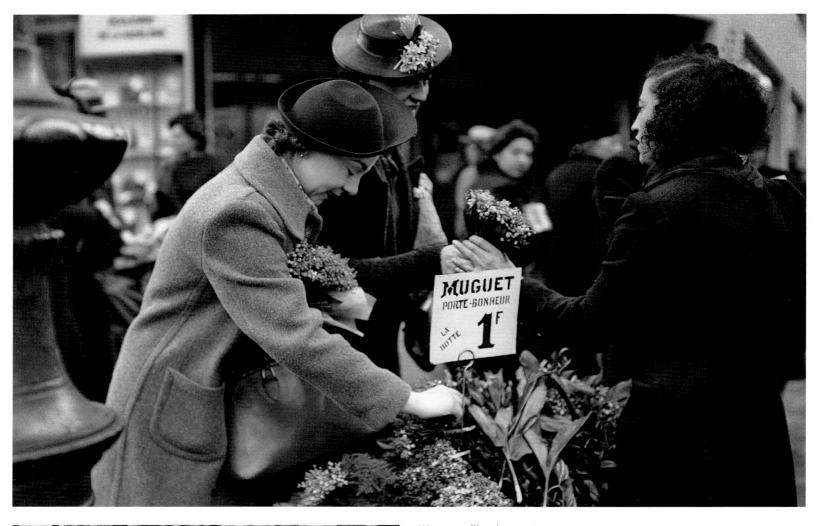

Woman selling bouquets
of lily-of-the-valley, a traditional
good-luck gift on May 1
ANONYMOUS, 1939

Finishing a bread delivery
ANONYMOUS, 1943

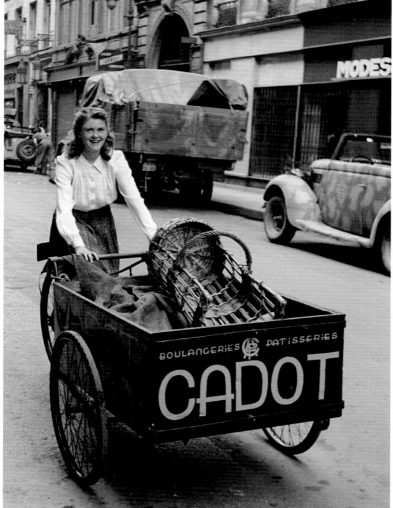

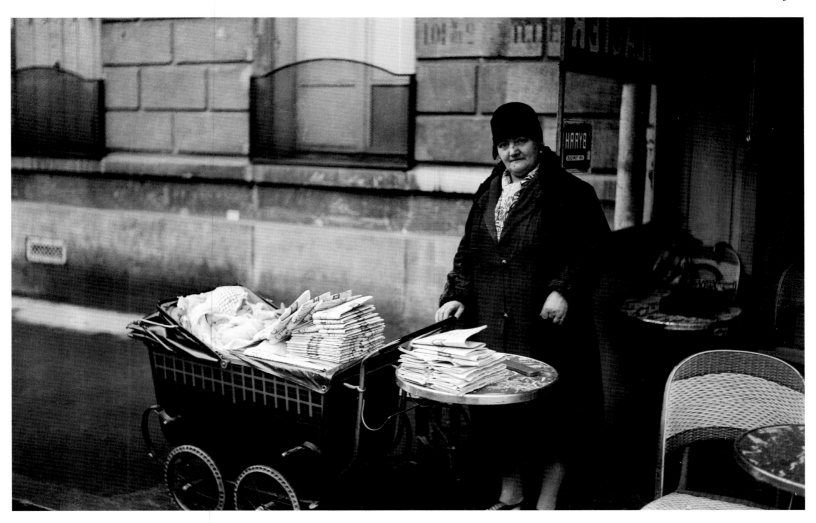

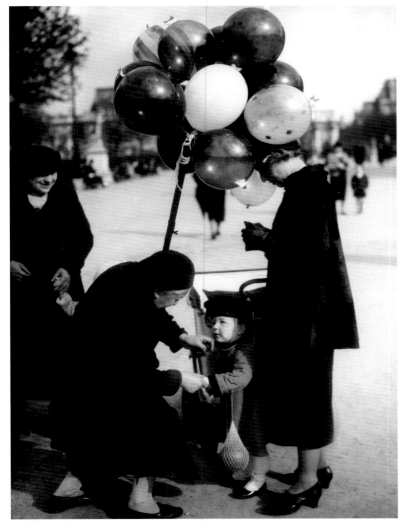

Woman with a baby,
selling newspapers from a pram
ANONYMOUS, 1930

Woman selling balloons
in the Jardin des Tuileries
ANONYMOUS, 1936

> **❝**I've seen you, beauty, and you belong to
>
> me now, whoever you are waiting for
>
> and if I never see you again….
>
> You belong to me and all Paris belongs to me.**❞**
>
> ERNEST HEMINGWAY, *A Moveable Feast*

Restaurant de l'Ancien
Cocher in the 11th
arrondissement in Paris
ÉDOUARD BOUBAT, 1952

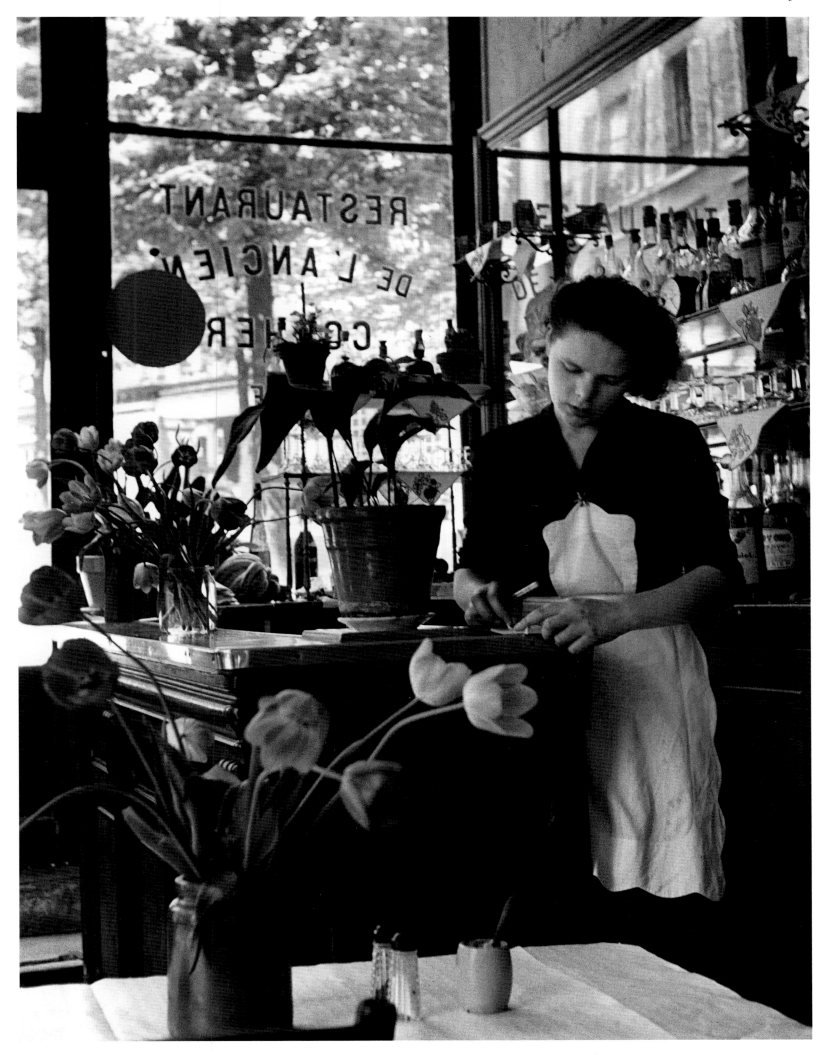

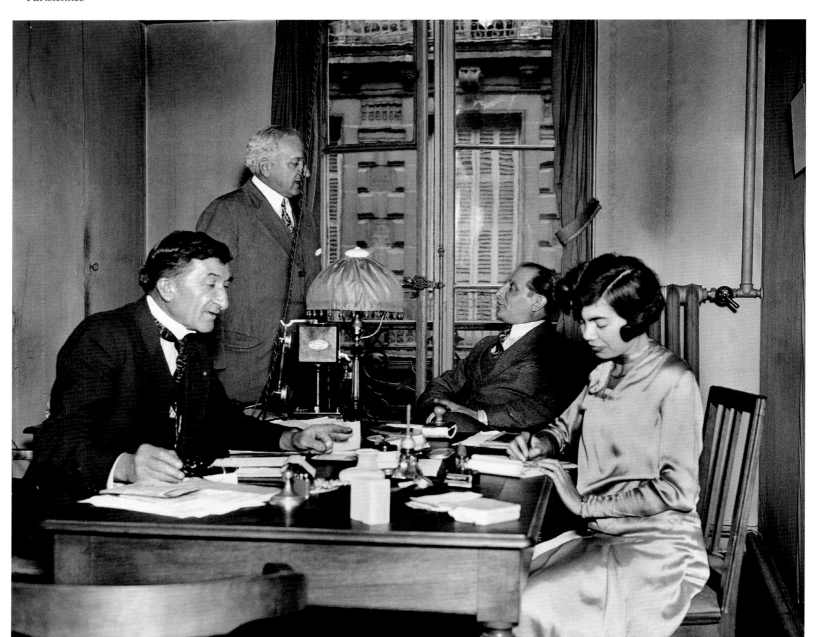

Employment agency, 1929

> **"** Work is less boring than play. **"**

FRANÇOISE GIROUD,
Journal d'une parisienne
("Diary of a Parisienne")

The first female winners of the
Concours Générale receive their
prizes at the Sorbonne. The
Concours is France's national award
for academic achievement in the
final years of high school
ANONYMOUS, 1934

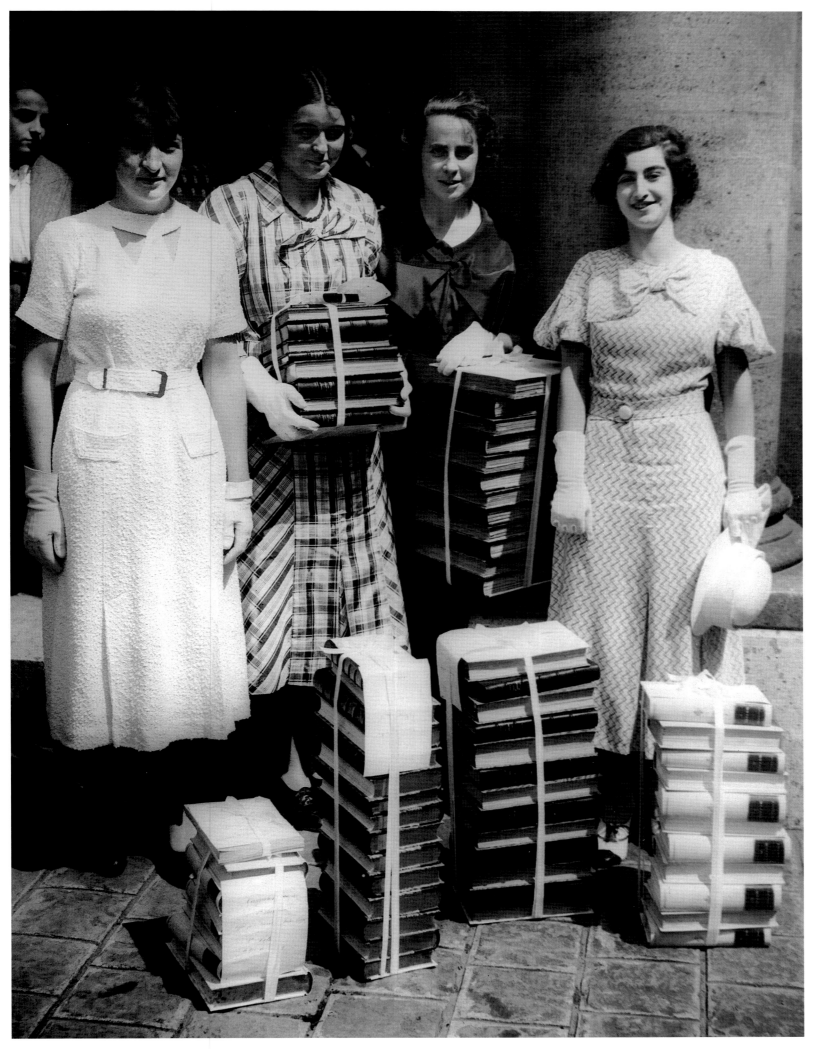

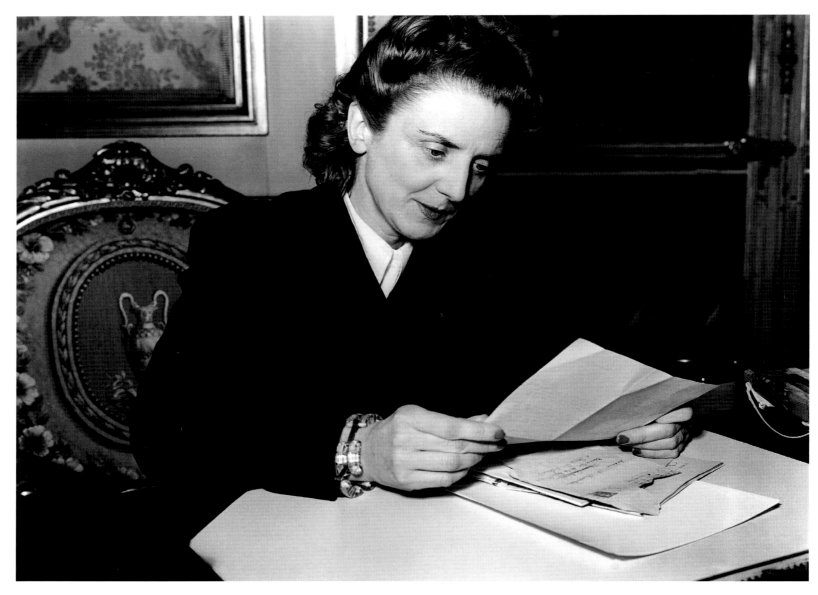

Gilberte Brossolette, vice-president
of the Senate, in her office at the
Palais du Luxembourg
ANONYMOUS, 1947

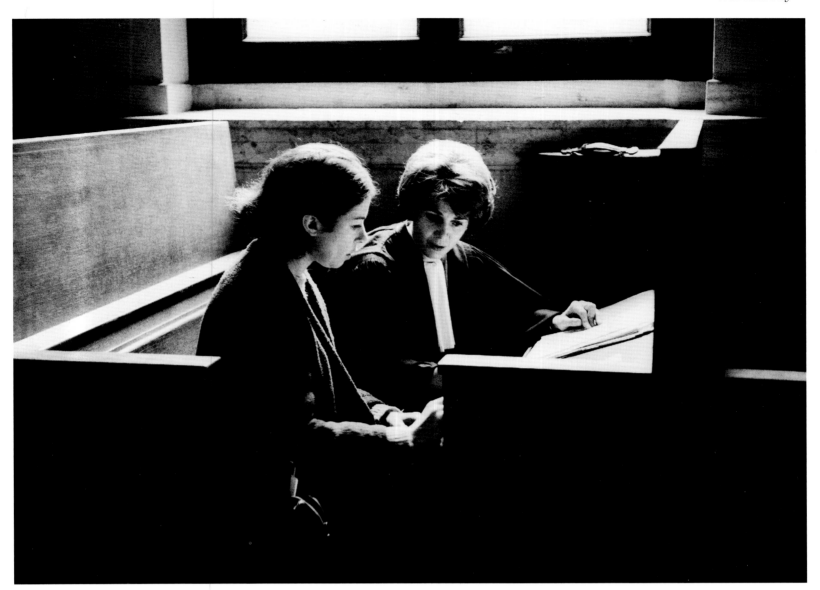

Gisèle Halimi, a barrister
specializing in women
victims of domestic violence
JANINE NIEPCE, 1967

" A woman who remains a woman is a complete being. "

COLETTE

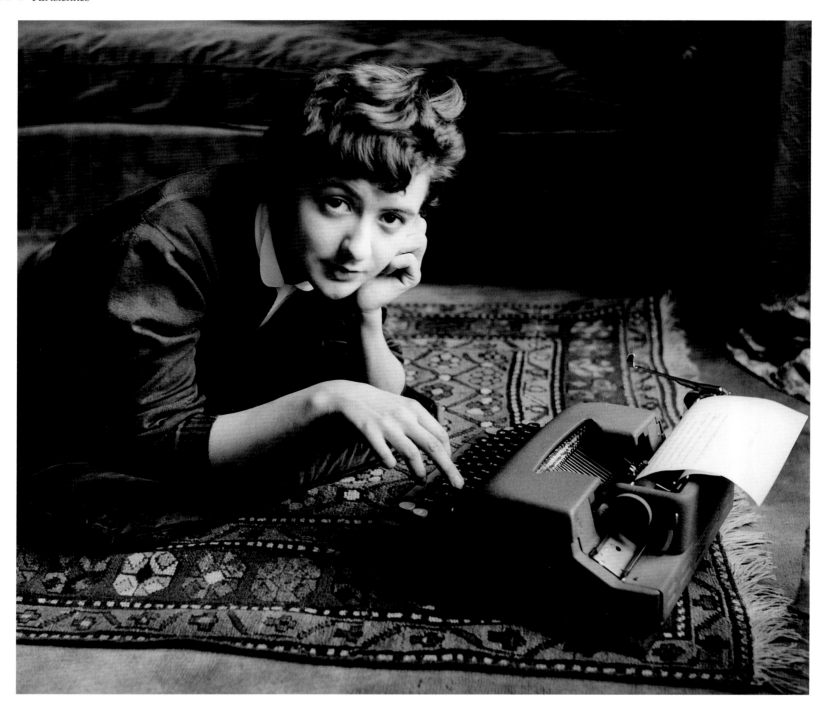

Françoise Sagan
SABINE WEISS, 1954

"The one thing I regret is that I will never have time
to read all the books I want to read."

FRANÇOISE SAGAN

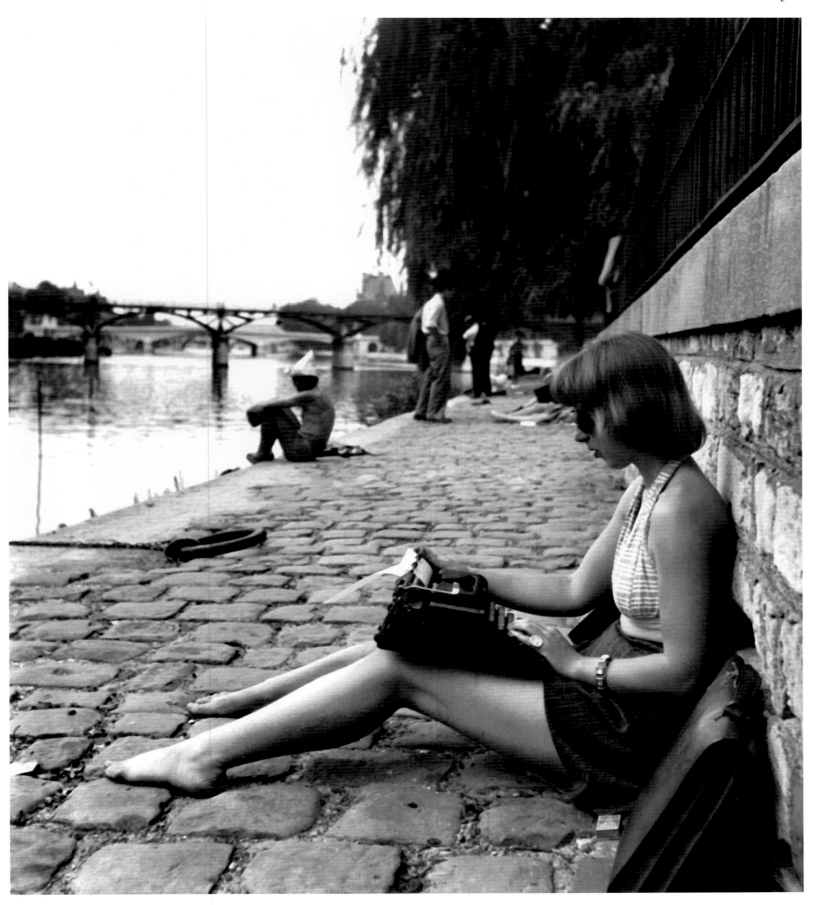

Woman typing on the banks
of the Seine
ROBERT DOISNEAU, 1947

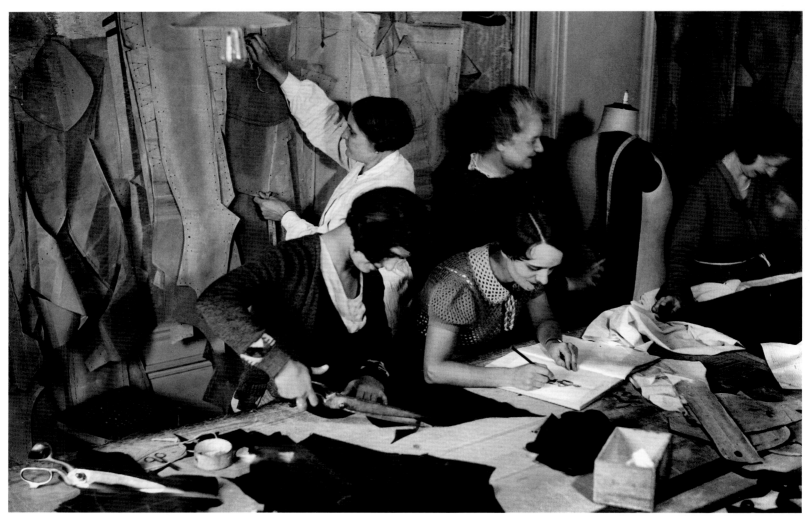

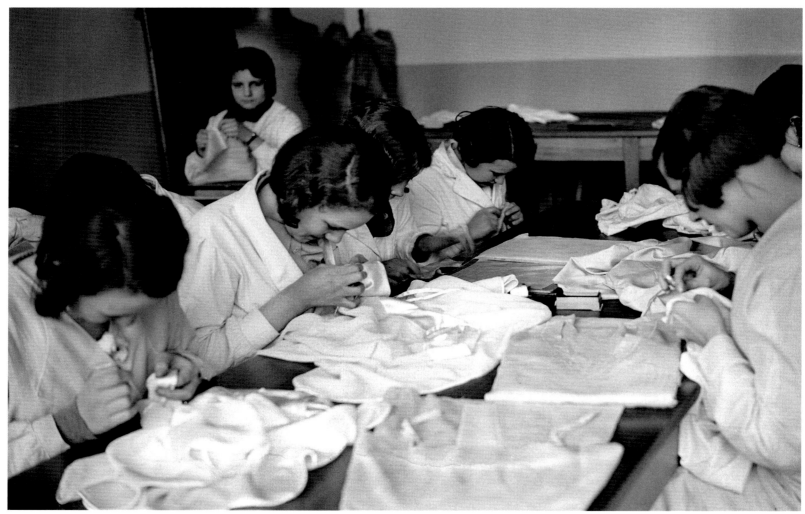

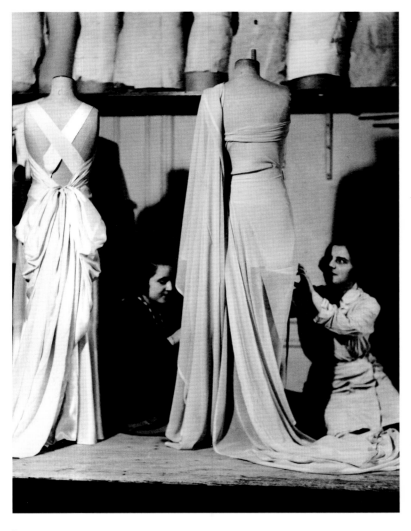

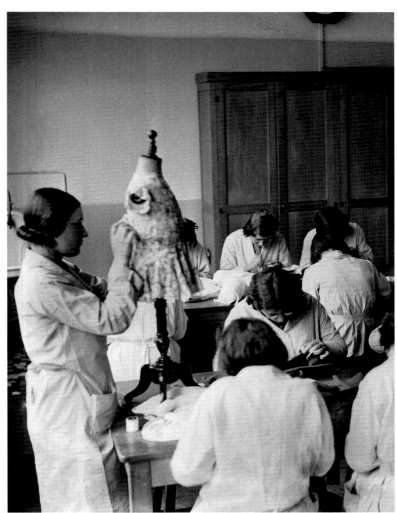

FACING PAGE, TOP
Couture workroom
ANONYMOUS, 1932

FACING PAGE, BOTTOM
Couture workroom
ANONYMOUS, 1935

ABOVE
Dressmakers preparing a mannequin
ANONYMOUS, 1936

ABOVE RIGHT
A sewing class
ANONYMOUS, 1935

" It is through work that women have covered the greater part of the distance separating them from the male of species. Only work can guarantee real freedom for women. "

SIMONE DE BEAUVOIR, *The Second Sex*

Spinning machine
WILLY RONIS, 1950s

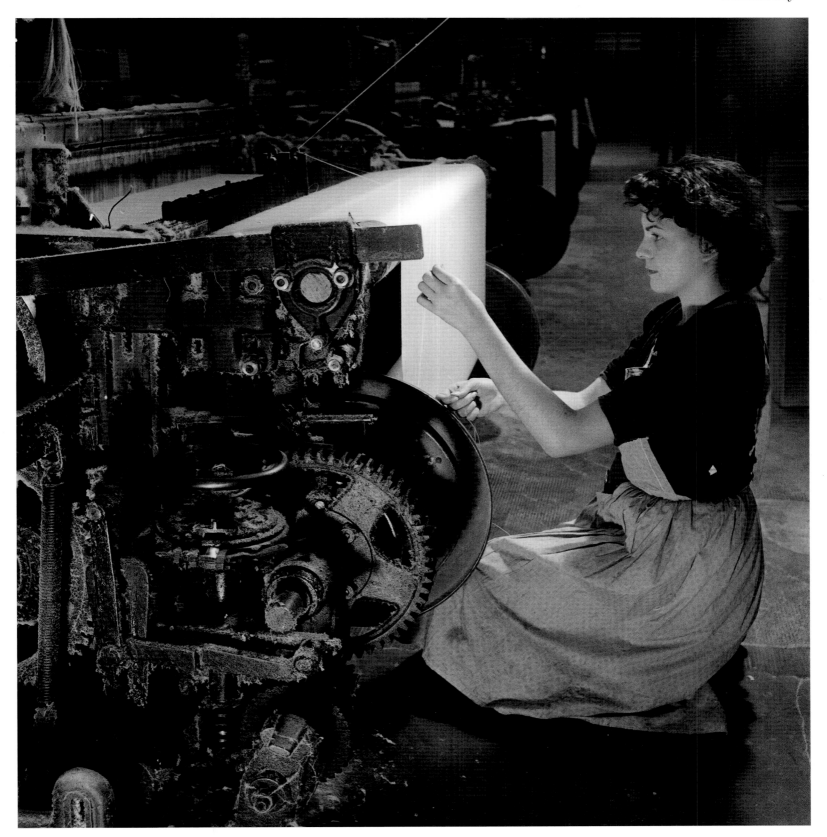

Weaving at a mechanical loom
WILLY RONIS, 1950s

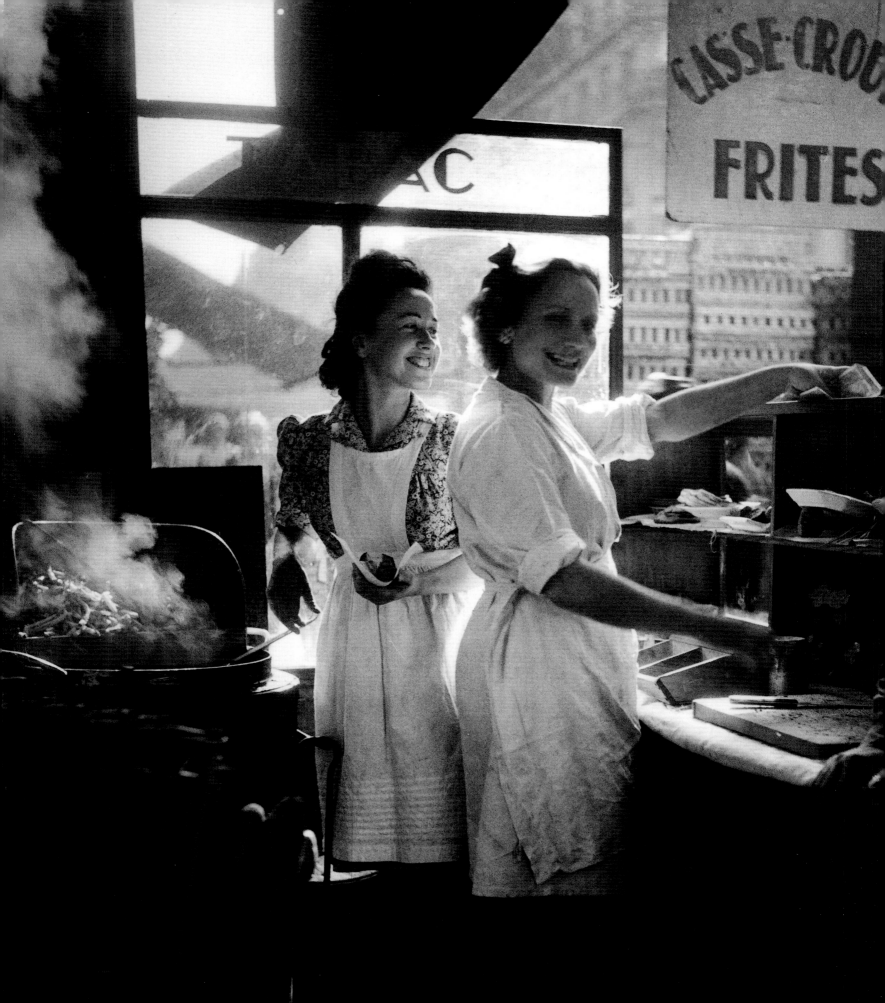

A café on rue de Rivoli
ROBERT DOISNEAU, 1957

" The Parisienne, then, is a woman equally at ease with Napoleon or his troops, who is impeccable at spelling, who knows her law as thoroughly as any counsel, who knows how to make ends meet, marries colonels, and saves outlaws. "

THÉOPHILE GAUTIER, *Paris and the Parisians*

Young women serving French
fries on rue Rambuteau
WILLY RONIS, 1946

"Her eyes, as blue as the sea in a storm, shoot barely contained lightning-bolts, and when she lowers them to the paper to write for hours on end without looking up, sitting at a table in the Flore or the Deux Magots, it's a wonder the white sheet doesn't catch fire."

JULIETTE GRÉCO, *Jujube*

Simone de Beauvoir at
the Café des Deux Magots
ROBERT DOISNEAU, 1944

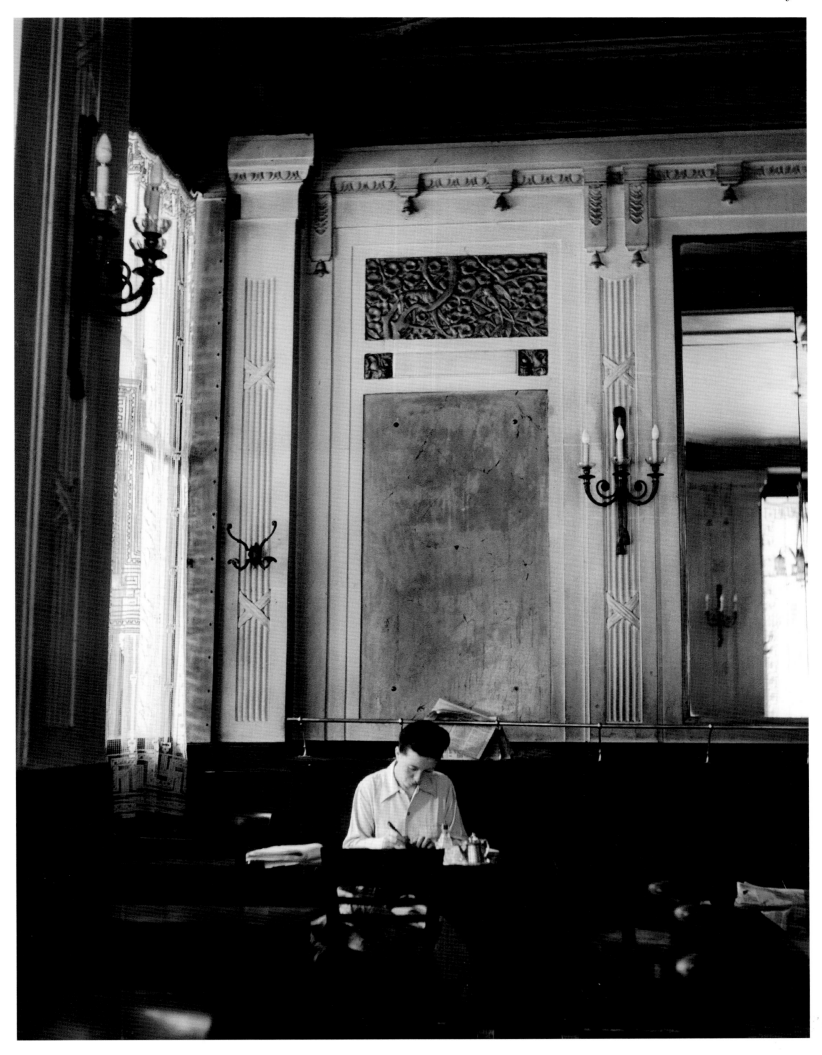

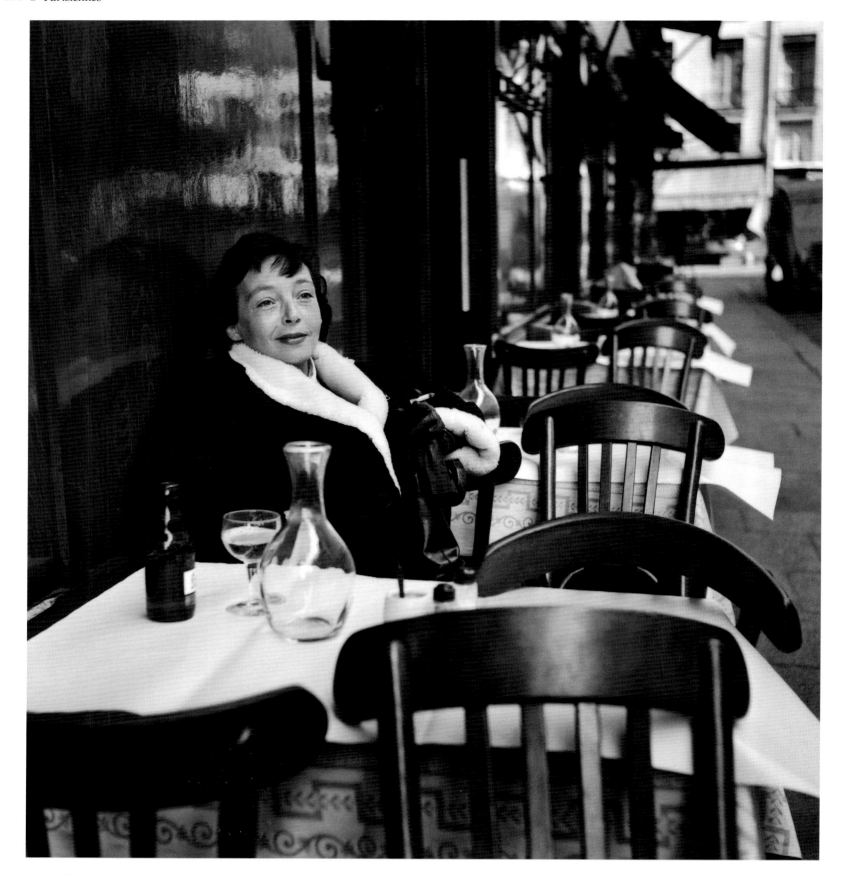

Marguerite Duras on rue Saint
Benoît, Saint-Germain-des-Prés
ROBERT DOISNEAU, 1955

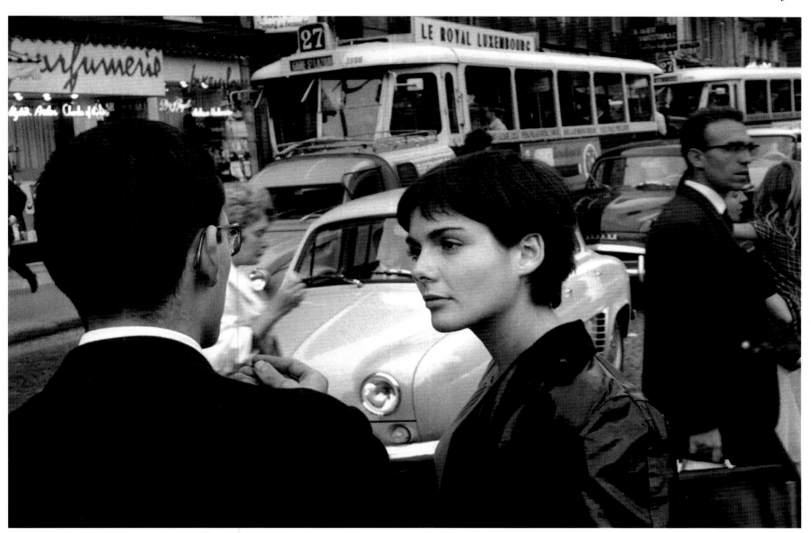

A student
JANINE NIEPCE, 1964

" I've landed up in Saint-Germain-des-Prés. It's 'my neighborhood,' my scene, my theater, my permanent cinema. I love the voyeurism of the café terraces, the attention of passersby impressed and a little alarmed by the crowds, the outlandish looks of writers sallying forth with bags of books. "

SONIA RYKIEL, *L'Écume des Pages*

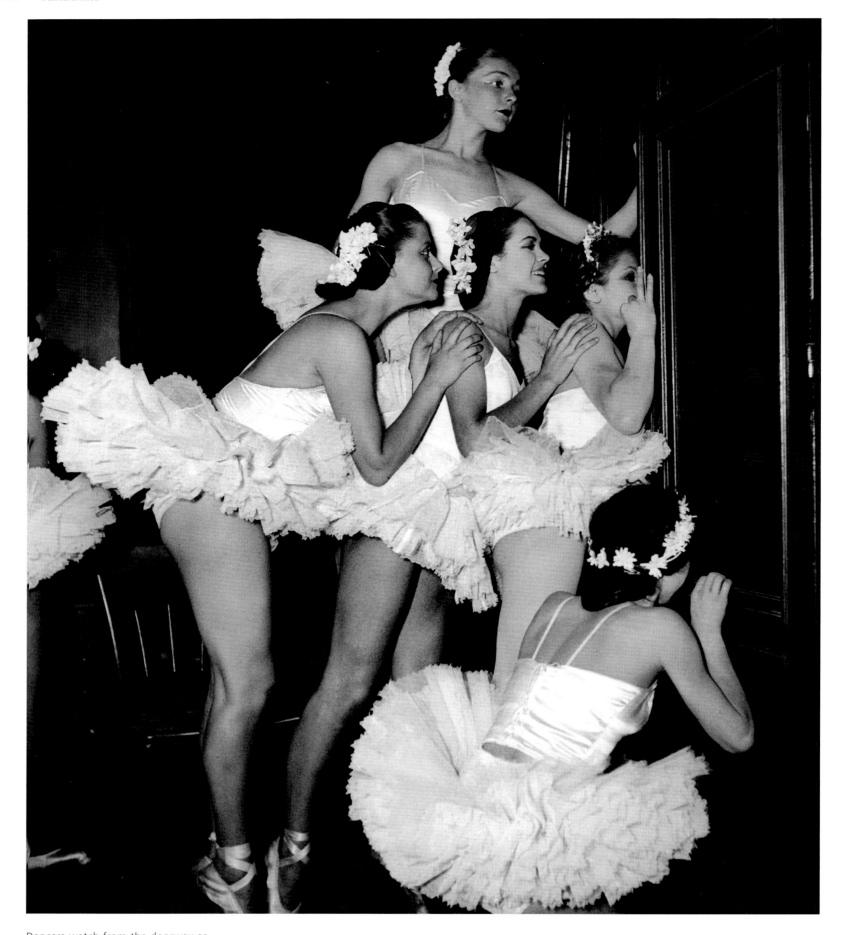

Dancers watch from the doorway as
their peers perform before exam
judges at the Paris Conservatory
ANONYMOUS, 1948

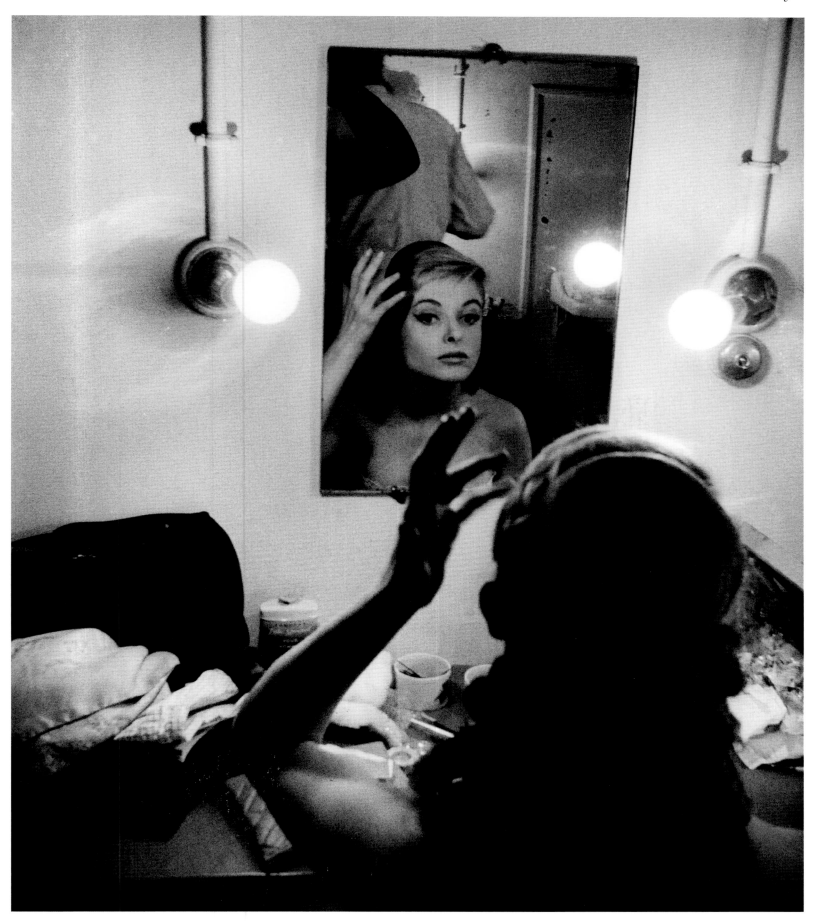

Catherine Anouilh in her dressing
room at the Théâtre de l'Odéon
WILLY RONIS, 1961

Snowball fight in front
of Notre Dame
ANONYMOUS, 1938

Skiing at Trocadero
ANONYMOUS, C. 1950

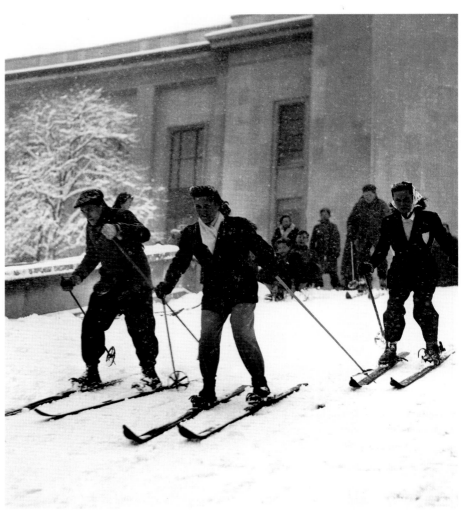

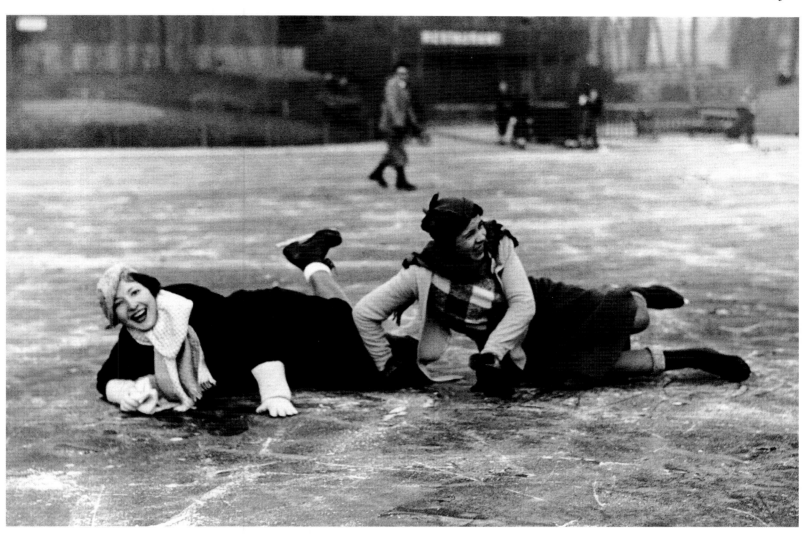

Young women falling while
skating at the Bois de
Boulogne
ANONYMOUS, 1930s

Skating on the frozen fountain
on the boulevard Saint-Michel
ANONYMOUS, 1938

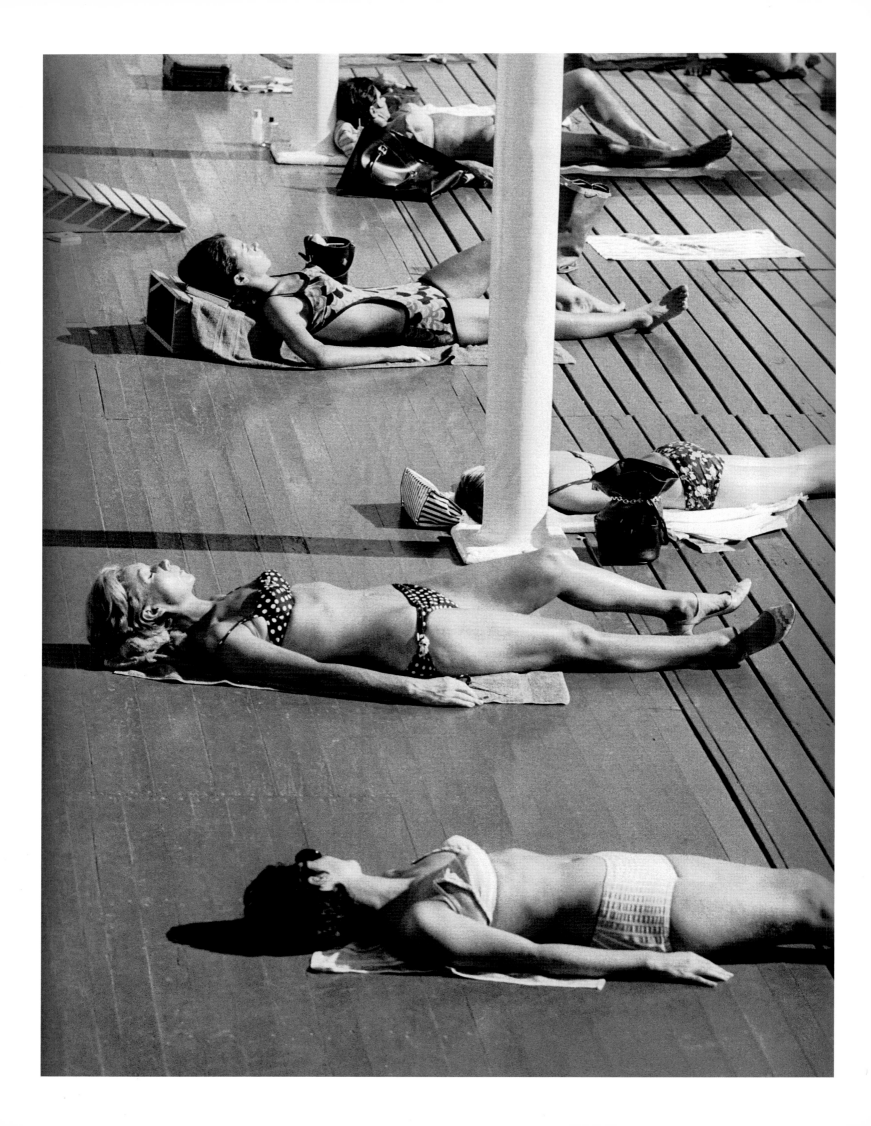

OUT AND ABOUT

Paris, from the incorrigibly frivolous point of view that has always—happily—been my own, is perhaps unique as a strategic location for amorous encounters. Because the instant a woman lingers, for even a few moments, on a café terrace, in front of a shop window, on a bench in a square, or on the *quais* beside the Seine, and particularly if the weather is sunny, she cannot fail—whether she is the most high-powered executive, the most passionate artist, the most sanctimonious guardian of the faith, or the most hardened strumpet—to find herself imperceptibly overtaken by a spirit of languorous joie-de-vivre that has wafted around the city's streets for centuries, and to feel virtuous resolutions slipping away.

And so—brothers in arms, unrepentant pick-up artists, inveterate seducers—it falls to us to seize this golden opportunity to complicate, deliciously or deplorably (after all, nothing ventured...) our existence as gentlemen of leisure. In short, Paris is indubitably, absolutely, the ideal place for chance encounters, and this is in large part due—I should point out—to its seemingly inexhaustible ability to generate, on contact, quantities of females intent on idling their time away. It should also be made clear that Parisiennes remain somewhat difficult to accost: bound by a kind of empathy with the city's great artistic past, their rhetorical expectations are high indeed, and well beyond the reach of common chitchat, which is unlikely to entice them to alight at a café table and spend a while in our company. The Parisienne demands to be amused by inventive, humorous talk, and we must, I fear, attempt to recapture the spirited intellect of the celebrated minds of Paris' illustrious history, such as the incomparable eighteenth-century wit Marivaux himself; that sharpest, most perceptive observer of the commerce of love, whom Paris finally acclaimed as her unassailable Grand Master.

Which is why, before we set out once again to lie in wait for languid, strolling beauties, we would be best advised to read most attentively Marivaux's *Game of Love and Chance* or *The Inconstant Lovers,* the better to penetrate the mind of the Parisienne. For is it not one of the great privileges of the subtle art of *Marivaudage*, that magnificent cultural legacy, to have the opportunity, if only for a few precious moments, of capturing the attention of the loveliest creatures dazzled by the City of Light?

Sunbathing at
the Deligny pool
ANONYMOUS, 1967

DENIS GROZDANOVITCH

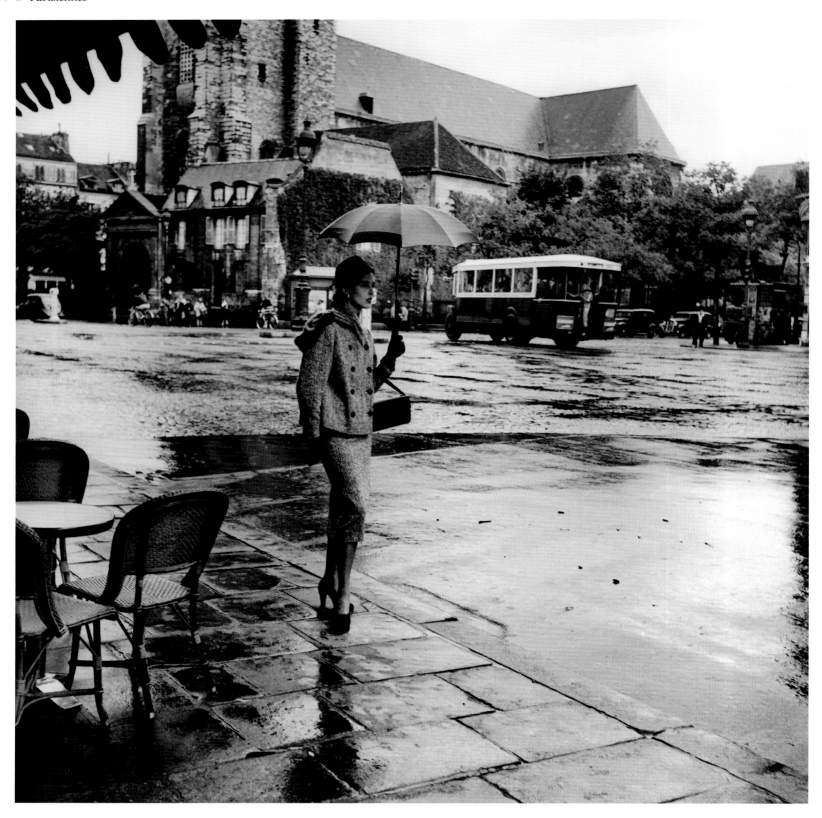

Saint-Germain-des-Prés
ÉDOUARD BOUBAT, 1951

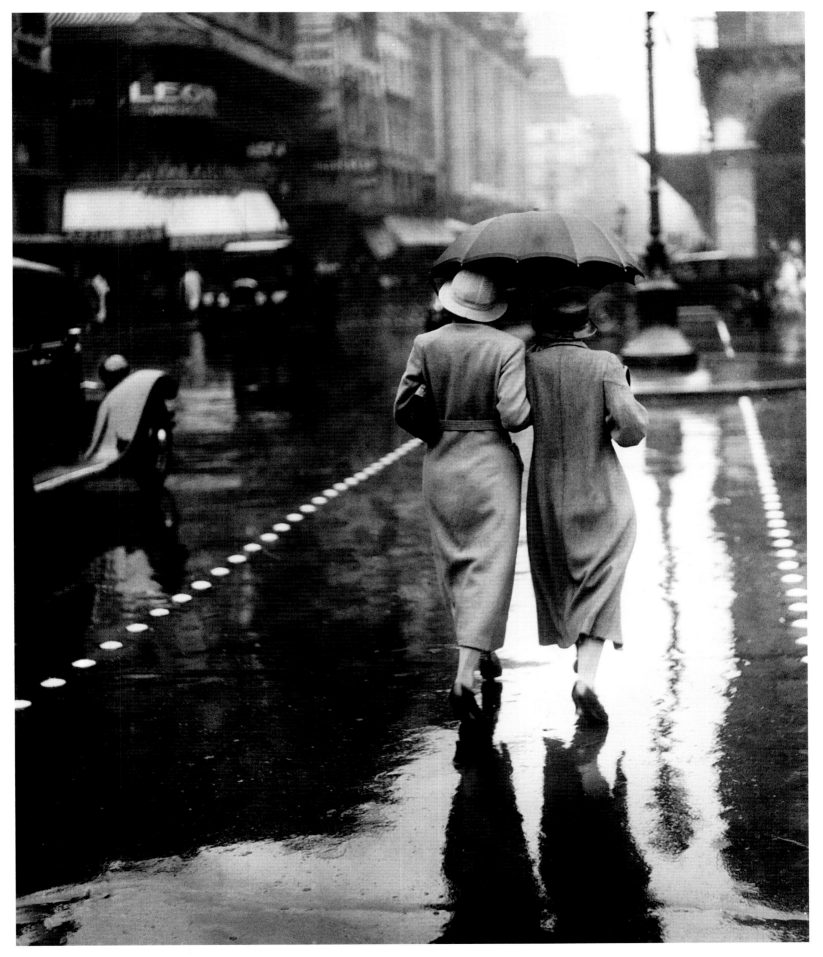

Women strolling in the rain
ANONYMOUS, 1934

> **"**My favorite pastime is letting time
> pass, having the time, taking my
> time, wasting my time, living out of
> time—against the current.**"**

FRANÇOISE SAGAN, *Réponses*

Miss Paris 1934, Mademoiselle
Elisabeth Argal, browsing
a newsstand on the morning
after her triumph
ANONYMOUS, 1934

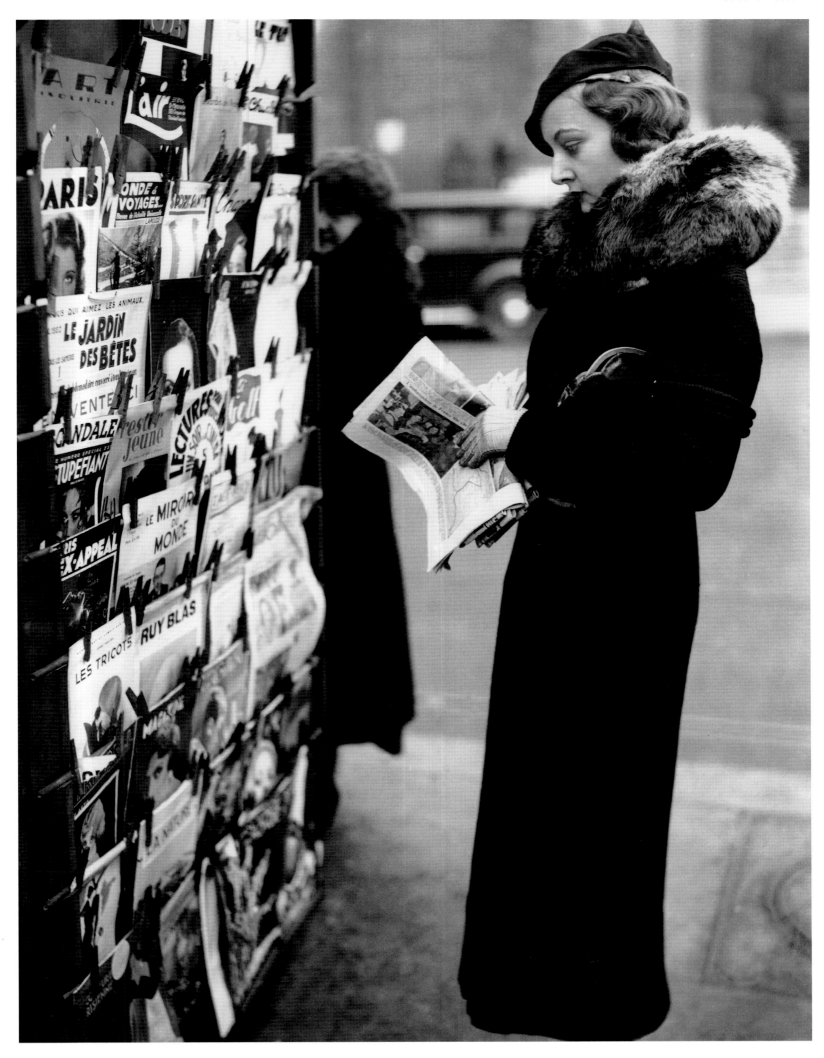

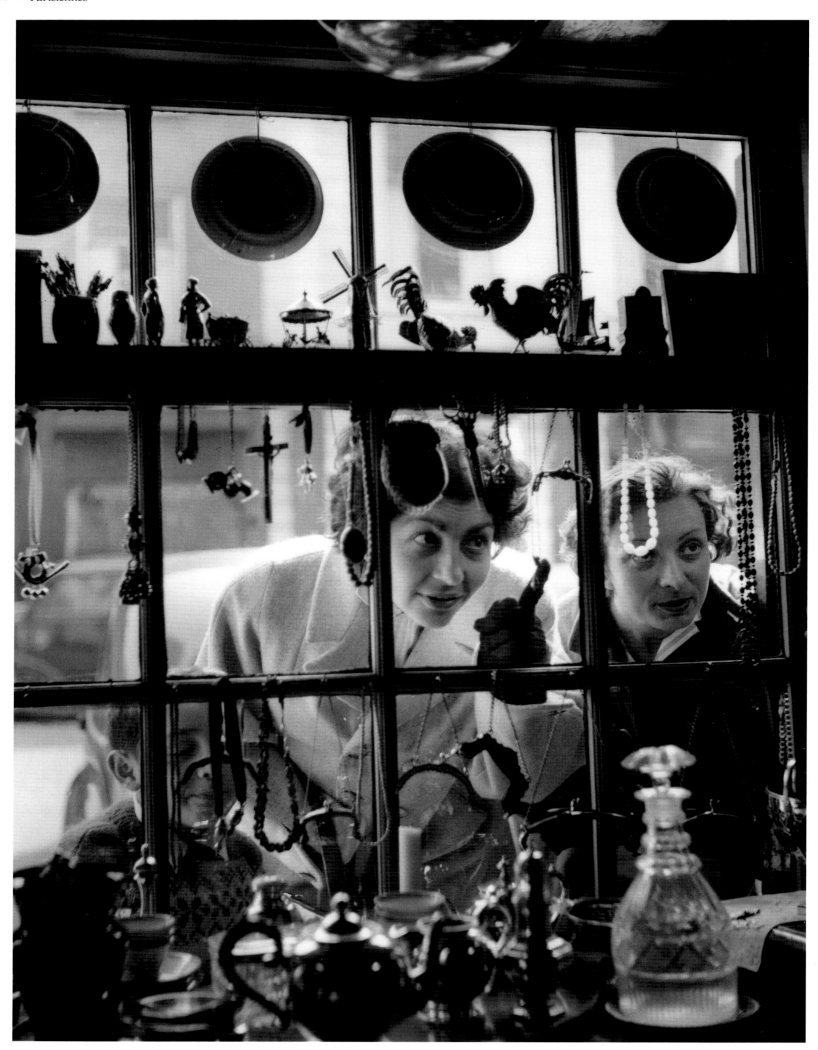

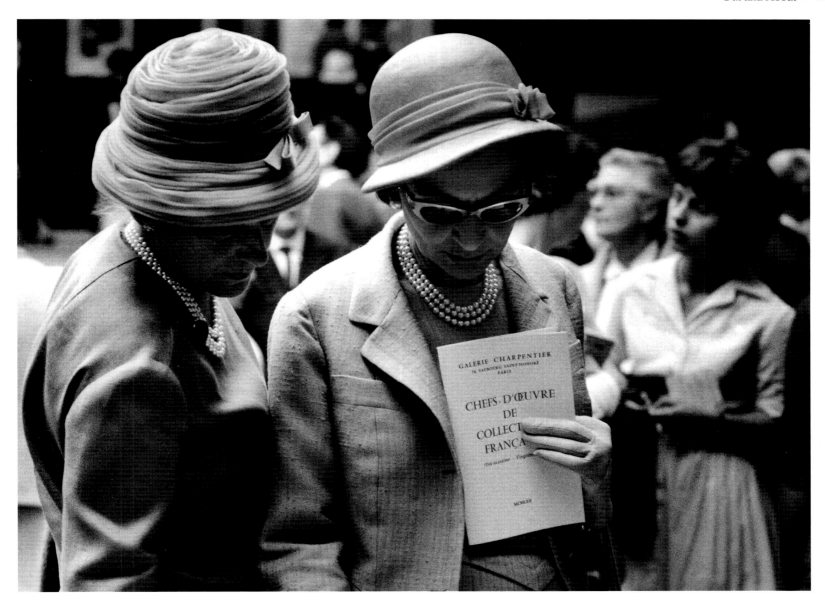

Galerie Charpentier
JANINE NIEPCE, 1936

“For the record: No self-respecting Parisienne on the boulevard Saint-Germain would ever cross on the white lines when the light is red. A self-respecting Parisienne watches the stream of cars and steps out, fully aware of the risk she's taking. To die for a window display at Paule Ka. Delicious.”

ANNA GAVALDA,
I Wish Someone Were Waiting for Me Somewhere

Two women window-shopping
ANONYMOUS, 1956

> "A woman passed, with a glittering
>
> hand. Raising, swinging the hem
>
> and flounces of her skirt."
>
> **CHARLES BAUDELAIRE,**
> from ***"To a Passer-by," Les Fleurs du mal***

A lady of fashion walks by the
poster displays near
the Opéra Garnier
JANINE NIEPCE, 1950s

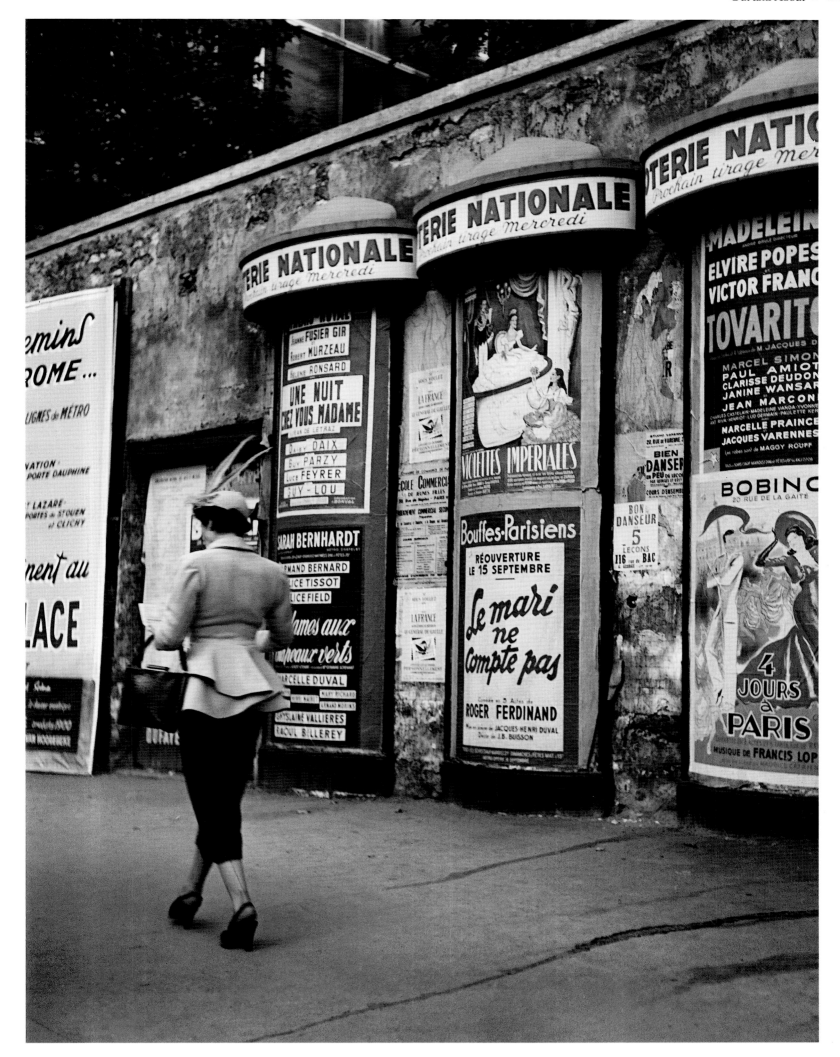

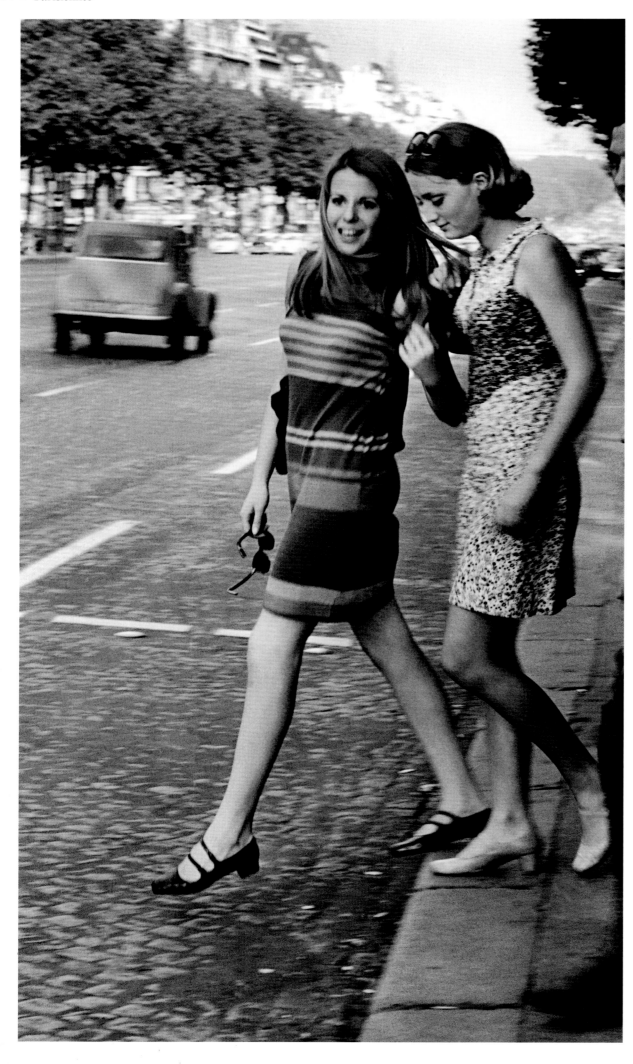

Young women on the
Champs-Elysées
JANINE NIEPCE, 1960s

Fashionable Parisienne on
boulevard Saint-Michel
ANONYMOUS, 1970

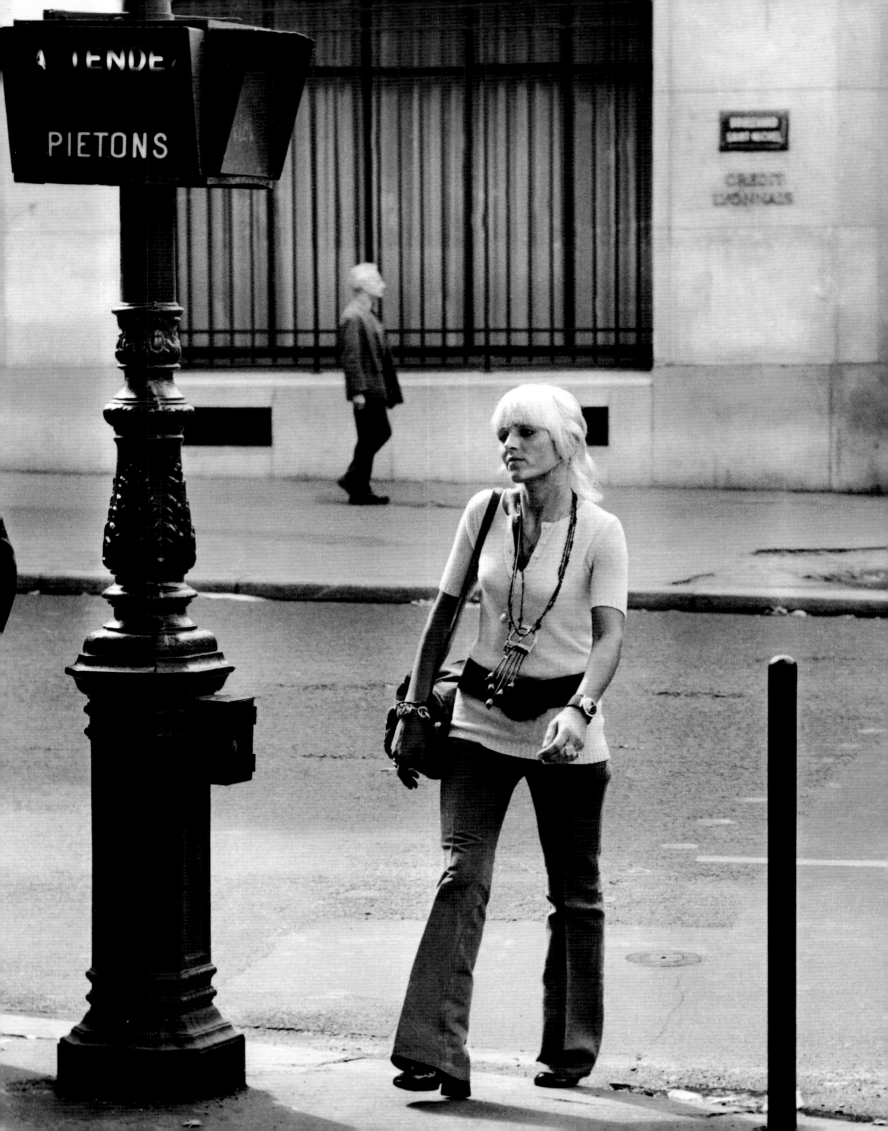

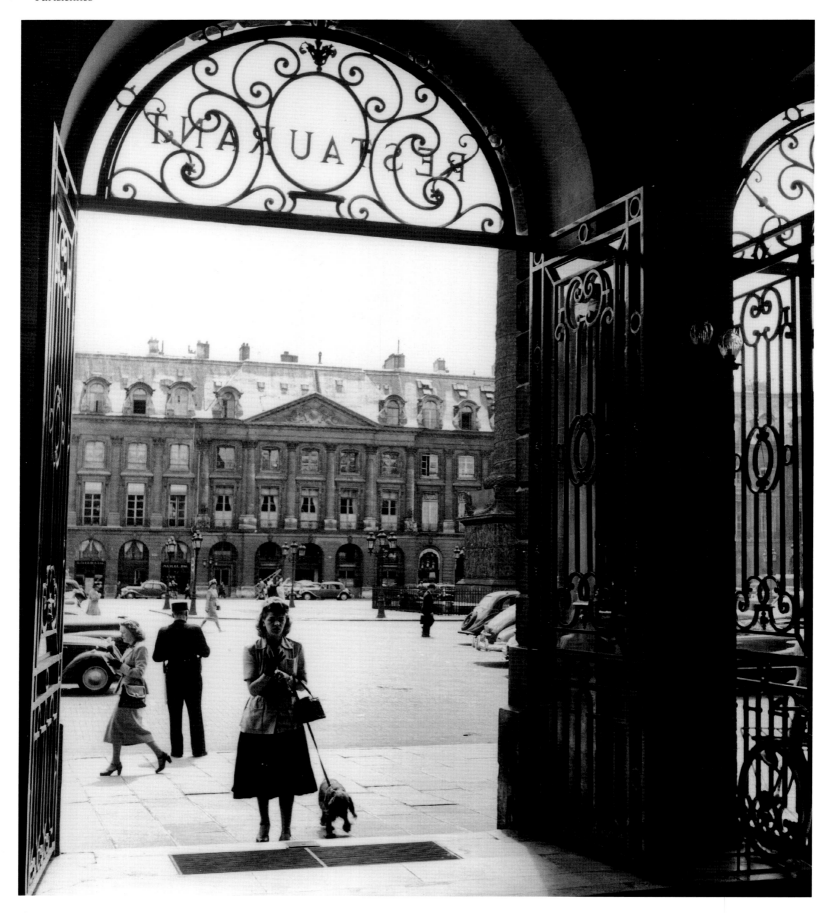

The entrance to the Paris Ritz
on place Vendôme
ANONYMOUS, C. 1948

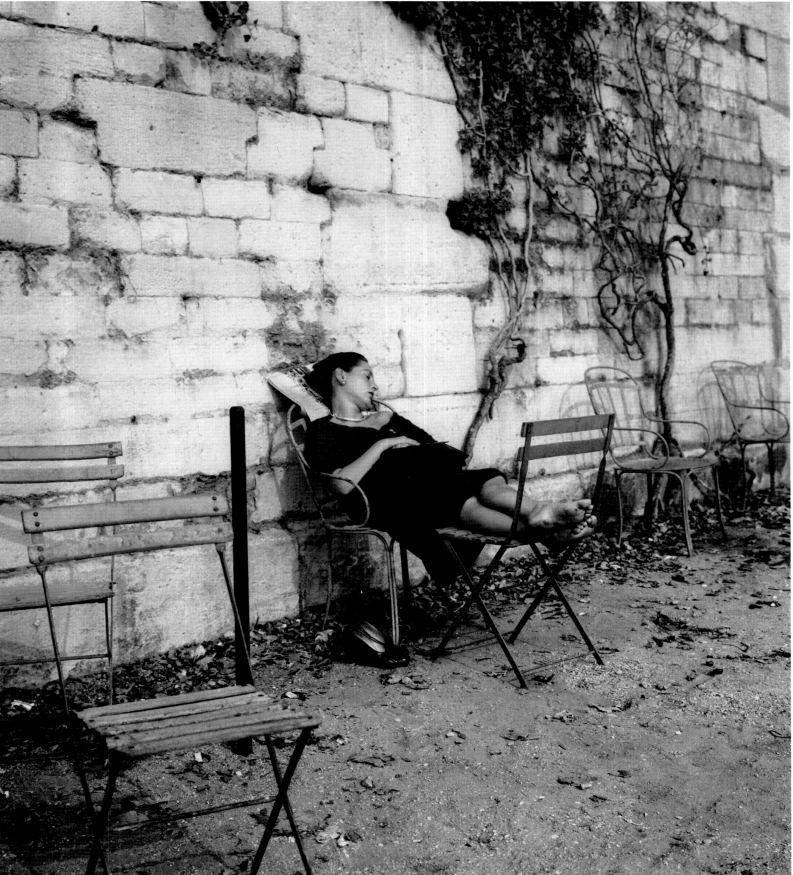

Napping in the Jardin des Tuileries
ANONYMOUS, 1956

" Great passions are prepared by great reveries. "

GASTON BACHELARD, from *La Poétique de la rêverie*
("The Poetics of Reverie")

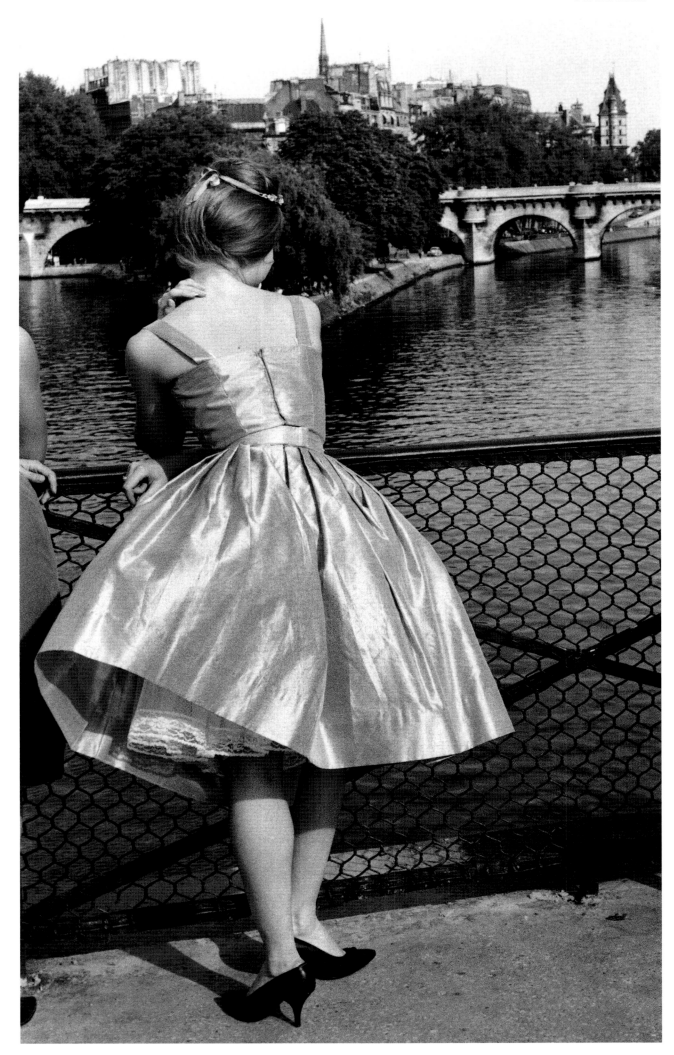

On the Pont des Arts
JANINE NIEPCE, 1962

PAGES 130–131
Paris roofscape, looking
towards Sacré Cœur
ANONYMOUS, 1960s

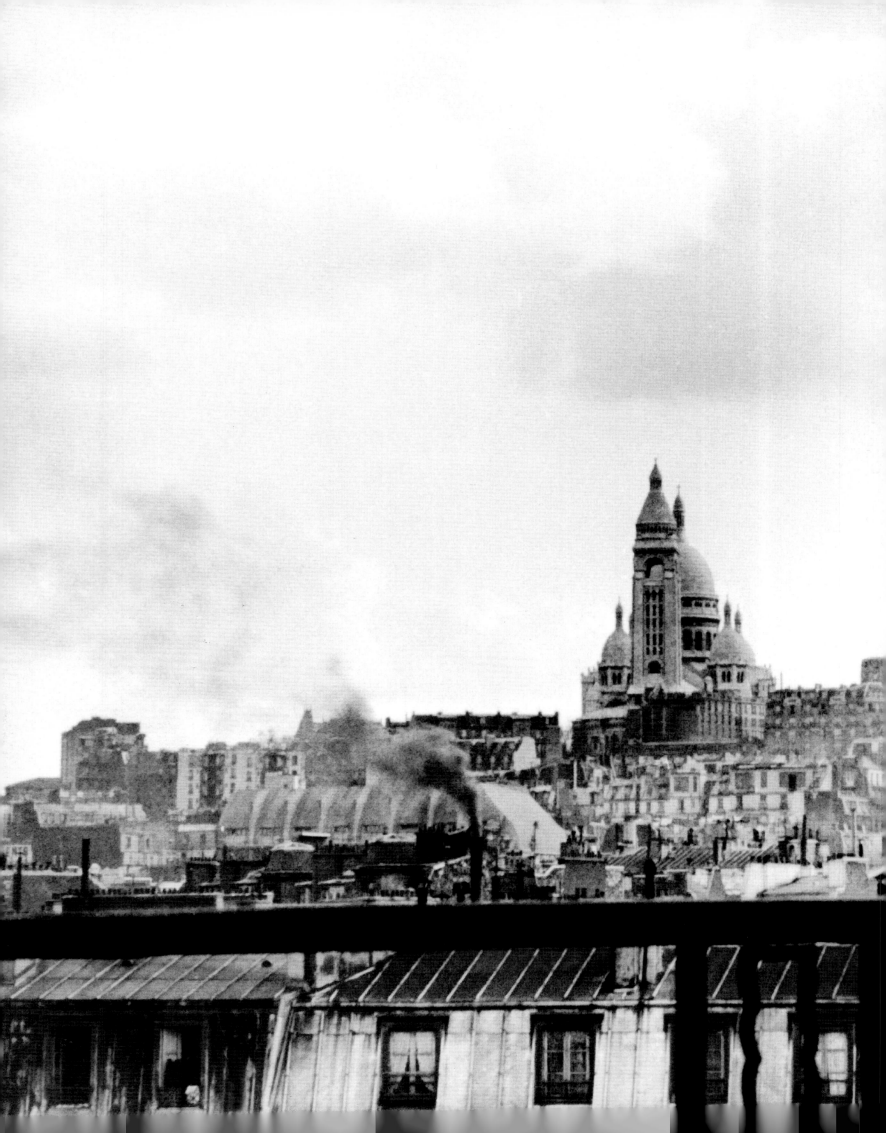

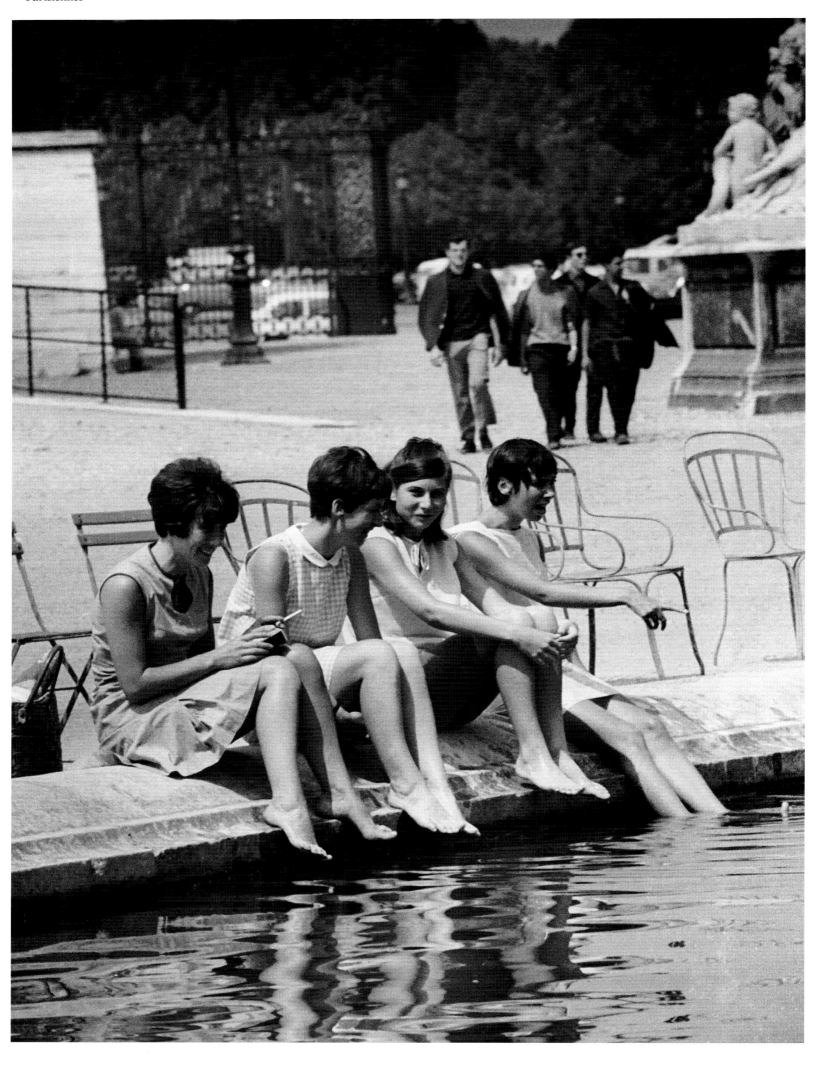

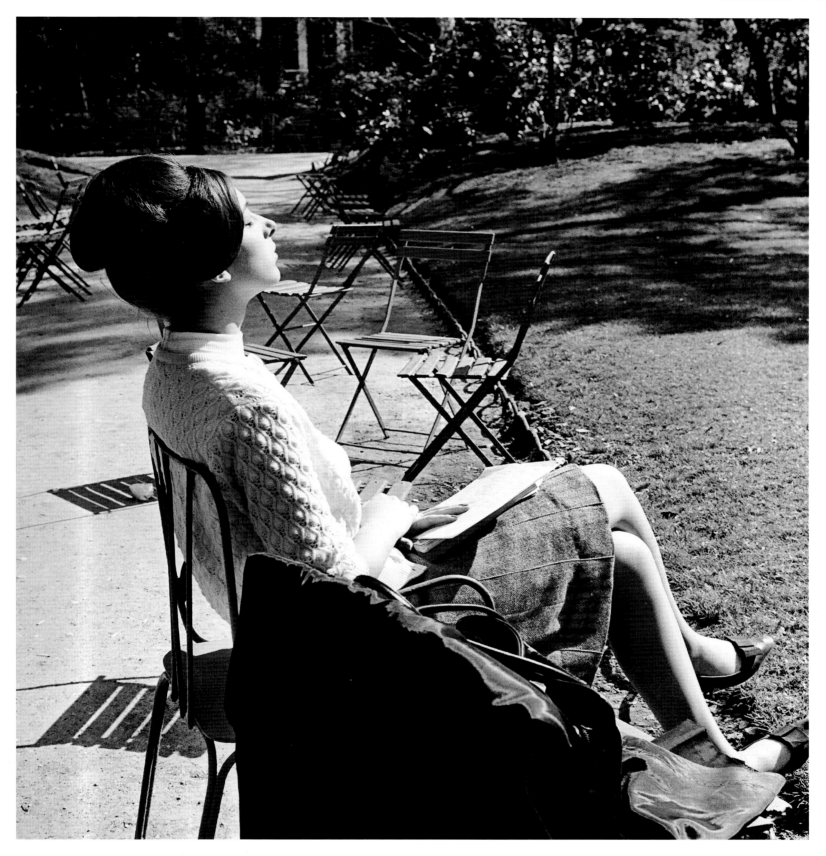

Parc Monceau
ANONYMOUS, 1960

Parisiennes dipping their
toes in a pond in the
Jardin des Tuileries
ANONYMOUS, 1967

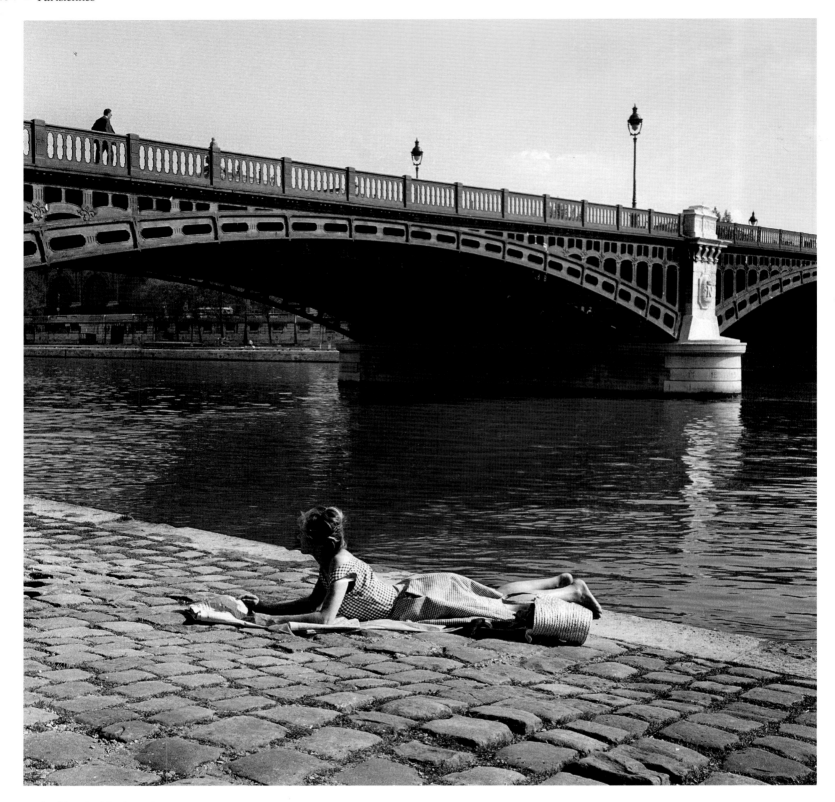

Sunbathing beside the Seine
ANONYMOUS, 1959

❝To love to read is to exchange hours of
ennui for hours of delight.❞

MONTESQUIEU

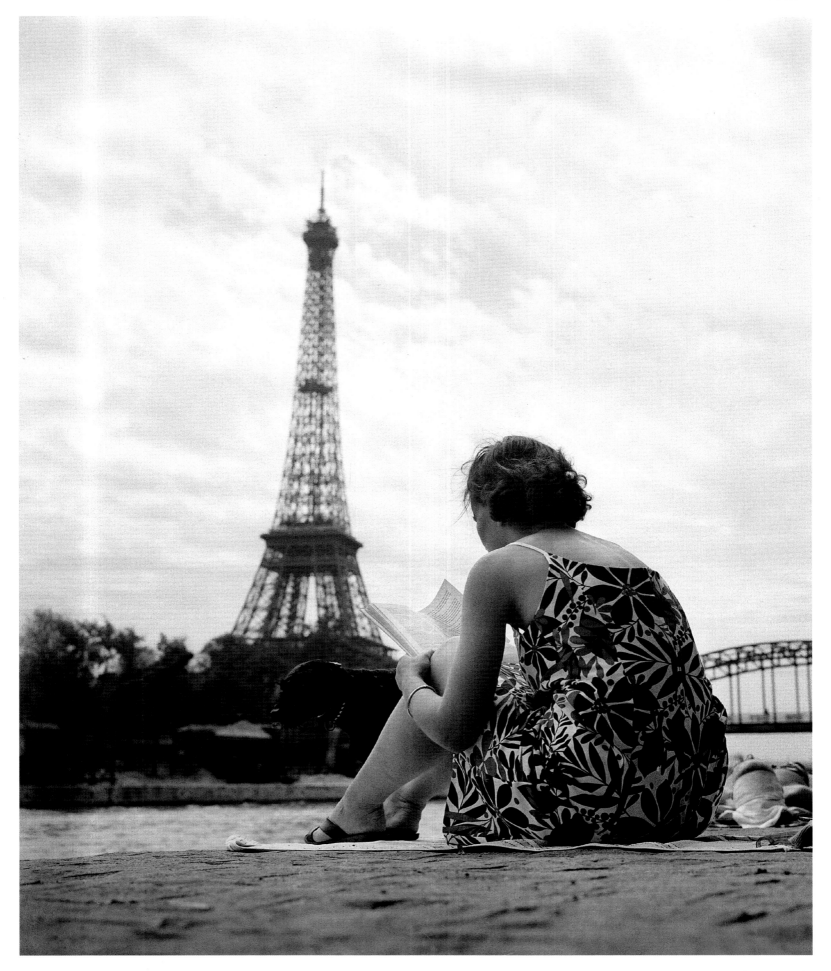

Reading in the sun on the
banks of the Seine, in front
of the Eiffel Tower
ANONYMOUS, 1965

Madeleine Chapsal at home
ÉDOUARD BOUBAT, 1960s

> " What does a woman want? To be loved. Not for
> her cooking, nor her writing: for herself. "
>
> MADELEINE CHAPSAL, *Oser écrire* ("Daring to Write")

Designer Sonia Rykiel
SABINE WEISS, 1970S

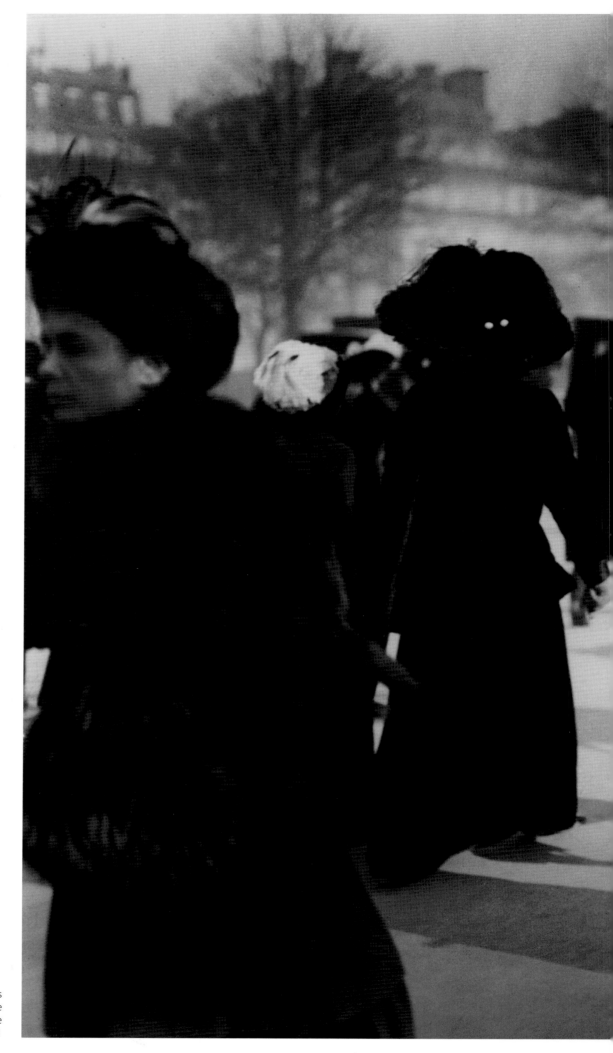

Max de Cazavent following his
elegant companions, avenue
du Bois de Boulogne
JACQUES HENRI LARTIGUE, 1911

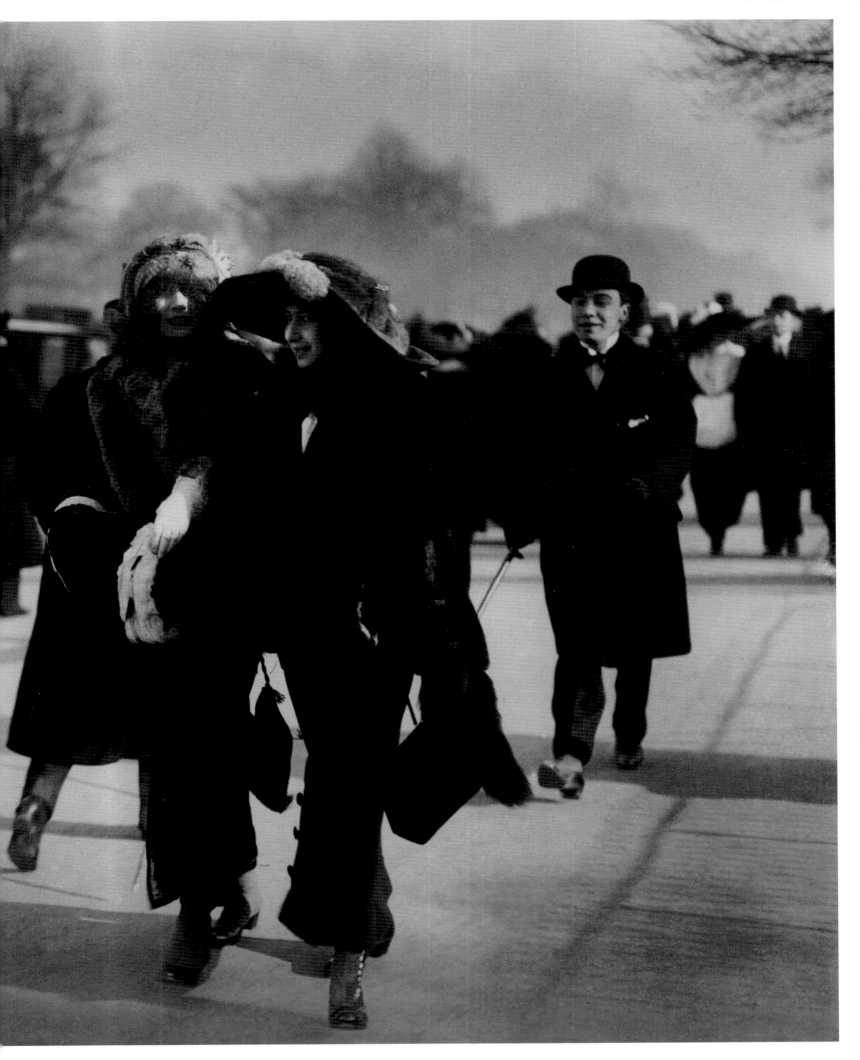

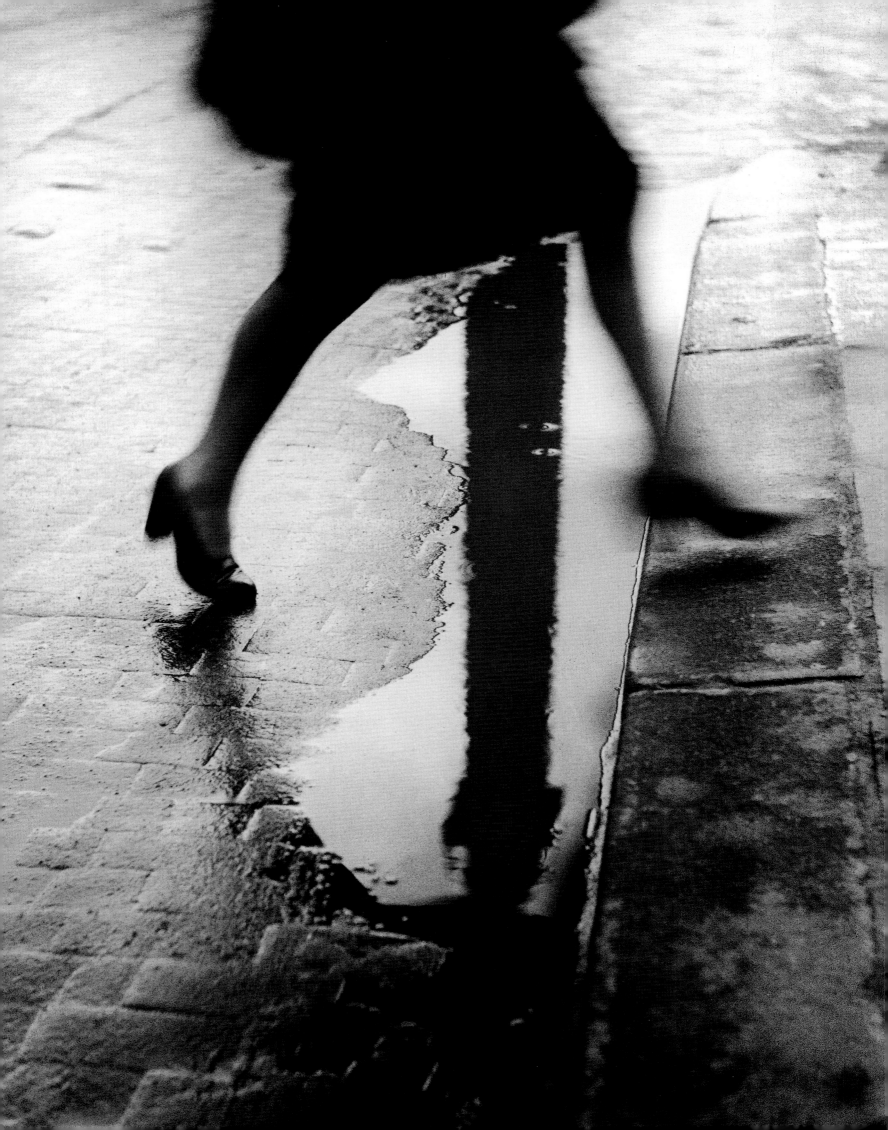

" Legs enable men to walk, and women to get on in life. "

ALPHONSE ALLAIS

Place Vendôme
WILLY RONIS, 1947

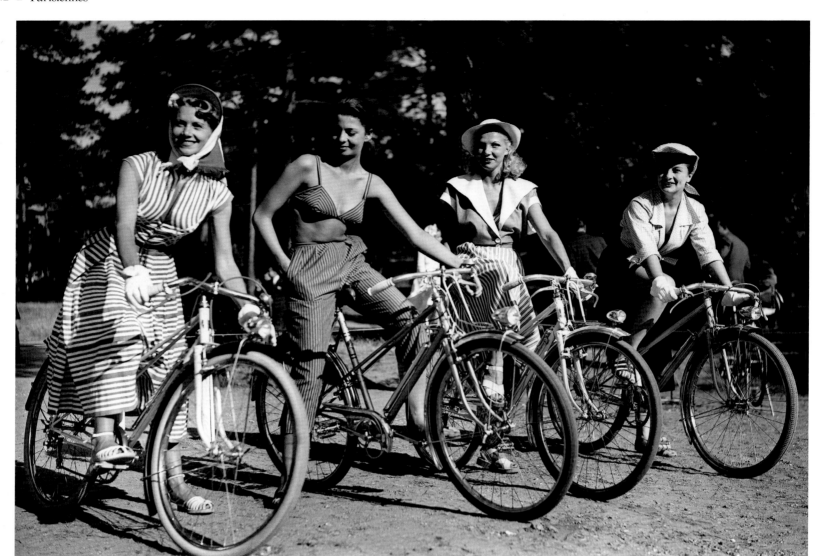

Women cyclists on
World Bicycle Day
ANONYMOUS, 1949

❝ A Parisienne's eyes always seem to do so much
more than merely look at one. ❞

CHEVALIER DE GRAMONT

Woman riding a Solex
motorized bicycle
ANONYMOUS, 1970s

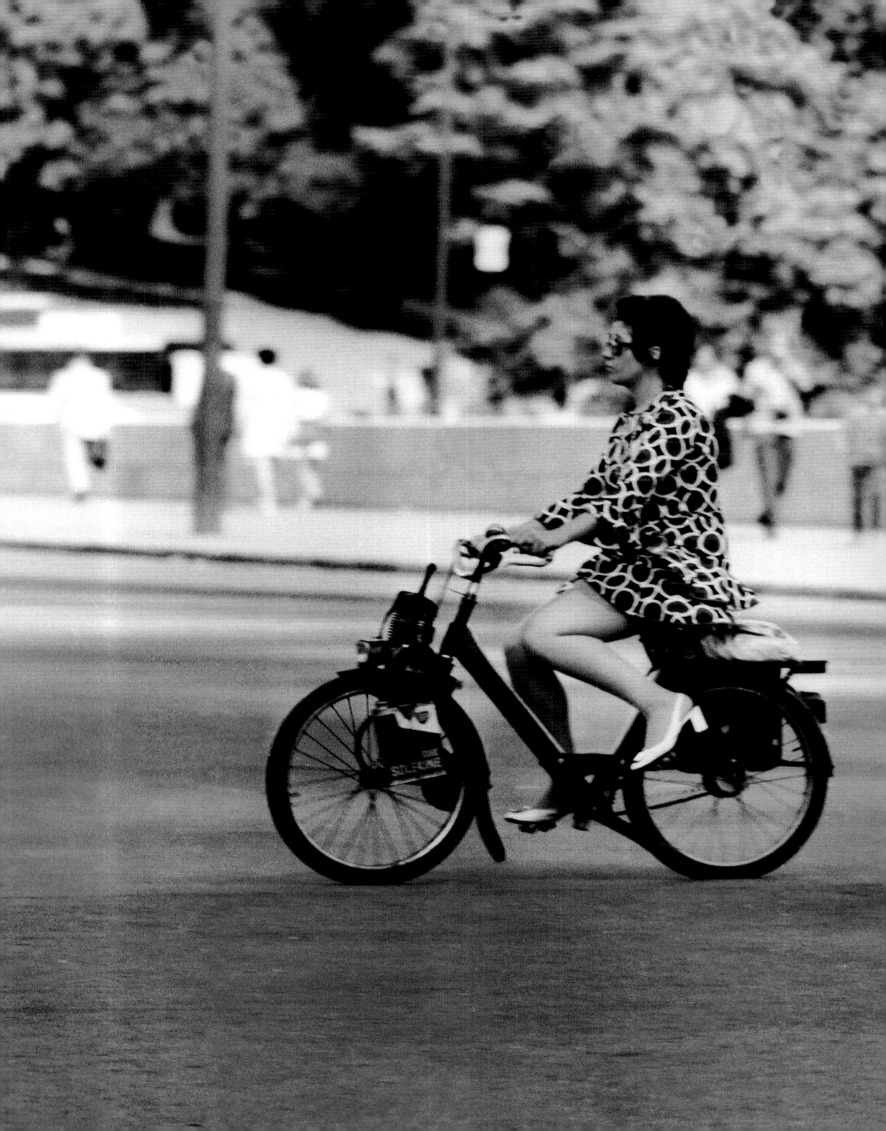

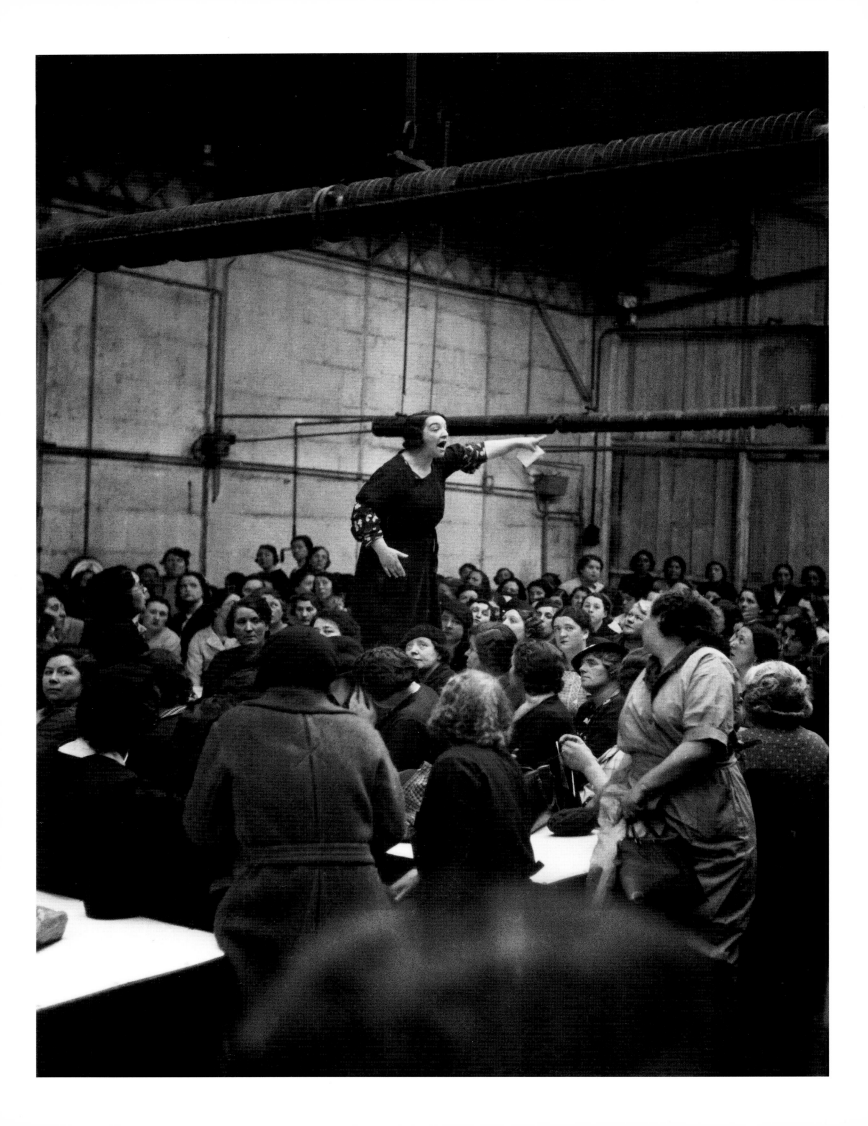

REBELLION

Watch closely: In the park, the tulips are in flower, flaming with color like a host of flags. A blonde woman approaches along the avenue of trees, hesitates for a moment, then crosses the lawn with hurried steps, wobbling in high heels until she takes off her sandals—oh that delicious feeling of grass beneath bare feet. She picks the tulips, quickly at first, but then she takes her time—flowers are for everyone, after all. And the children join her; they run towards her, then stop just a few steps away. "Aren't they beautiful?" says the woman. "Take them, here." She holds out armfuls of tulips for the children to take. But watch again, now: two police officers have appeared in the avenue. The woman sees them at the same time as the children. All three of them look guilty, but the woman can't stop herself from smiling, really the flowers are so lovely, the children were so pleased. The police officers come to a halt at the edge of the grass, and one of them calls out in stern tones: "Come off there, Madame, you are not allowed to walk on the grass, and especially not to pick the flowers." Softly, she tells her charges: "Come on, you two," then heads for the avenue with the children clinging to her heels like shadows. The police officers gaze at the tulips with an expression of appropriate severity. Then they look at the children's faces, and God alone knows what mute fear they read there. Because now the second police officer asks: "Whose children are these?" The woman gazes down at the dark eyes fixed on hers, and smiles. She answers: "They're mine, of course. Whose do you think?" And because the police officer carries on looking at them with an air of suspicion—the children have very brown skins, and kinky hair—she finally stops smiling, looks the man straight in the eyes and adds: "I wasn't able to have children of my own, Monsieur," (she's not lying) "do you have a problem with that?" At length, and reluctantly, the police officer speaks: "I'm letting you, but don't let me catch you again."

The woman and the children wait until the police officers have disappeared around a bend in the avenue of trees. She forces a smile, but her eyes are sad. The children have held onto the flowers so tightly that now they're all crumpled. The children walk away slowly, dragging their feet, and the woman watches them as they cross the esplanade. They're a long way off now. Isn't their mother worried? No, she has stopped trembling now. She was hiding, her eyes fixed on the blonde lady, and when she crouches down the children throw themselves into her arms, with their bunches of tulips.

A strike at the Citroën factory
WILLY RONIS, 1938

DOMINIQUE MAINARD

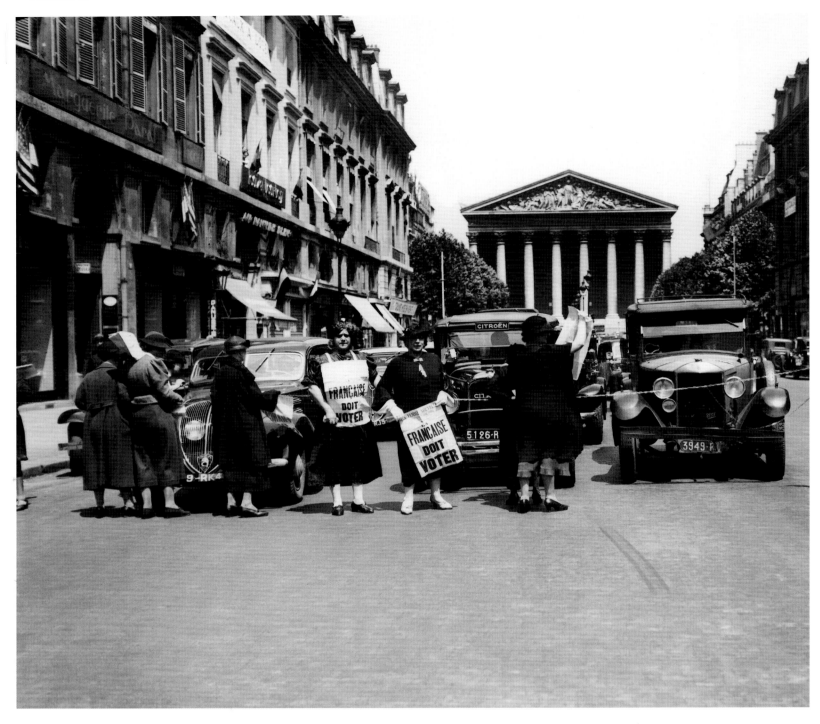

Women demonstrating for the right to vote
in front of the Église de la Madeleine
Anonymous, 1936

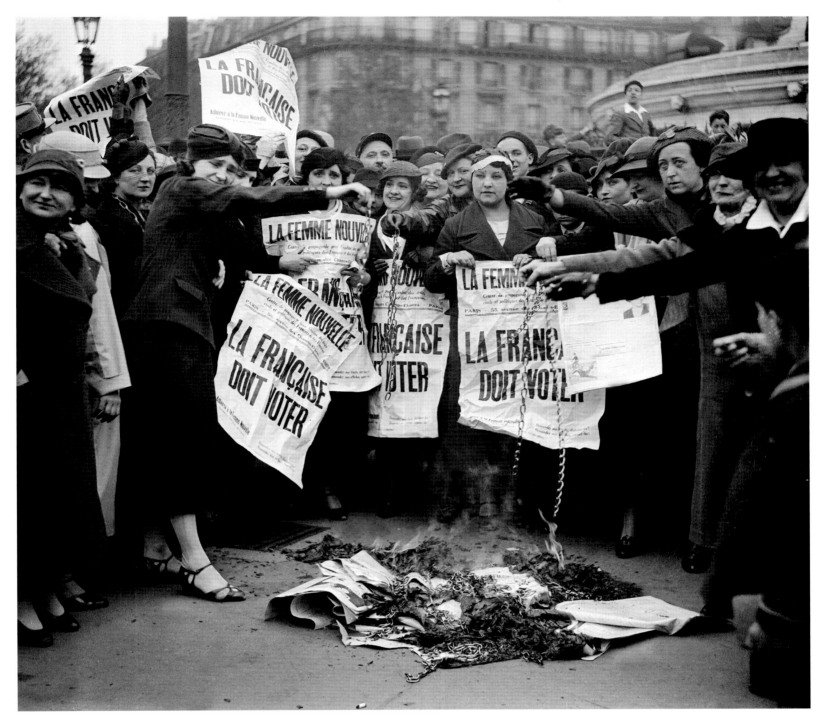

Women demonstrating
for the right to vote
ANONYMOUS, C. 1930

" We cannot tear out a single page of our life, but we
can throw the whole book in the fire. **"**

GEORGE SAND

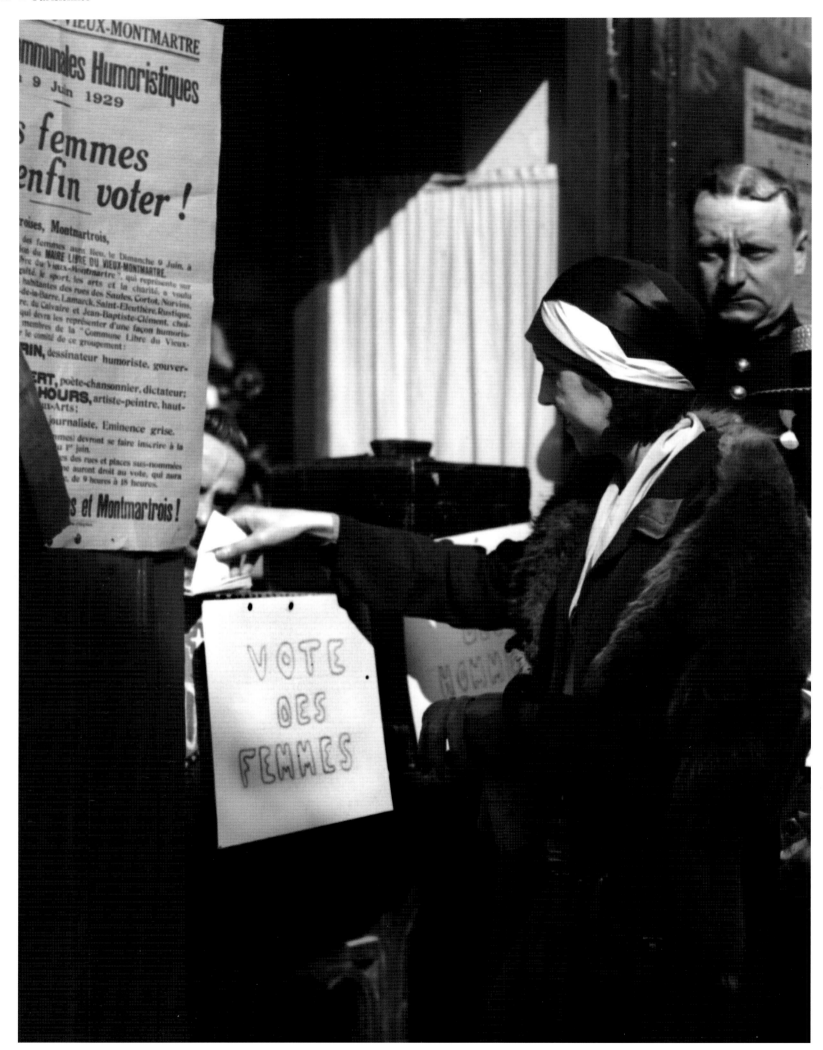

" In this century, which has taken as its governing principle the ending of the French Revolution and the beginning of the revolution of man, and given that the equality of the sexes is part and parcel of the equality of men, what was needed was a truly great woman.

VICTOR HUGO, *Actes et paroles* ("Words and Deeds")

A woman casts her vote in municipal
elections for the Commune Libre
du Vieux Montmartre
ANONYMOUS, 1929

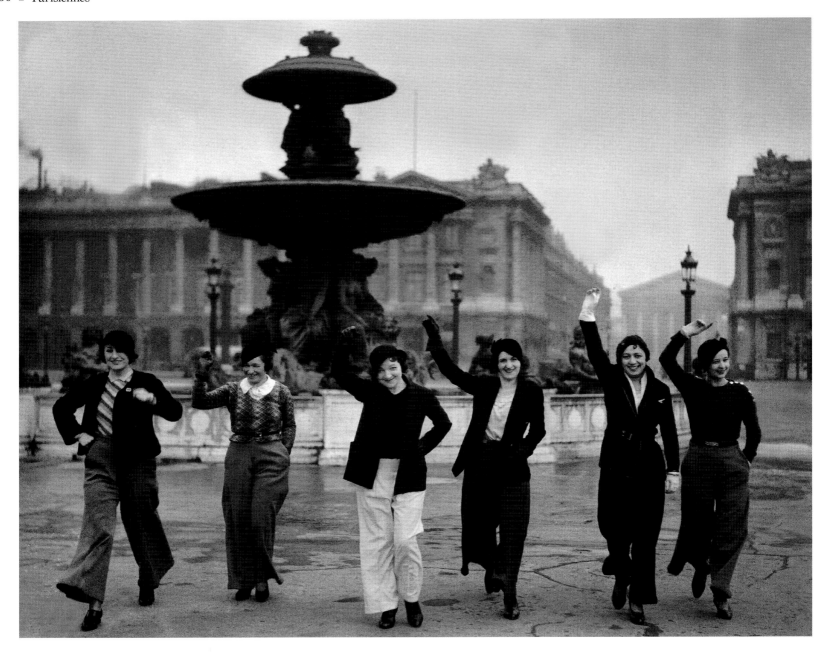

The first Parisiennes to wear trousers,
place de la Concorde
ANONYMOUS, 1933

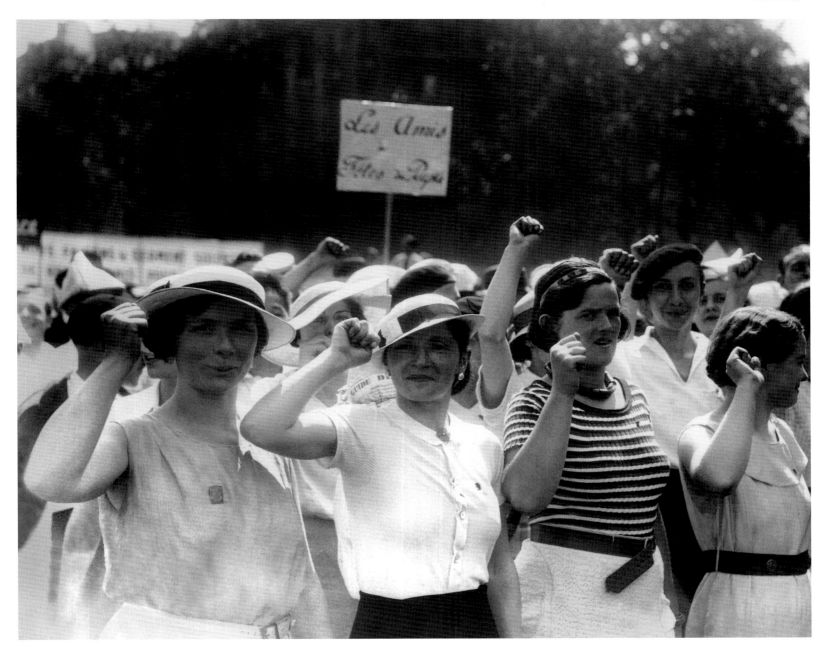

Communist activists protesting
against right-wing extremism
ANONYMOUS, 1935

“ Even war is everyday. ”

MARGUERITE DURAS,
Whole Days in the Trees

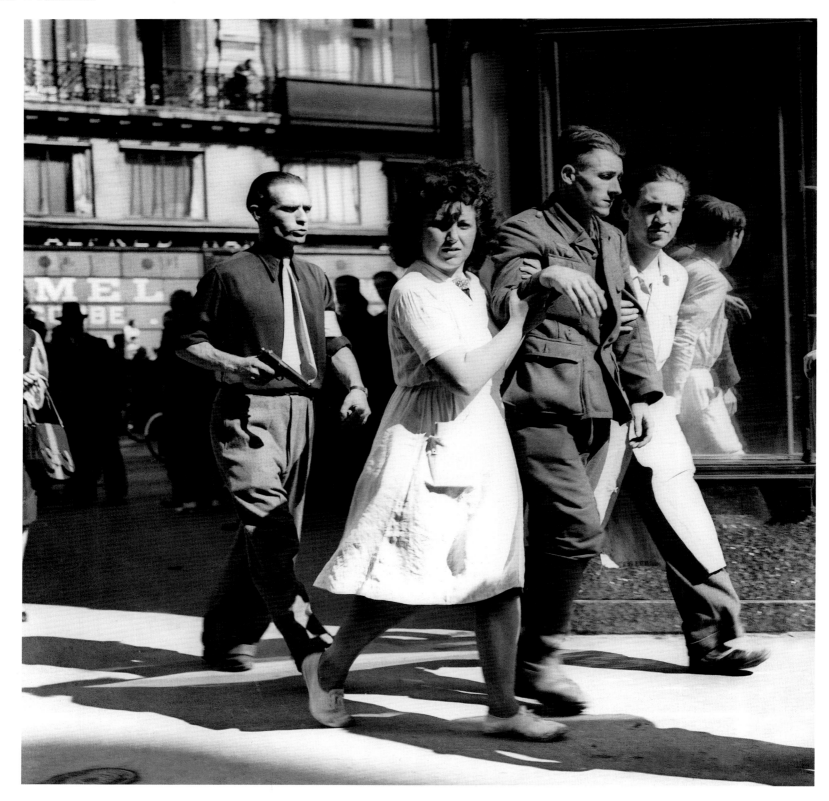

A German soldier arrested by members of the
Forces Françaises de l'Intérieur (FFI; the united
Resistance force)
ANONYMOUS, August 25, 1944

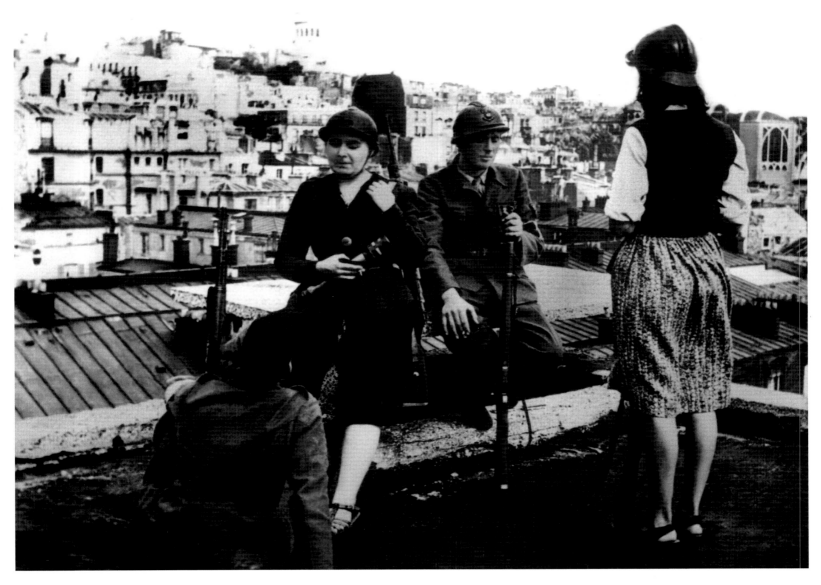

Men and women of the FFI keeping
watch together on the rooftops of Paris
ANONYMOUS, 1944

"Life should be seen as a game you can
either win or lose."

SIMONE DE BEAUVOIR

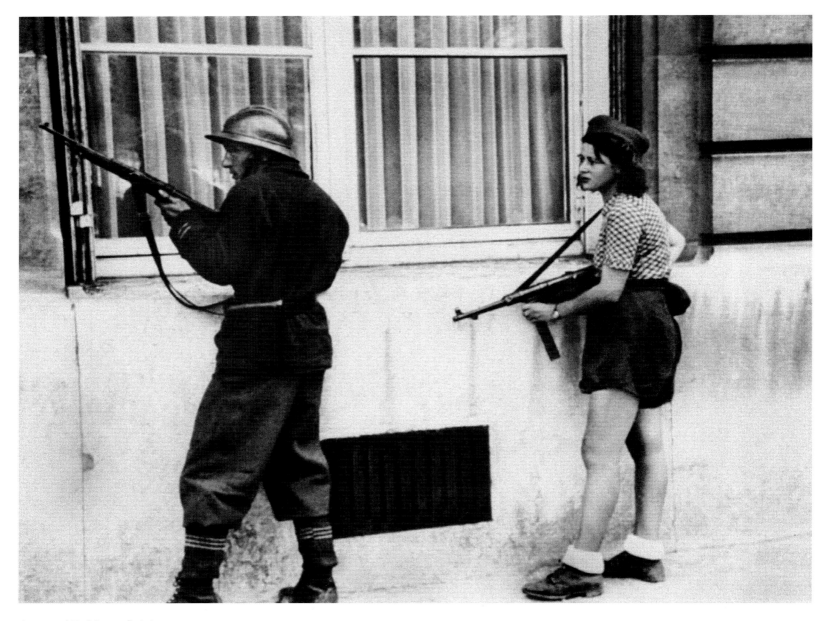

An armed Parisienne fighting
for the liberation of Paris
ANONYMOUS, 1944

Members of the Resistance
ROBERT DOISNEAU, 1944

PAGES 156–157
Members of the FFI on
place de la Concorde
ANONYMOUS, 1944

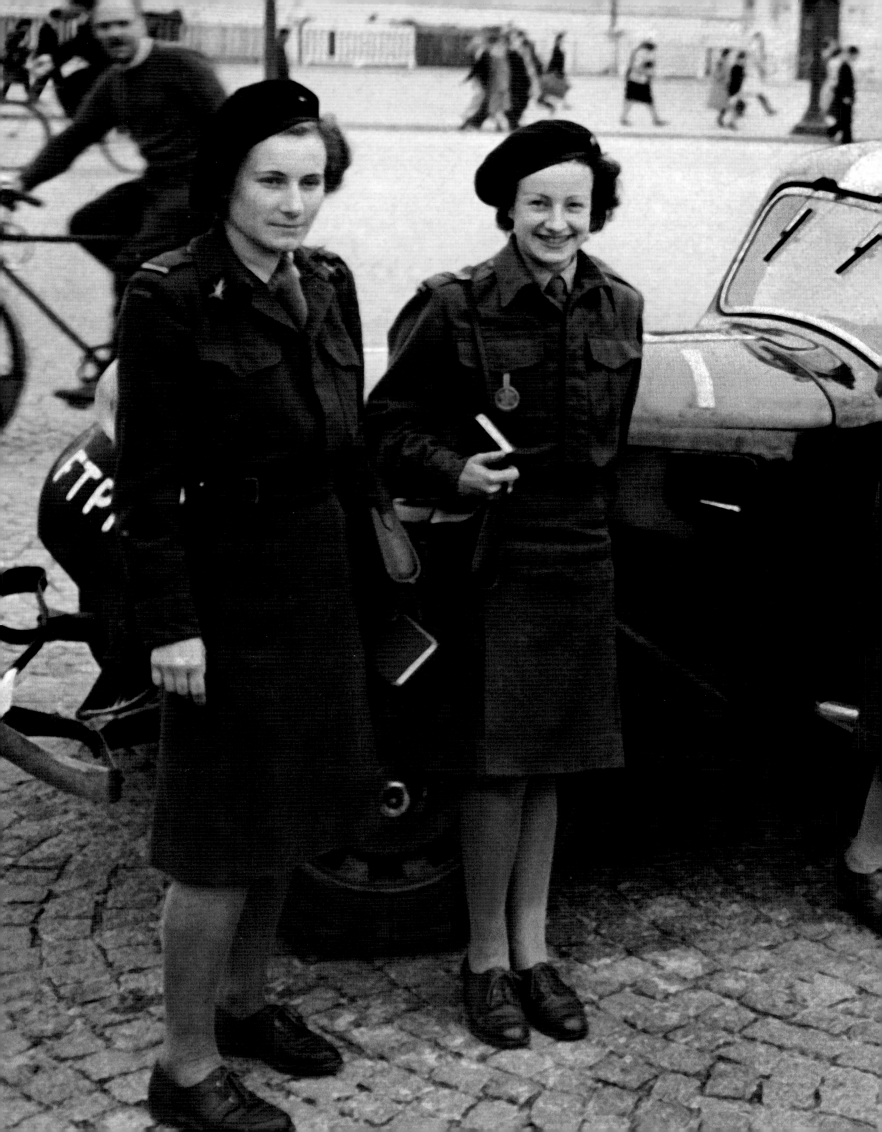

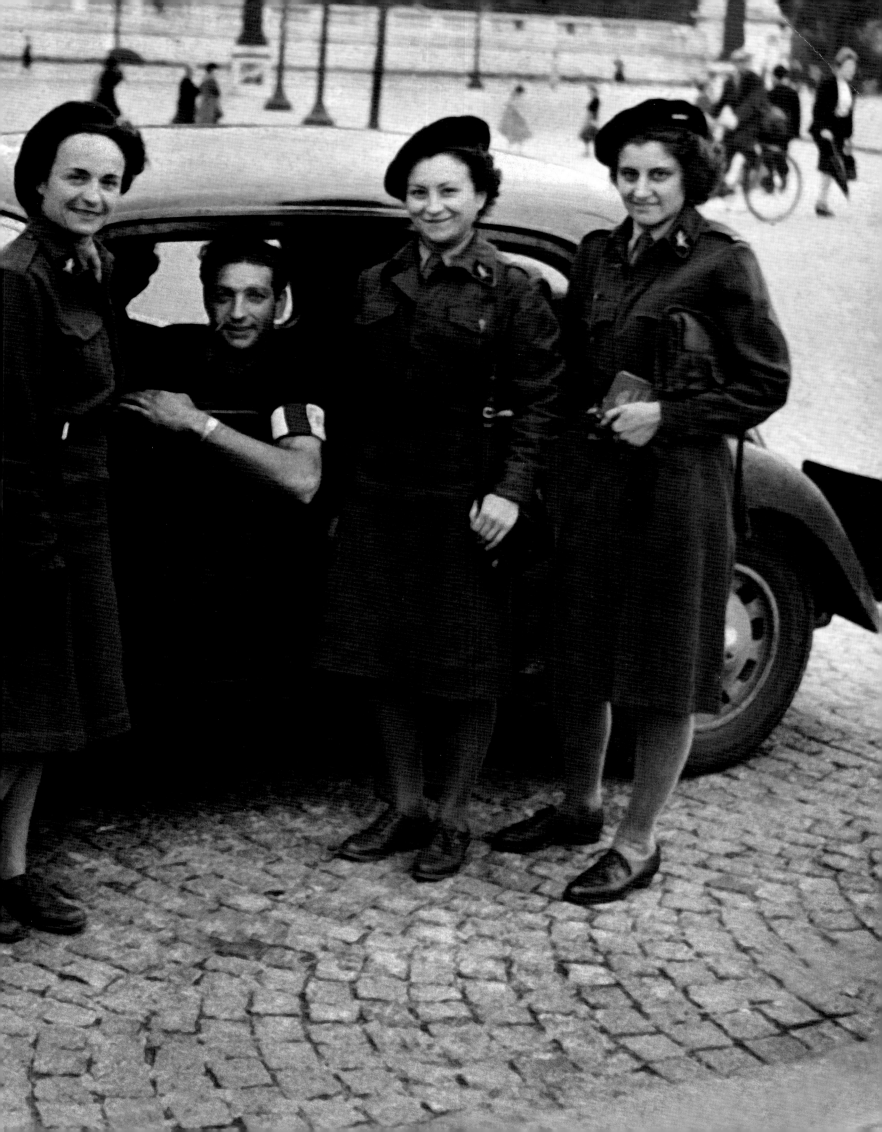

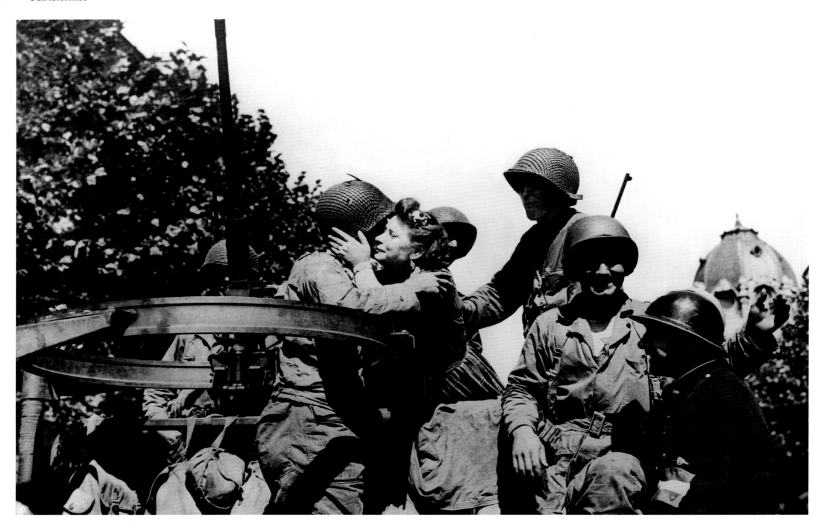

The Liberation of Paris:
An enthusiastic Parisienne kisses a soldier
from General Leclerc's Second Armored
Division, composed of French soldiers
in US uniform
ANONYMOUS, August 25, 1944

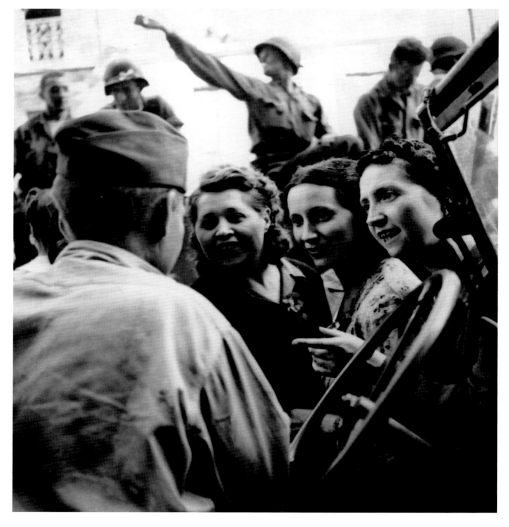

The Liberation of Paris:
Parisiennes greeting
American soldiers
ANONYMOUS, August 1944

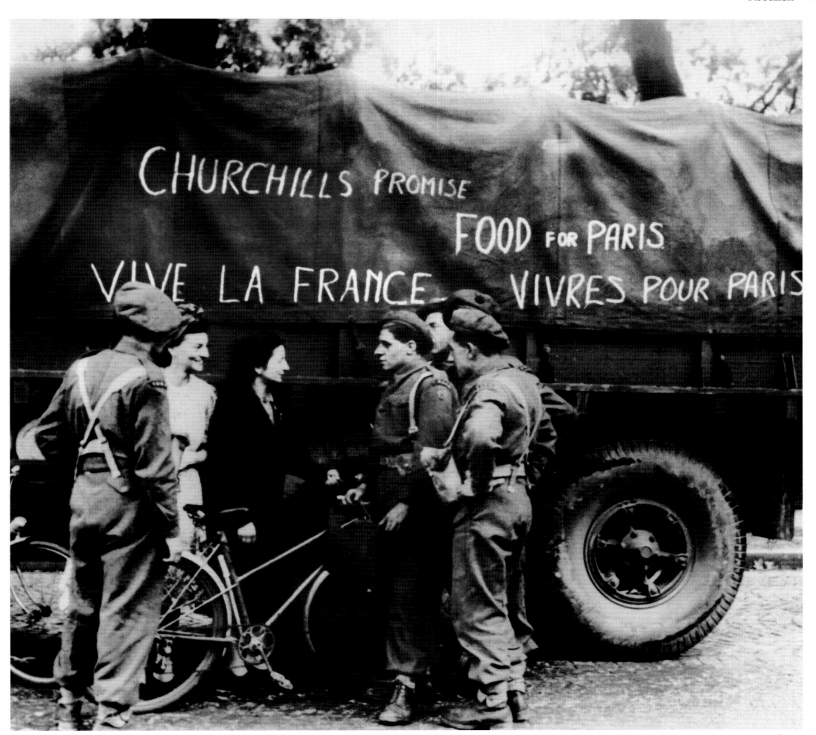

The Liberation of Paris:
Young Parisiennes conversing
with English soldiers
ANONYMOUS, 1944

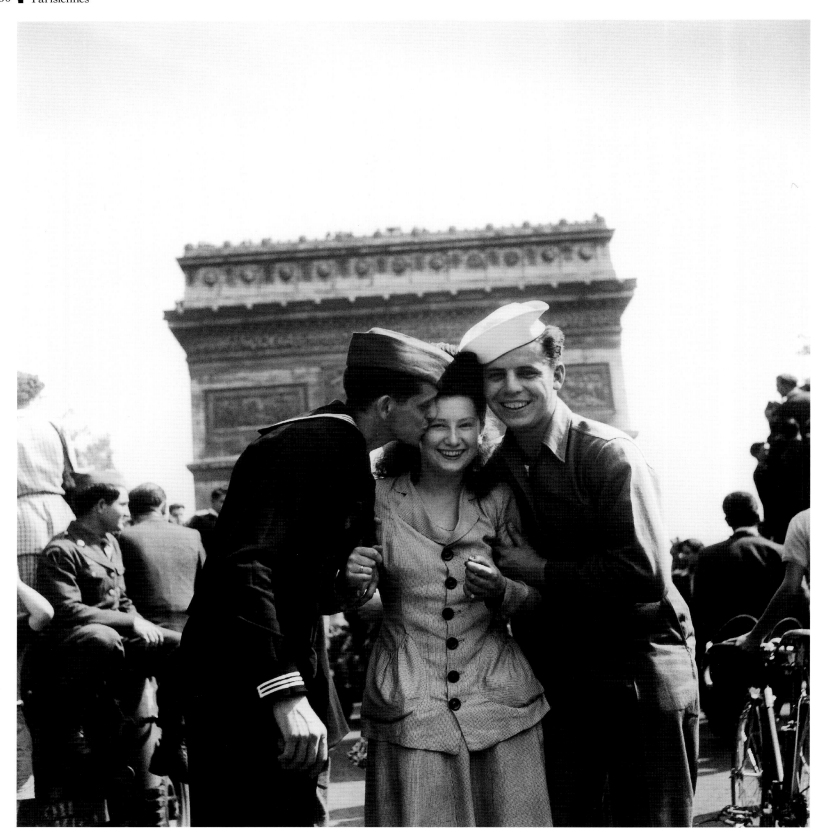

The Liberation of Paris
ROBERT DOISNEAU, 1944

"The world's only true language is that of the kiss.

ALFRED DE MUSSET, *Idylle* ("Idyll")

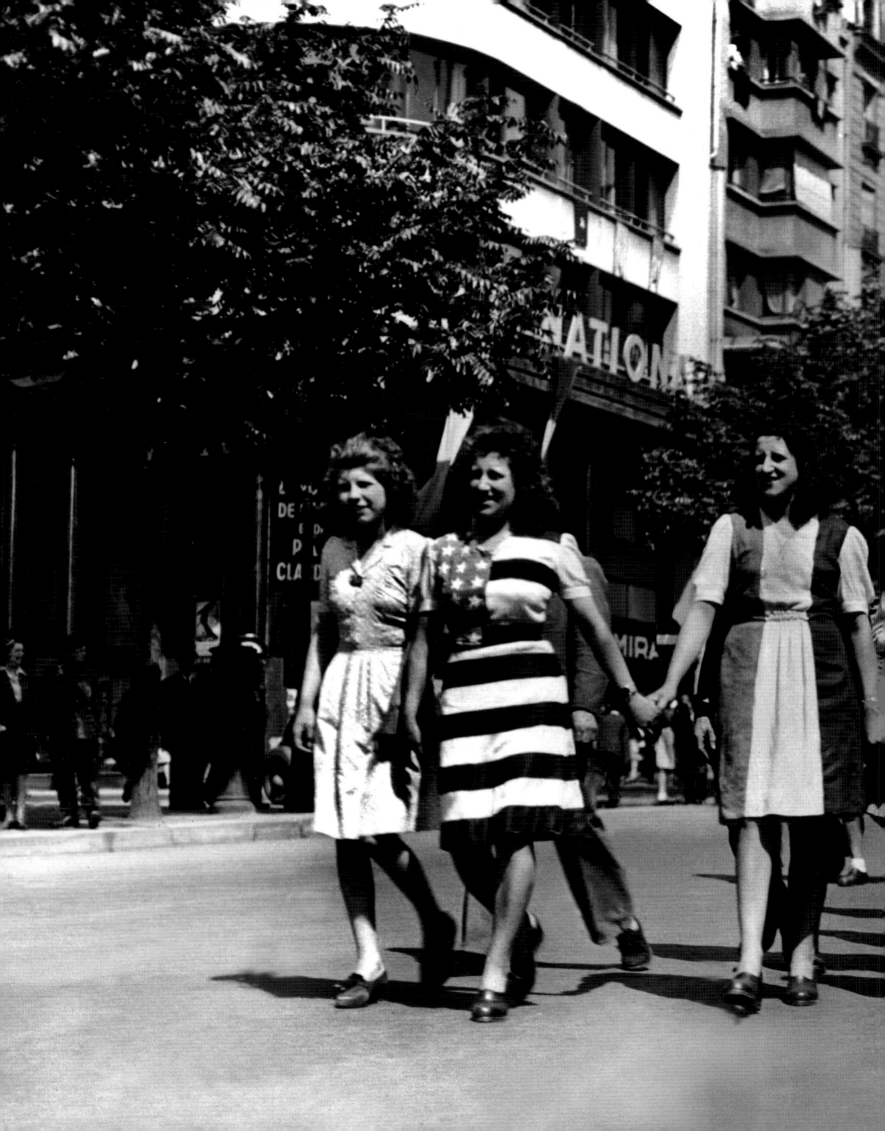

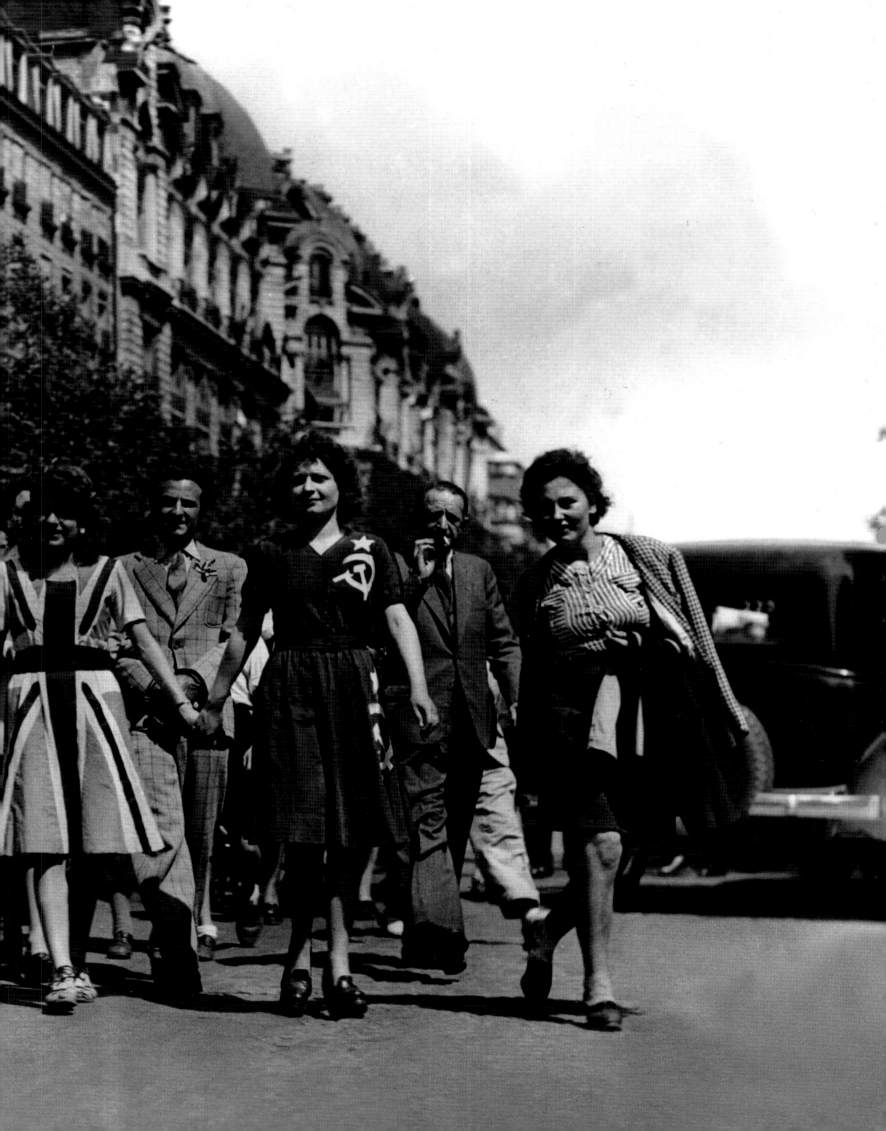

"People not only spoke to one another, they sang together. Street corners would sprout a small band—accordion, violin, drummer, and vocalist—whose leader would sell 'song sheets' to the public, so that people could join them in the refrain. Even in the metro someone would sing, and sometimes a dozen people in the carriage would hum along."

ROBERT DOISNEAU, 1944

PAGES 162–163
Parisiennes sporting dresses representing
the flags of the Allied nations
ANONYMOUS, May 8, 1945

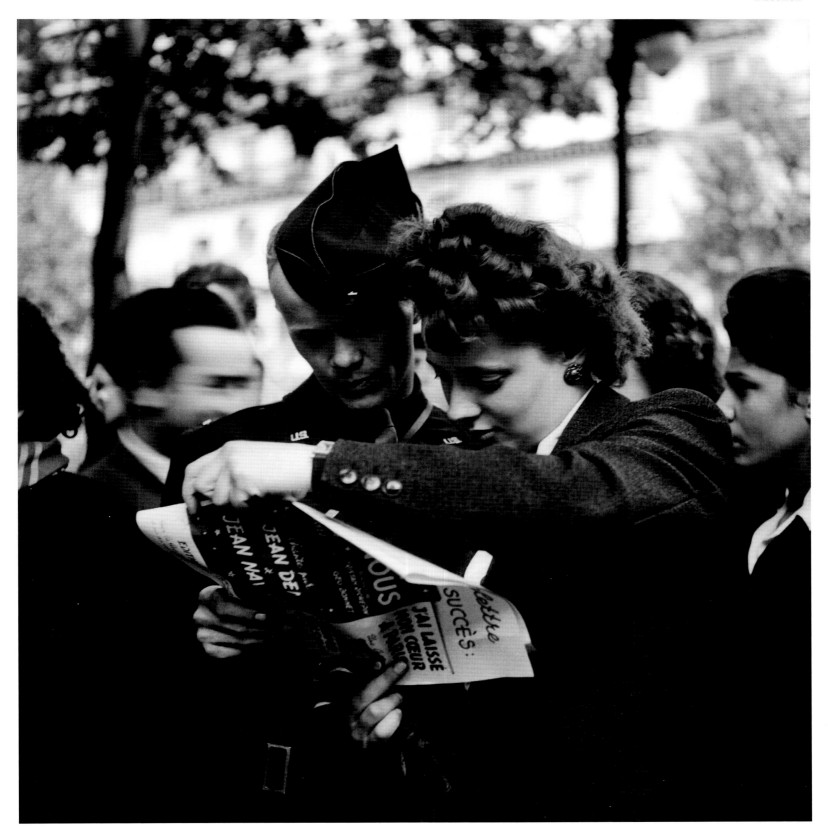

Song sheets
ROBERT DOISNEAU, 1945

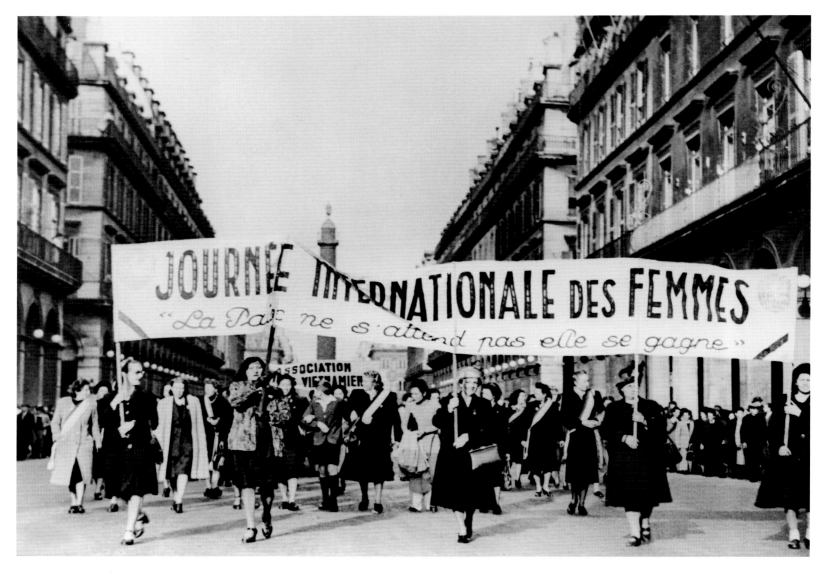

Young Parisiennes from
the World Peace Movement on
a peace march on rue de la Paix
ANONYMOUS, **March 8, 1948**

" The end of wisdom is to dream high enough

not to lose the dream in the seeking of it. "

WILLIAM FAULKNER, *Sartoris*

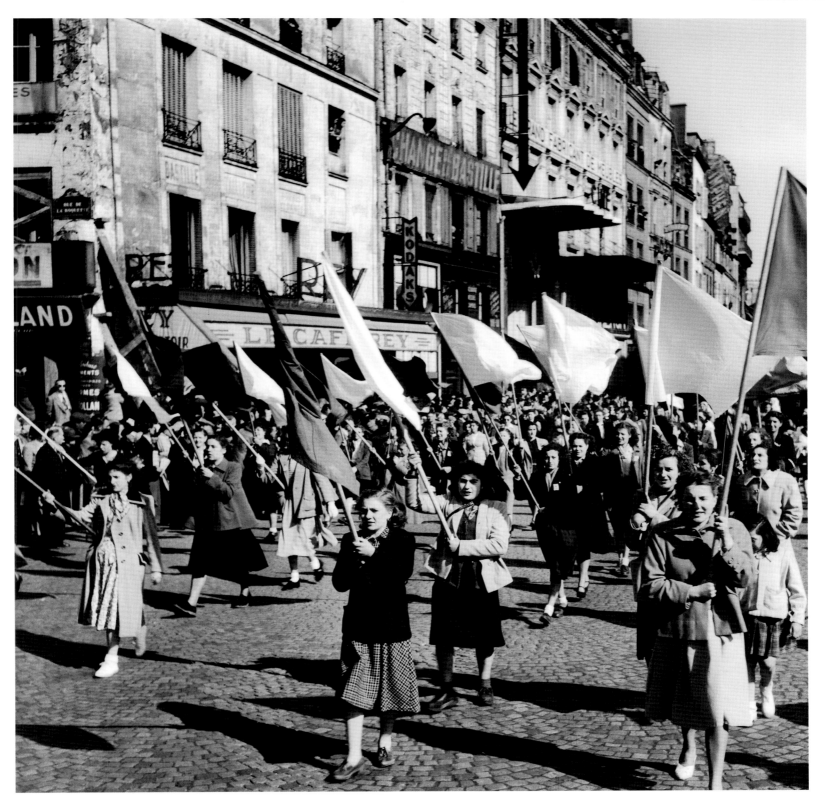

ROBERT DOISNEAU, 1949

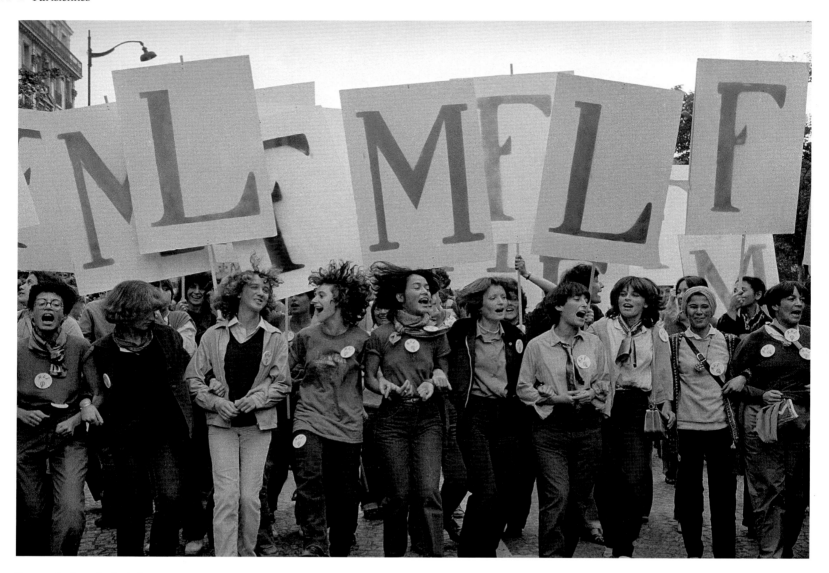

Demonstrations in Paris for
the right to free abortions
ANONYMOUS, 1979

“ Always wanting; this is the condition of Paris. ”

VICTOR HUGO, *Paris*

A demonstrator holding a placard calling
for more individual liberties,
flexible working hours, and a thirty-five-hour week
ANONYMOUS, May 1968

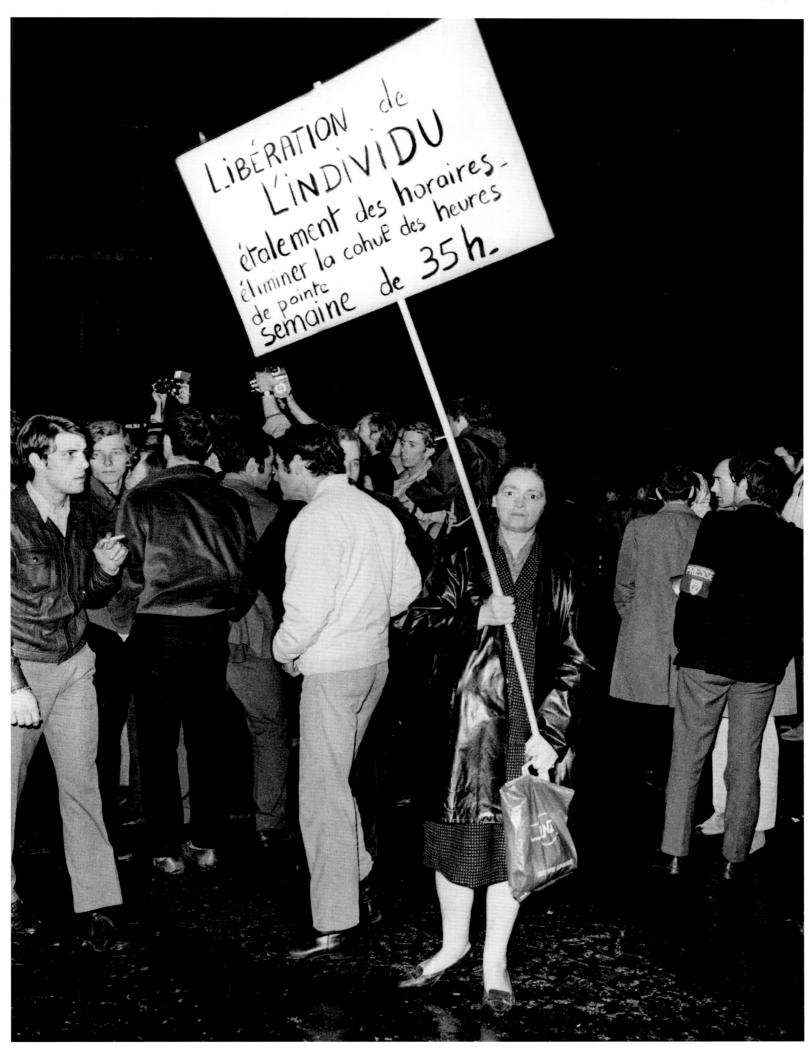

NATIONAL
FEMMES

COMITE INTERNATIONAL
DU DROIT DES FEMMES

RMC

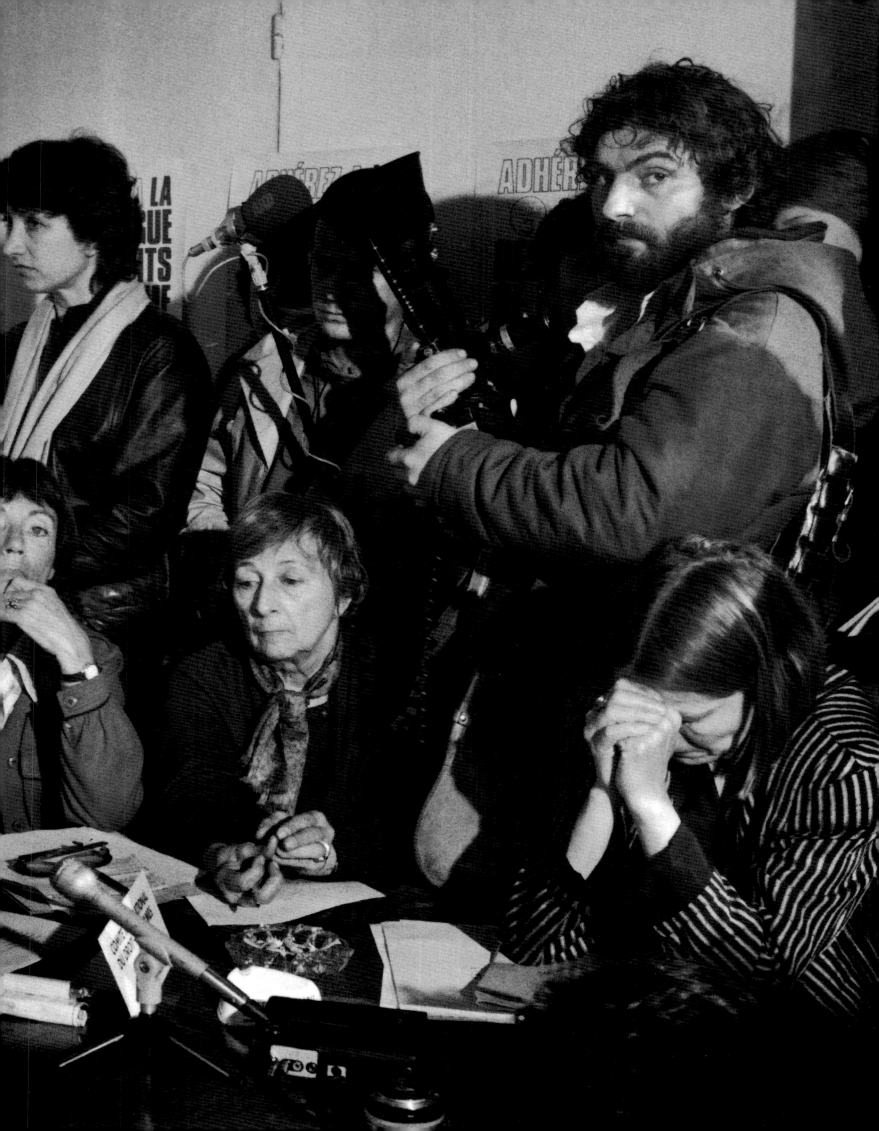

> "And so the storms of revolution shall come, shaking everything in their path… The equality of the sexes shall be recognized, and this will mark a great breach in the history of human stupidity. And man and woman shall walk hand in hand."

LOUISE MICHEL, *Memoirs*

PAGES 170–171
The International Committee for Women's
Rights with (on the left) Simone de Beauvoir
and (center) Benoîte Groult
JANINE NIEPCE, May 1968

Young woman
with a flag on place de la Bastille
JANINE NIEPCE, May 1968

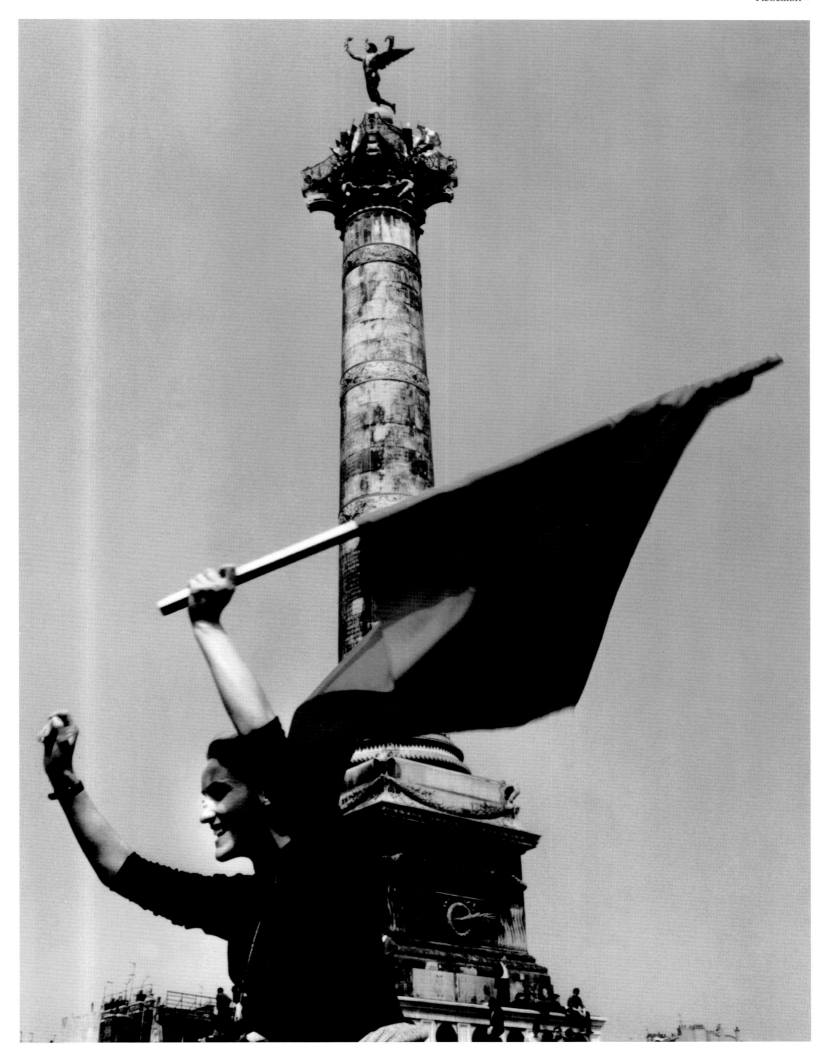

ELEGANCE

All cities have their own sense of style but the elegance of the Parisienne is recognized the world over. This elegance, seemingly effortless, is nonetheless something of a paradox.

No one looks more natural than the Parisienne. For her, elegance is simple. She moves and walks with feline grace, nonchalant. She seems to take her own appearance for granted. It doesn't preoccupy her; it's just right for the person she is. Coco Chanel, for example, posing on a sofa, covered in jewelry, looks completely natural. And yet Cecil Beaton didn't photograph her when she had just got out of bed. So what's the secret?

Elegance takes time and maturity (which is why, perhaps, the French woman seems to have cornered the market in aging gracefully). Learn to be yourself. Accept yourself. Know yourself. And don't allow yourself to look like anyone else. This is the secret of true elegance.

The French woman learns to stop thinking about appearances, so that other people accept the radiant impact of her elegance as an absolute, obvious matter of fact. For this reason it seems to me that seduction only works when you look like your own being. The Parisienne strikes a perfect balance between what she shows of herself, and what she is—whether that balance is true or false, calculated or learned, whether her femininity is communicated or acquired through the looks of others, be they men or women.

When I represent Chanel abroad, people always know that I am from France, just as clearly as if they saw me with a *baguette* under my arm. It's something I, like all Frenchwoman, seem to communicate from the very first glance, whether I want to or not. I am profoundly Parisienne, whether in an evening dress or jeans. Although some small accessory may give a clue to my current state of mind, or my mood, simplicity is the watchword for me. I could never dress like that *grande dame* Loulou de La Falaise—Parisienne herself, but a with a style inimitably her own. If we were to swap wardrobes, no one would give either of us a second glance: we would disappear under the welter of false impressions, because our appearance would have said nothing about the person underneath. Like all Parisiennes, our elegance lies, ultimately, in our gestures; and for these gestures to be pure and untainted, for our ease to flourish, we must forget the wrapping.

These things should come to you, on impulse, like desire. Just as the meeting of your inner desires with the real world should be by chance, not the result of a deliberate quest, so perhaps real elegance is simply a true encounter with oneself.

Arriving at a gala ball on place
Vendôme
WILLY RONIS, 1950

CAROLE BOUQUET

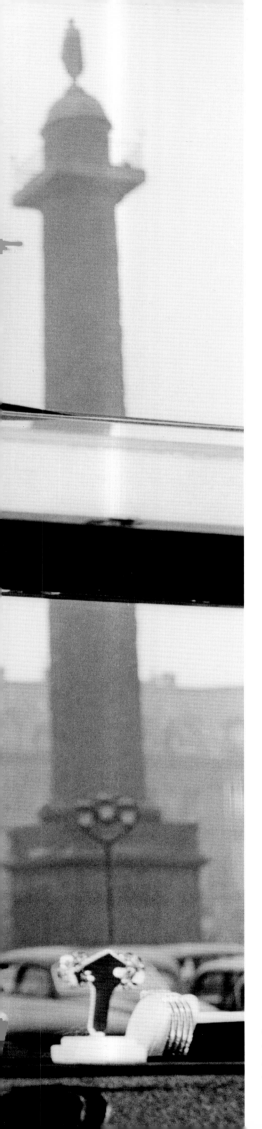

"Paris, city of magic, city of desire, city of promises; Paris, where women are lovelier than anywhere else, where women reign supreme."

RÉGINE DEFORGES

The model Bettina posing in front of the window display at Van Cleef & Arpels, place Vendôme
JEAN-PHILIPPE CHARBONNIER, 1953

"Provincial ladies are slaves to fashion, but Parisian ladies dictate it, and each knows how to bend it to her advantage. Parisian women dress so well, or at least their reputation in this is such that they serve as models to the rest of the world, as in all else."

JEAN-JACQUES ROUSSEAU, *Julie ou la Nouvelle Héloïse*

A lady of fashion
ÉDOUARD BOUBAT, 1951

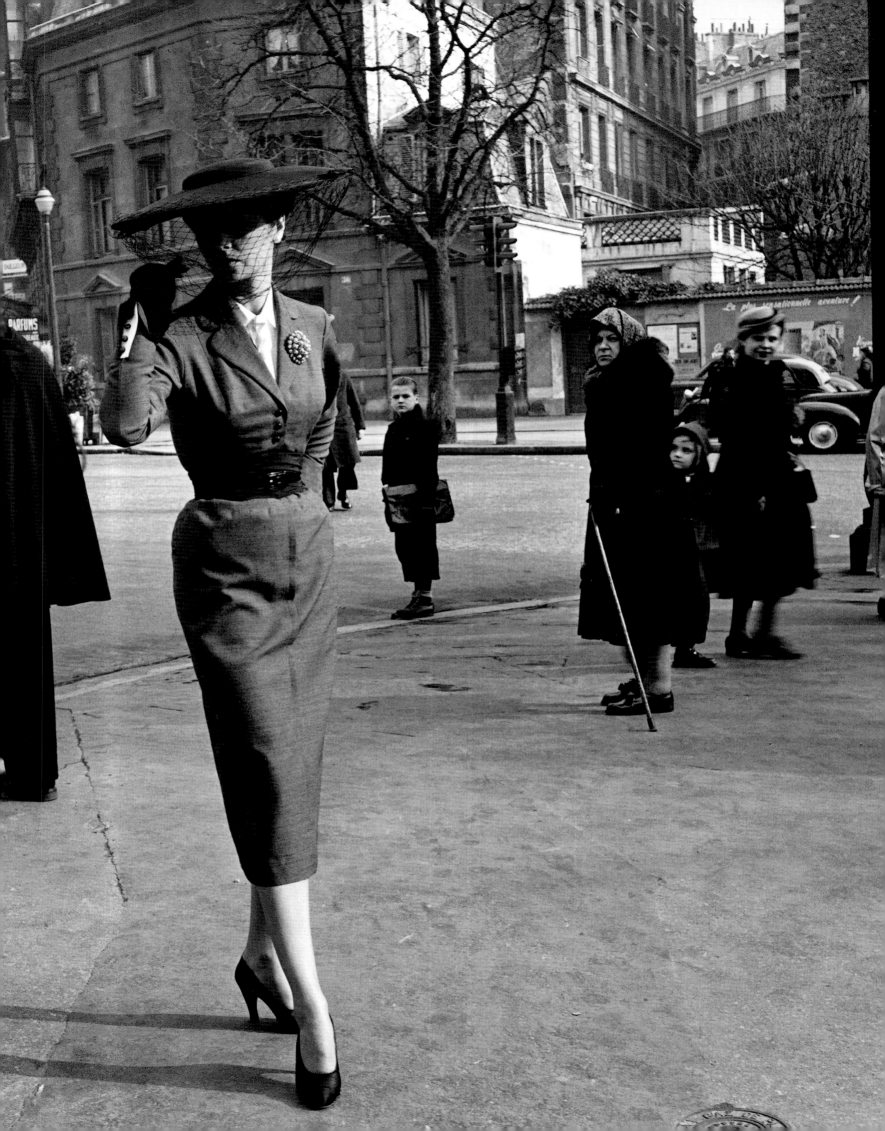

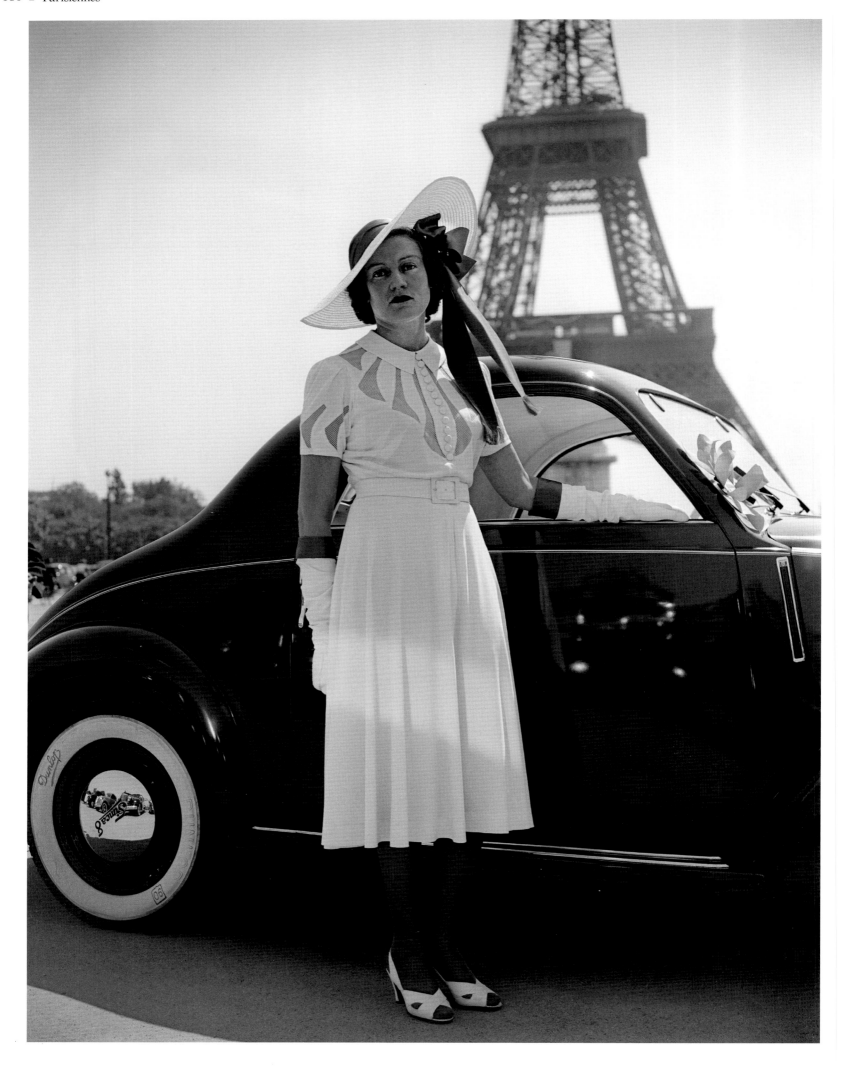

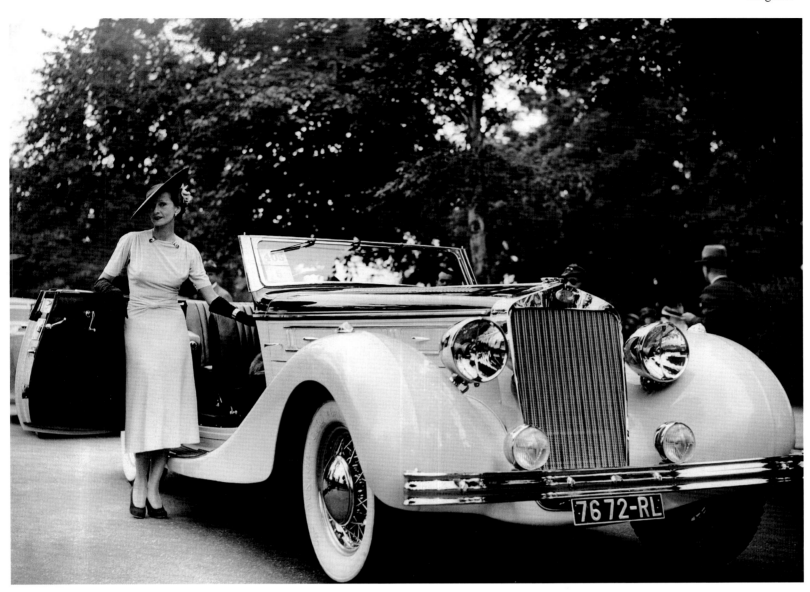

Hélène Arpels, wife of the jeweler
Louis Arpels, wins first prize at a
concours d'élégance for her Delahaye car
ANONYMOUS, 1937

A concours d'élégance
automobile (car show) at the
foot of the Eiffel Tower
ANONYMOUS, 1939

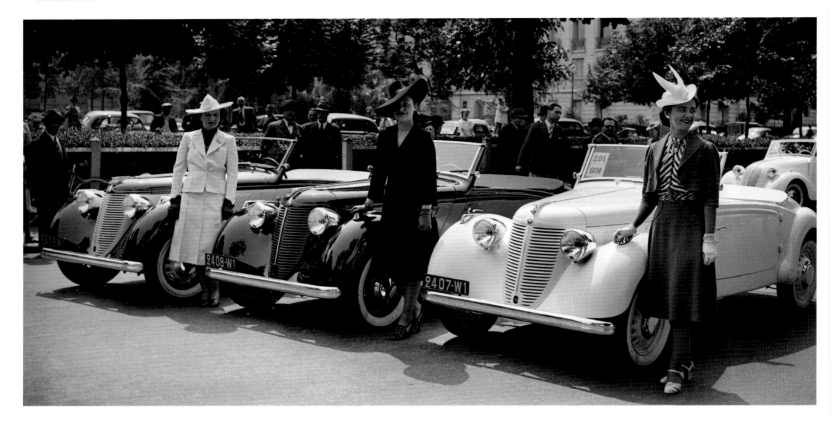

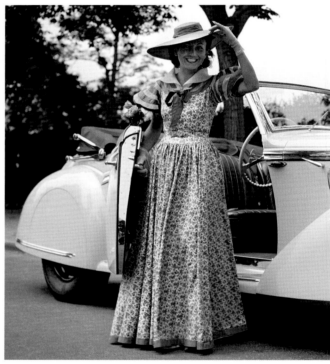

Concours d'élégance
ANONYMOUS, 1938 and 1939

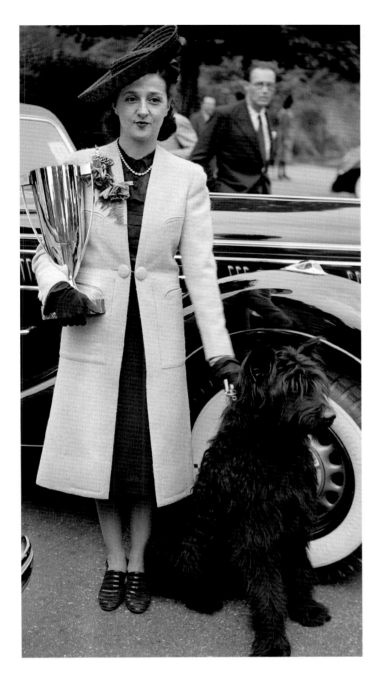

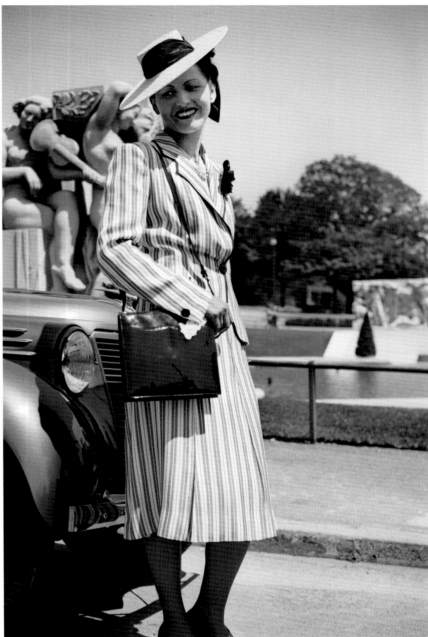

Elegant women at the
Longchamp races
ANONYMOUS, 1947

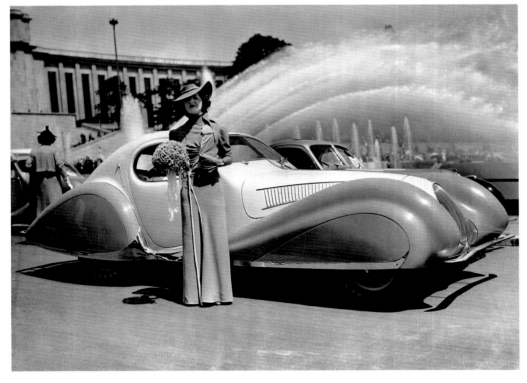

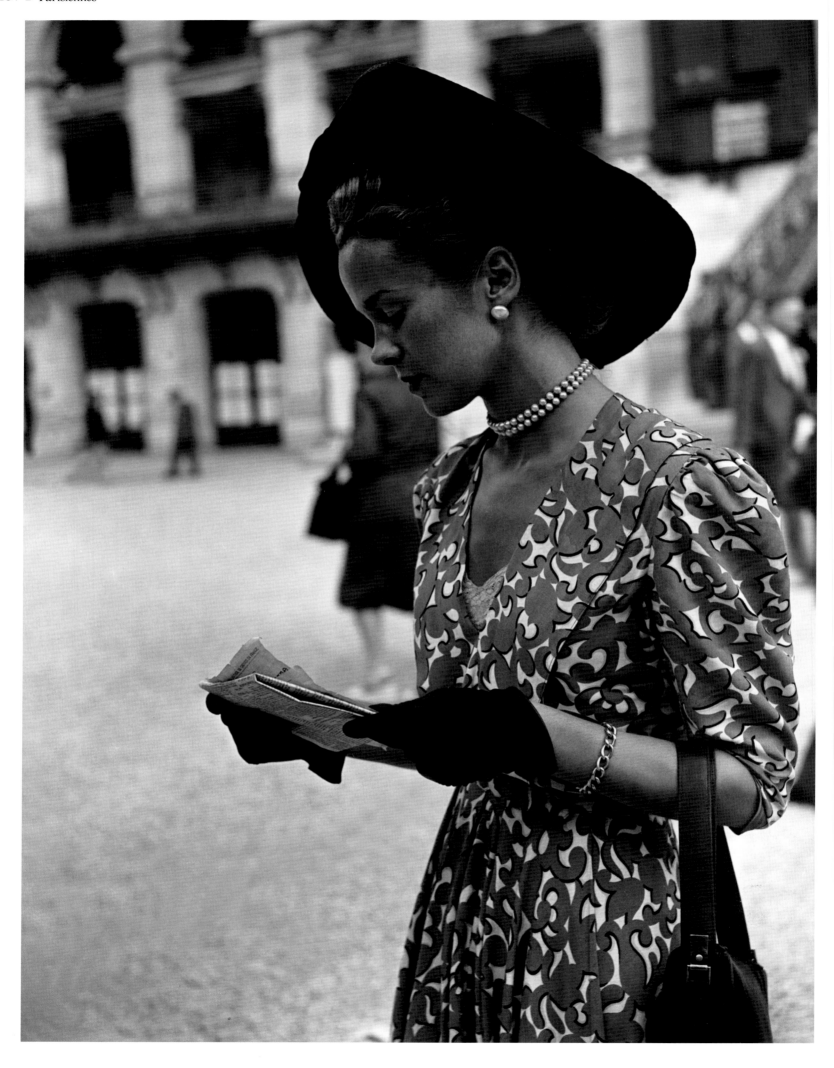

> "Paris does more than make the law,
> for it makes fashion."
> Victor Hugo, *Les Misérables*

Elegant woman at Longchamp
Anonymous, 1947

"I don't understand how a woman can leave the house without fixing herself up a little, if only out of politeness. And then, you never know, maybe that's the day she has a date with destiny. And it's best to be as pretty as possible for destiny."

COCO CHANEL

Coco Chanel
CECIL BEATON, 1934

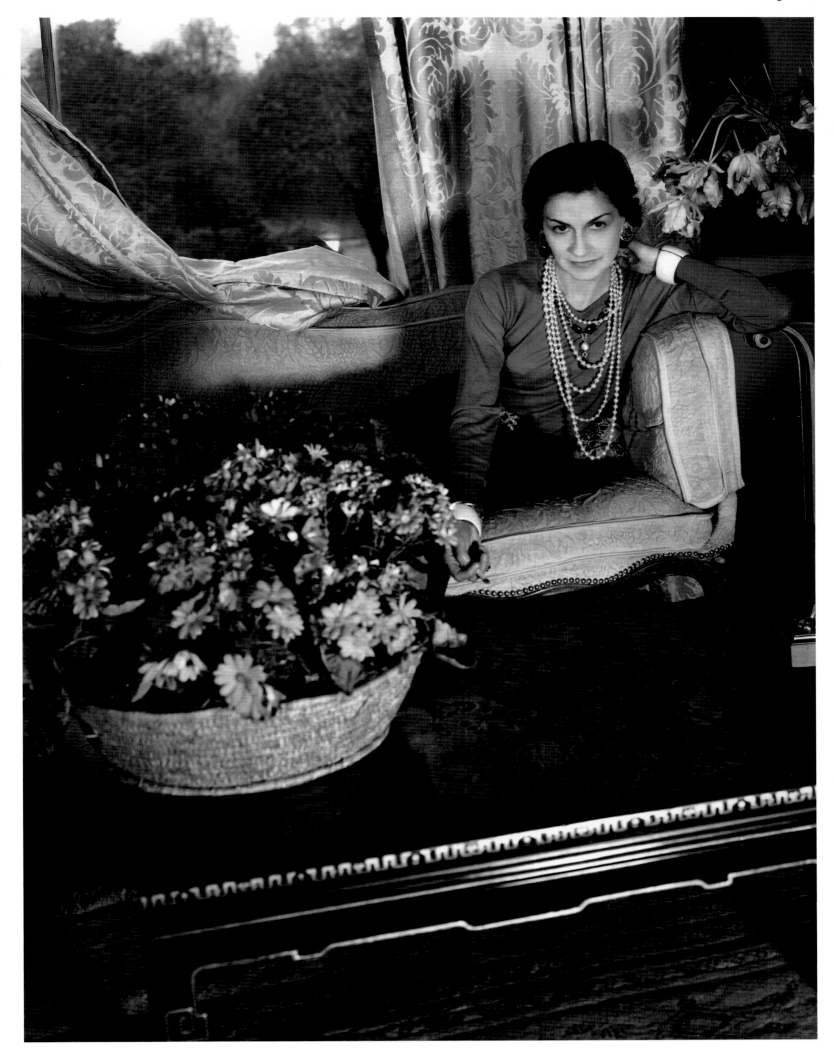

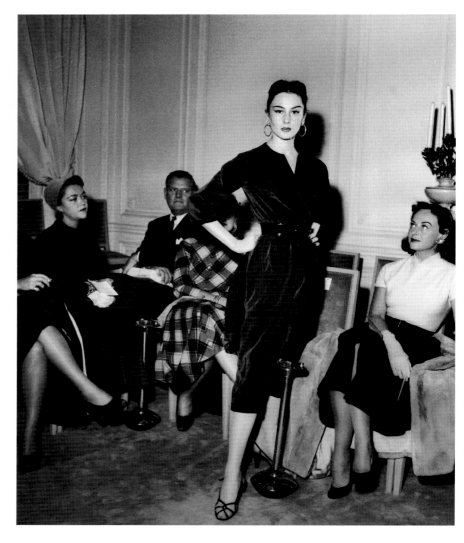

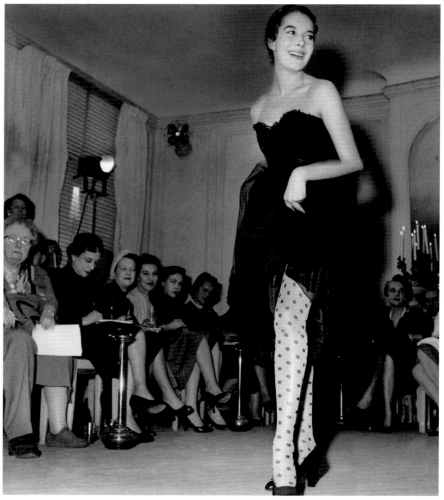

LEFT TO RIGHT, AND TOP TO BOTTOM ·
Outfit by Jacques Fath
ANONYMOUS, 1955

A creation by Givenchy
ANONYMOUS, 1955

Fashion plate showing an outfit
by Jacques Fath
ANONYMOUS, 1954

A fashion show by Jacques Fath
ANONYMOUS, 1953

Outfit by Christian Dior
ANONYMOUS, 1955

Outfit by Christian Dior entitled
"Café de Flore"
ANONYMOUS, 1960

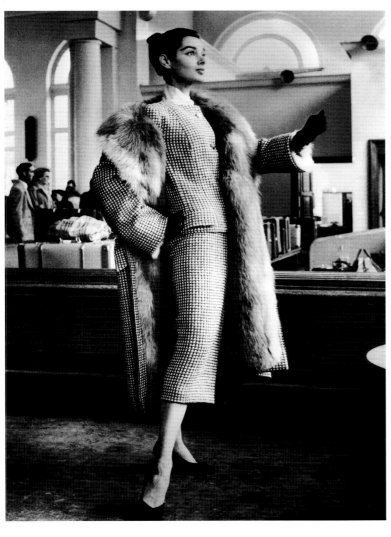

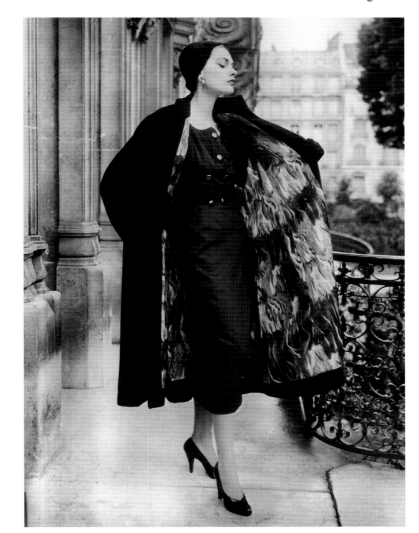

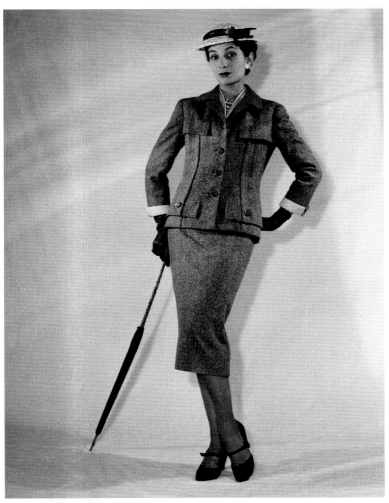

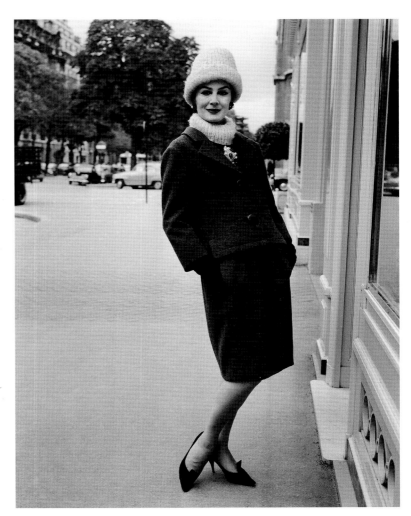

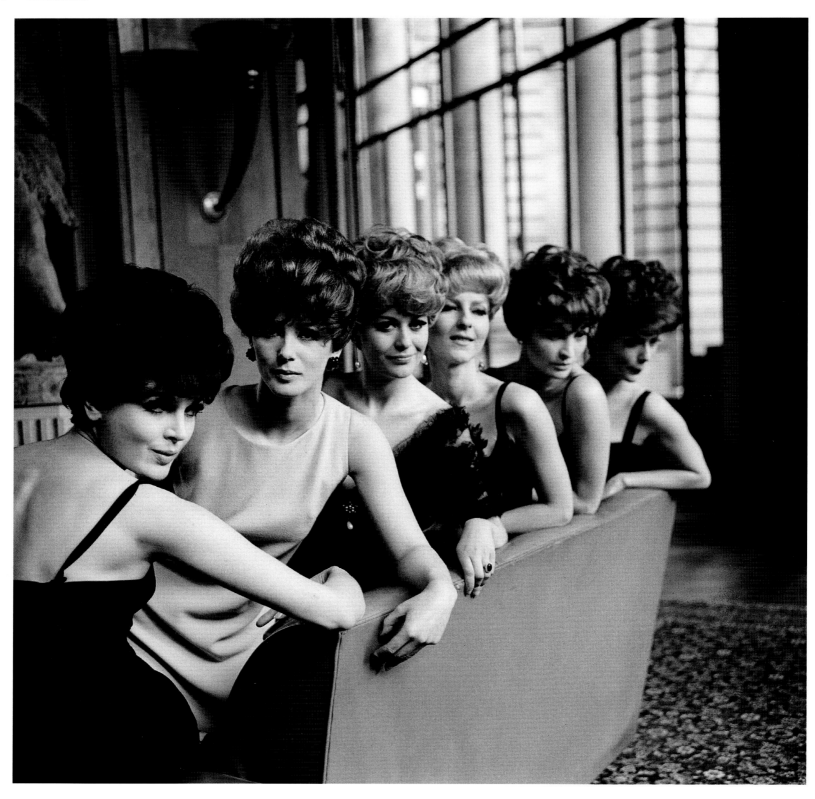

Haute coiffure
ANONYMOUS, 1965

A line-up of award-
winning fancy stockings
ANONYMOUS, 1965

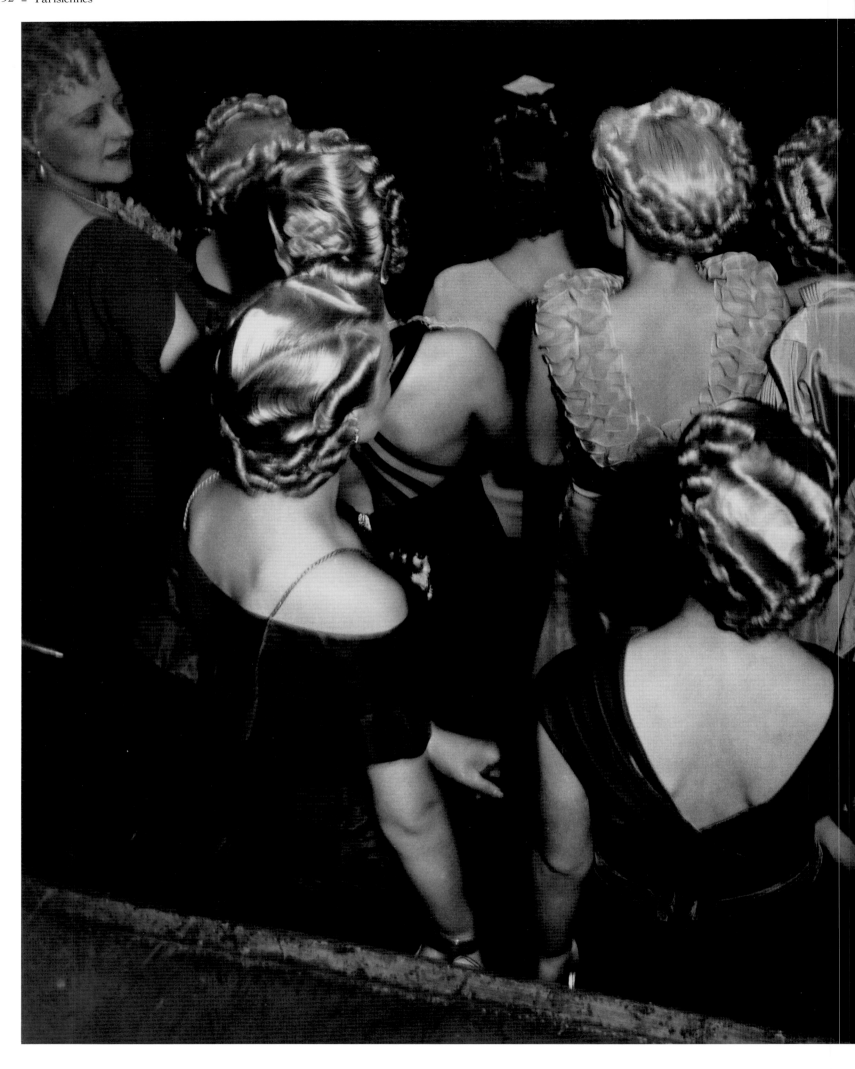

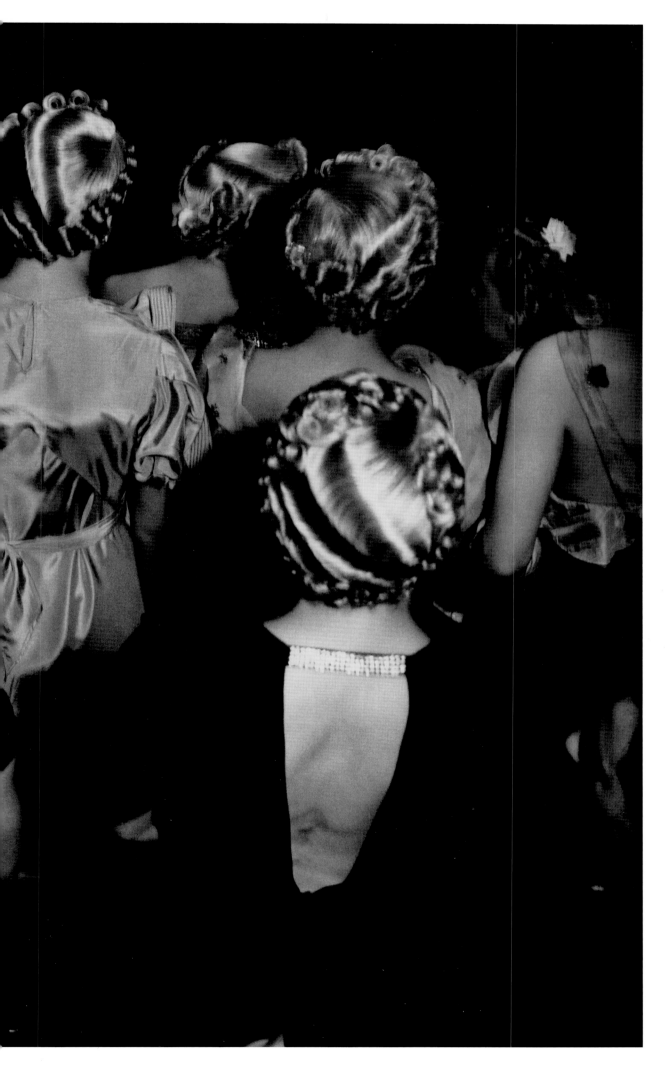

Models at a hair-styling event.
BRASSAÏ, 1930

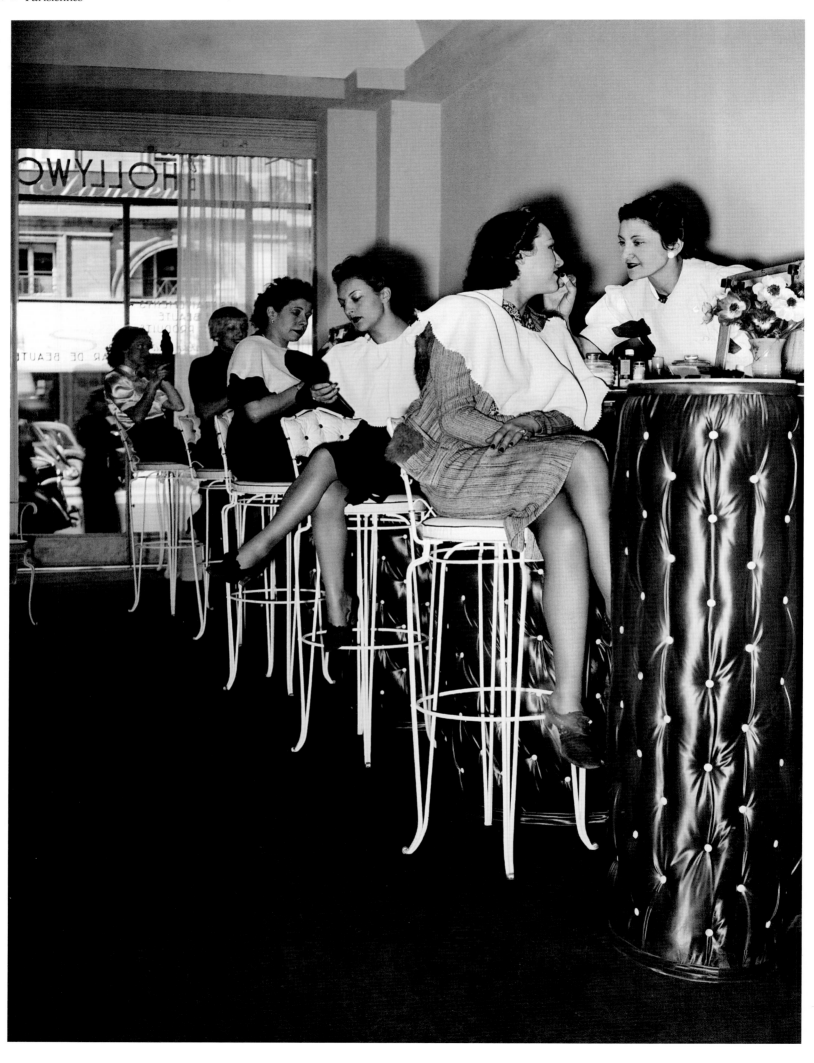

International hair-styling championships
at the Palais de la Mutualité
ANONYMOUS, 1933

A "beauty bar" on rue Royale in Paris
ANONYMOUS, 1938

Colette inspects luxurious treatments at
her Paris beauty parlor
ANONYMOUS, 1932

We are charmed by simple elegance.

OVID, *Ars Amatoria*

The other face of Colette: as a
professional beautician;
the celebrated writer opened a
beauty parlor on rue de Miromesnil
ANONYMOUS, 1932

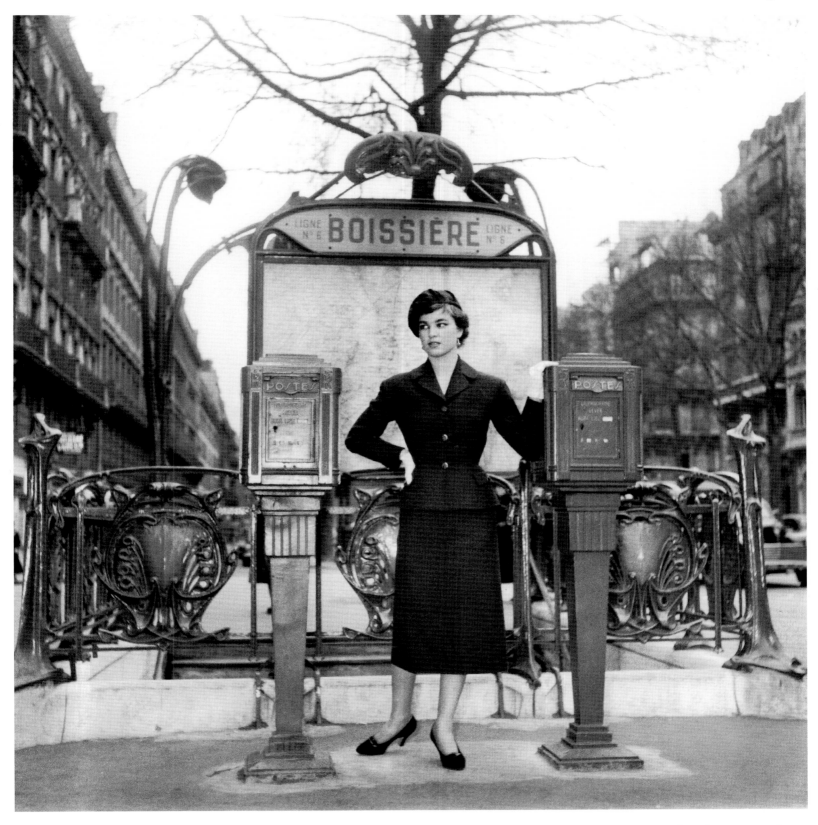

New uniform for metro employees
ANONYMOUS, 1954

Lilies-of-the-valley on the metro
ROBERT DOISNEAU, 1953

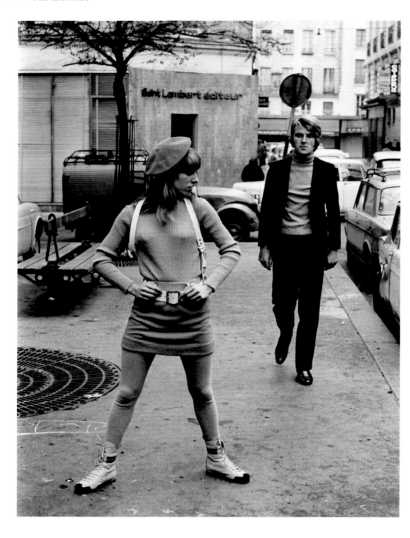

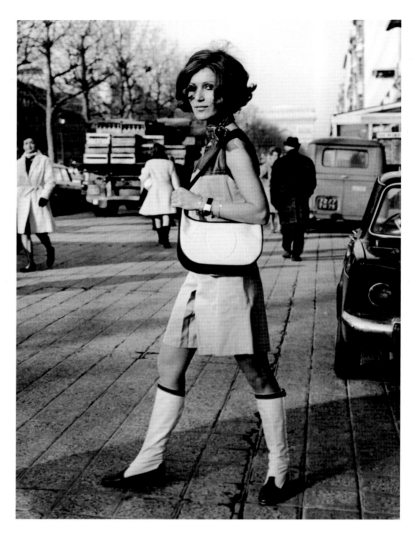

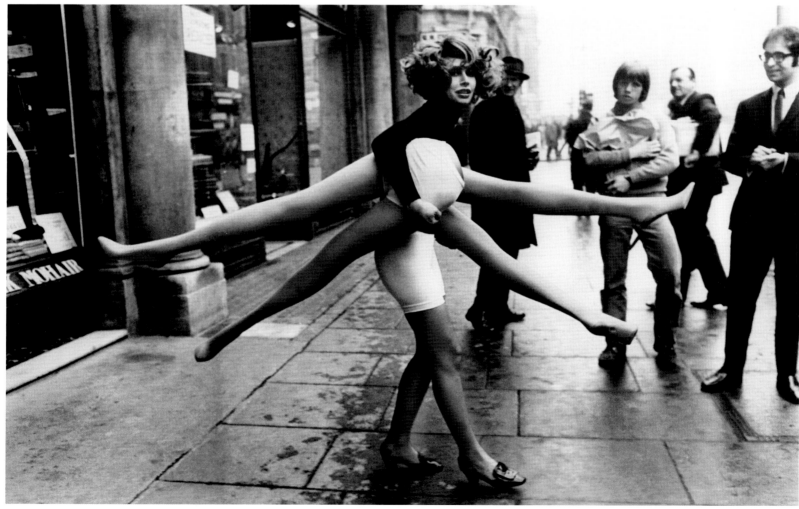

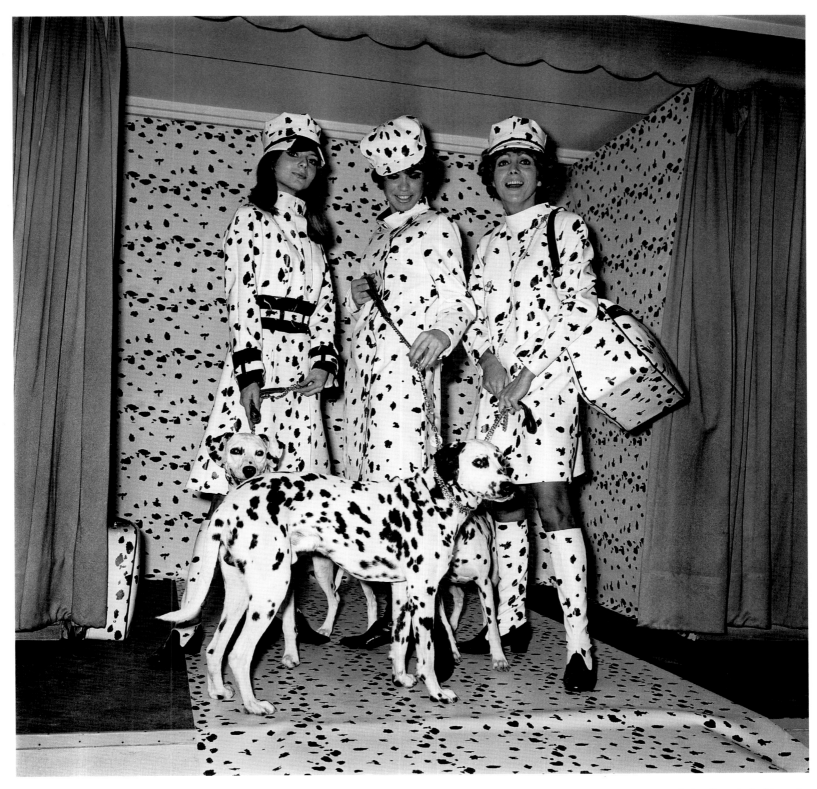

Dalmations in fashion—by
Jacques Esterel
ANONYMOUS, 1967

FACING PAGE:
English fashions come to Paris!
Fashion shot showing a mini-skirt
on place du Marché Saint-Catherine
ANONYMOUS, 1966

Durer boots photographed on the
Champs-Elysées
ANONYMOUS, 1968

Young woman carrying two pairs of
mannequin legs
ANONYMOUS, 1968

FLIRTATION

It was there, yes, just there, by the bicycle racks opposite the Brazilian restaurant, I remember. In the middle of Paris, at 3 a.m., in a near-deserted street, I lifted up my skirt to show J. what a thong was. Mine was in cream lace, prettily designed, skimming the line of my hips without digging in. At the time J. knew more about the Left Bank than he did about women's lingerie, so he'll have learned that, at least. The first time, I mean the first glass, in the bar of a classy hotel, that same summer, we kept our distance, each in our own armchair, a distance that comes before things become blurred. He was wearing an old-fashioned shirt with pale stripes, and there was a scent of sandalwood in the air. I think I was being provocative. Those half-smiles like promises, color on my lips, my feet in high heels. I'm talking about those things that aren't said, like a warm feeling on my neck; the way he looked, like a fighter.

Wait—no, I remember now: the first time was somewhere else. Porte Maillot, on a café terrace. Just in front of the metro entrance. We talked about love for hours, over a *croque monsieur*. We conversed like experts in the humid August heat; I was wearing a flowery skirt.

Another day, we met on the steps of the Opéra; we walked at night, crossing streets and bridges, from bar to bar, our mouths glued to one another. On boulevard Saint-Germain I showed him my panties, taking them out of my pocket like a trophy—I had taken them off in the restroom, out of sheer provocation, or as a dare. On the other side of the river, I sometimes pass the restaurant where we ate dinner, on another evening; where I caressed his leg with my bare foot. We drank white wine at the back of a softly lit room, and said the right things. We kissed standing up, my body weighing against his—it was a moment of pure emotion, pure eternity, the sort of moment that isn't quite real. The last time, dawn broke over the Seine after we had drunk and walked all night; the door of the taxi was open and he held me by the arm on the sidewalk of the boulevard Saint-Michel. I laughed because I was so pretty in his eyes; he said, "I love you, I'll wait for."

I never saw him again.

DELPHINE DE VIGAN

A young girl sitting on her bed, seen through her open window
WILLY RONIS, 1946

Actress Sabine Azéma
ROBERT DOISNEAU, 1985

" All the ladies wore lace

And delightful froufrous,

Behind them apace,

We relished the view.

What was under their gowns?

All we saw were their boots

But the rain came down

And they lifted their skirts

Not because of the wet,

Ah no—but to flirt! "

ALIBERT, *Mon Paris* ("My Paris")

Black basque
ROBERT DOISNEAU, 1950

On the footbridge
leading to the Ile
Saint-Louis
ÉDOUARD BOUBAT, 1965

ÉDOUARD BOUBAT, 1950



❝ Eroticism is one of the basic means of

self-knowledge, as indispensable as poetry. ❞

ANAÏS NIN,
A Woman Speaks



Deena photographed from behind
WILLY RONIS, 1955

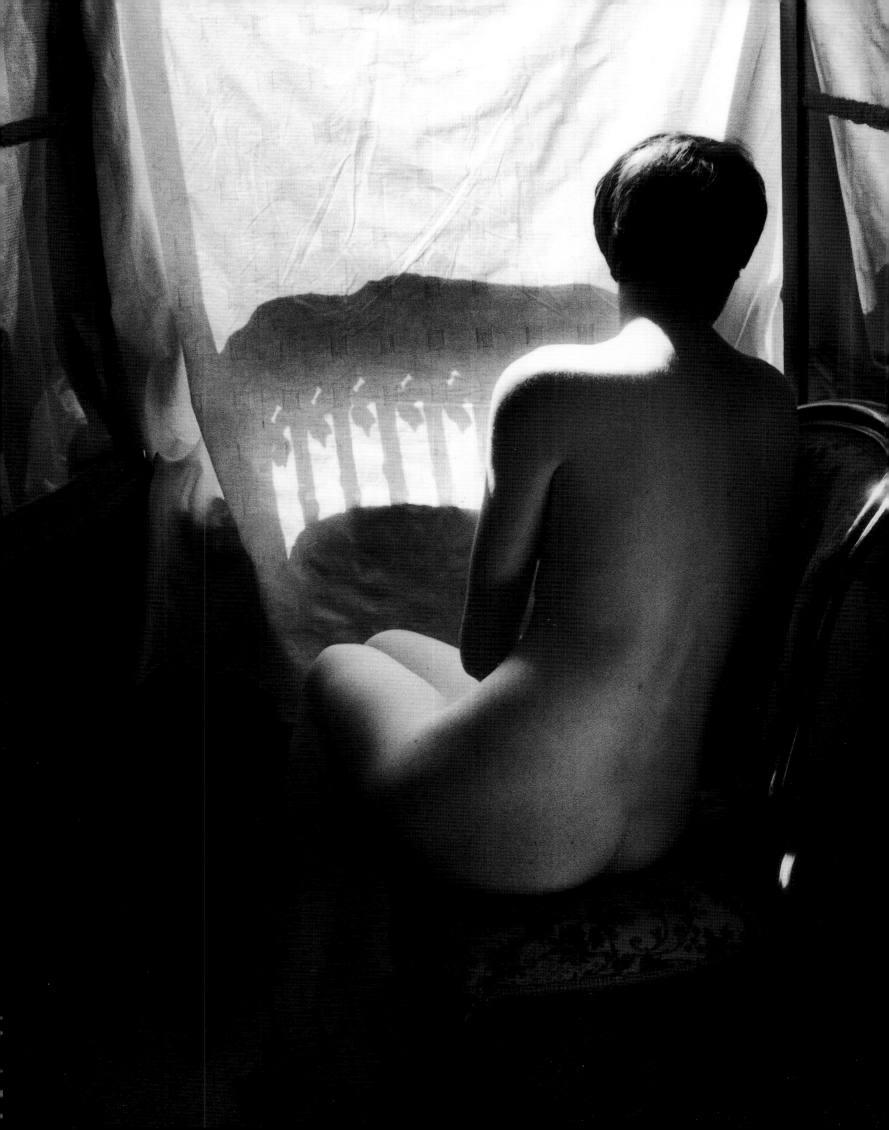

"French woman have been made beautiful by the French people, they're very aware of their bodies, the way they move and speak, they're very confident of their sexuality. French society's made them like that."

CHARLOTTE RAMPLING

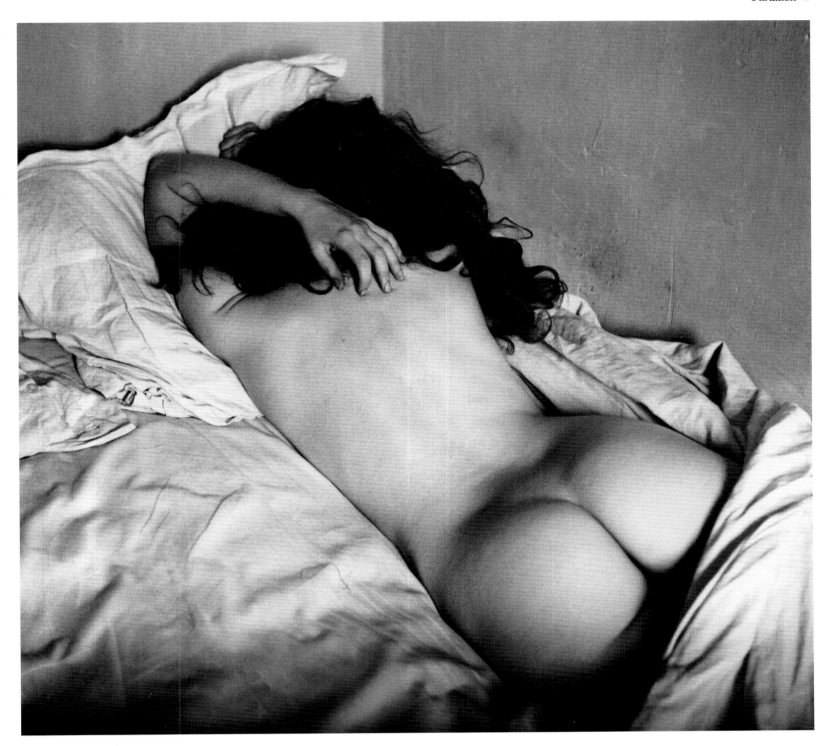

ÉDOUARD BOUBAT, 1950

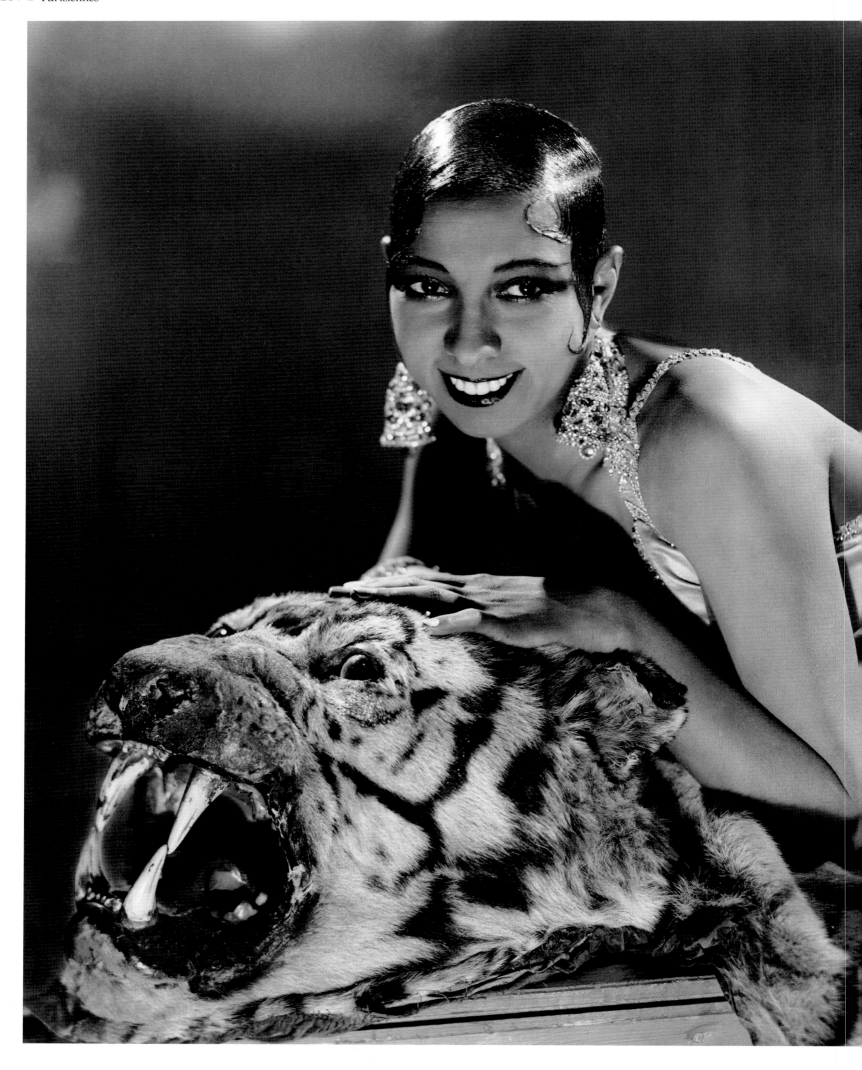

> **" I have two loves,**
> **my country and Paris. "**
>
> JOSÉPHINE BAKER

Josephine Baker posing on a tiger
skin for a studio photograph
at the height of her success
at the Casino de Paris
ANONYMOUS, **1931**

The Folies Bergère
ÉDOUARD BOUBAT, 1960

Cabaret dancer with an ostrich-
feather fan
ANONYMOUS, 1928

Zizi Jeanmaire on stage
at L'Olympia
ANONYMOUS, 1968

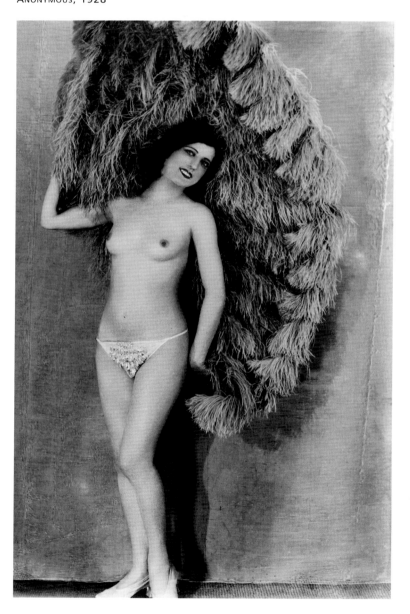

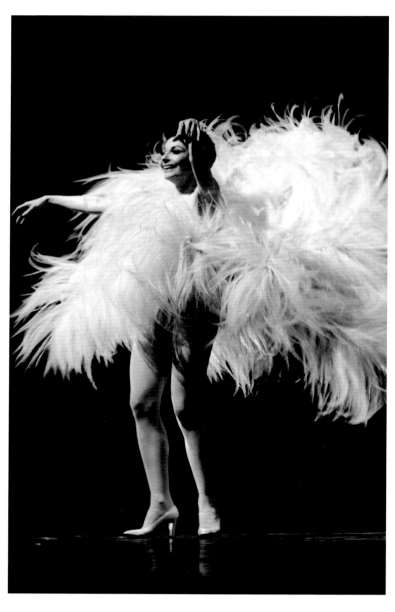

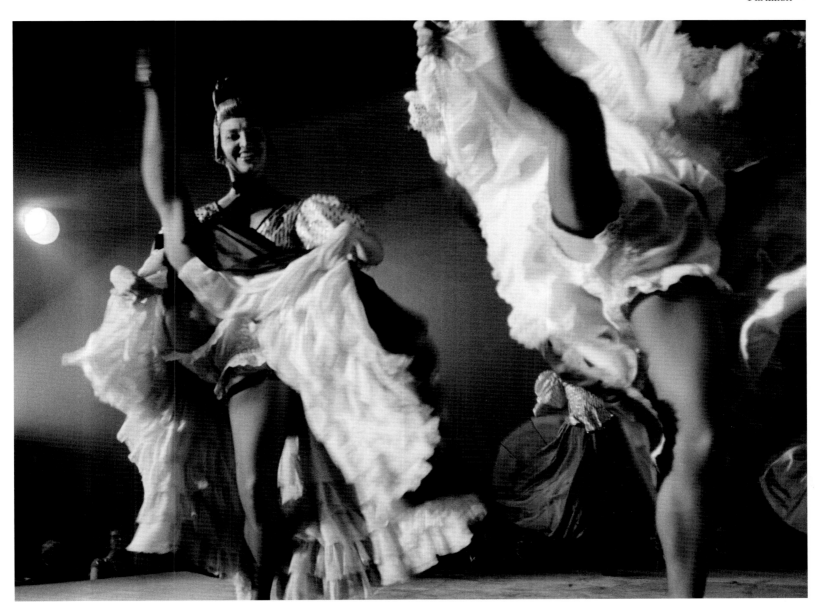

The French cancan
at the Moulin Rouge
ROBERT DOISNEAU, 1955

Dancer at the Crazy Horse
ANONYMOUS, 1951

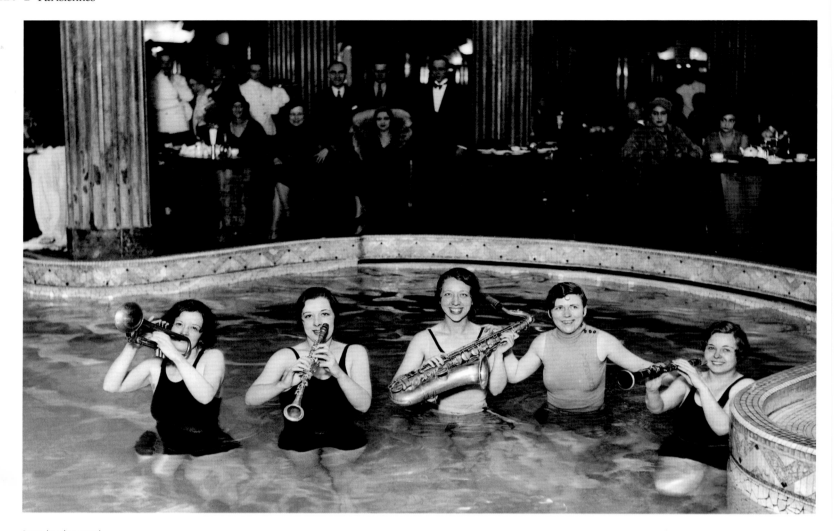

Jazz in the pool
at the Lido de Paris
ANONYMOUS, 1931

" In love, there's a time to dive in, but wait until

the pool is full or you'll dive into a foot-bath. "

FANNY ARDANT

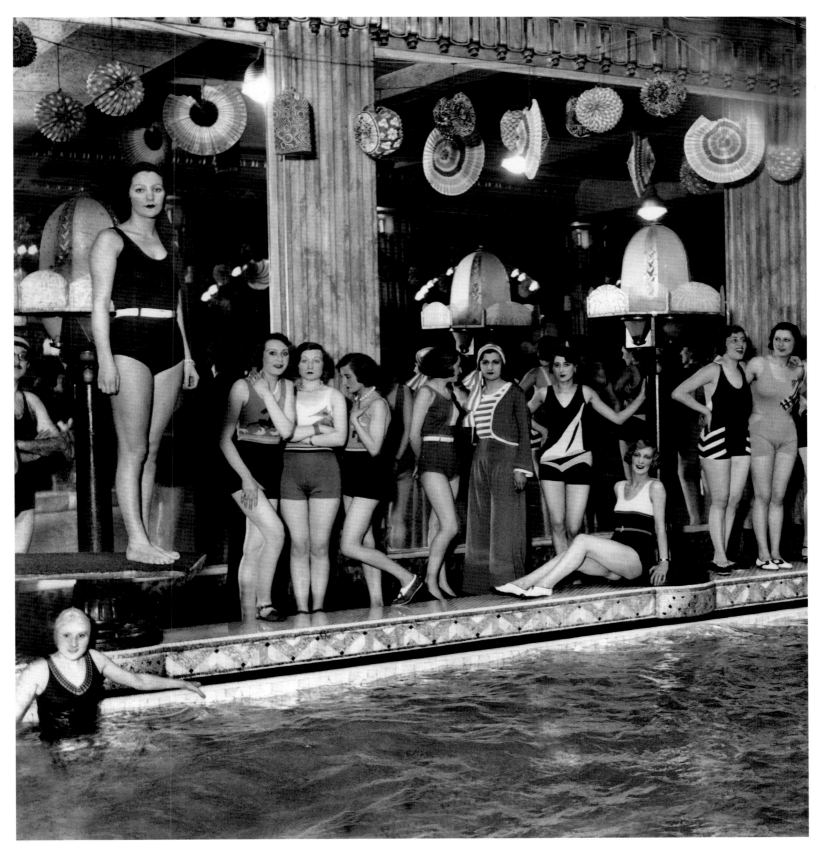

Ladies bathing at the Lido
ANONYMOUS, C. 1930

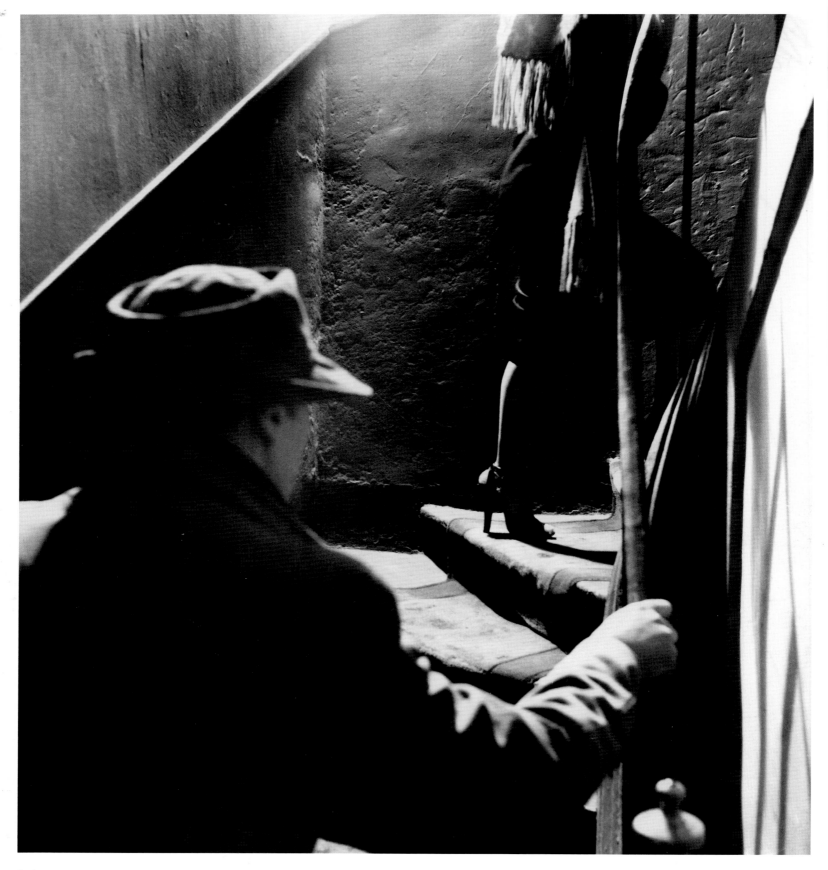

Staircase
ROBERT DOISNEAU, 1952

Prostitution in Paris
ROBERT DOISNEAU, 1953

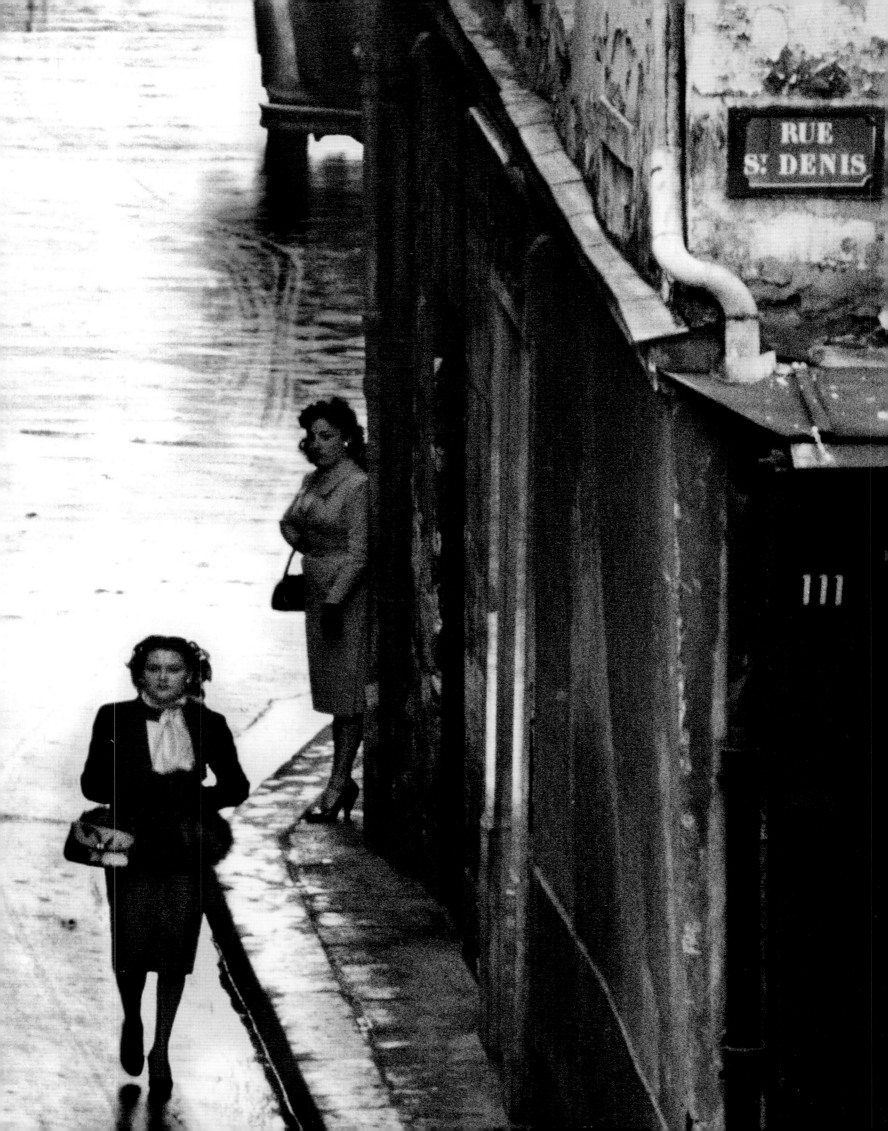

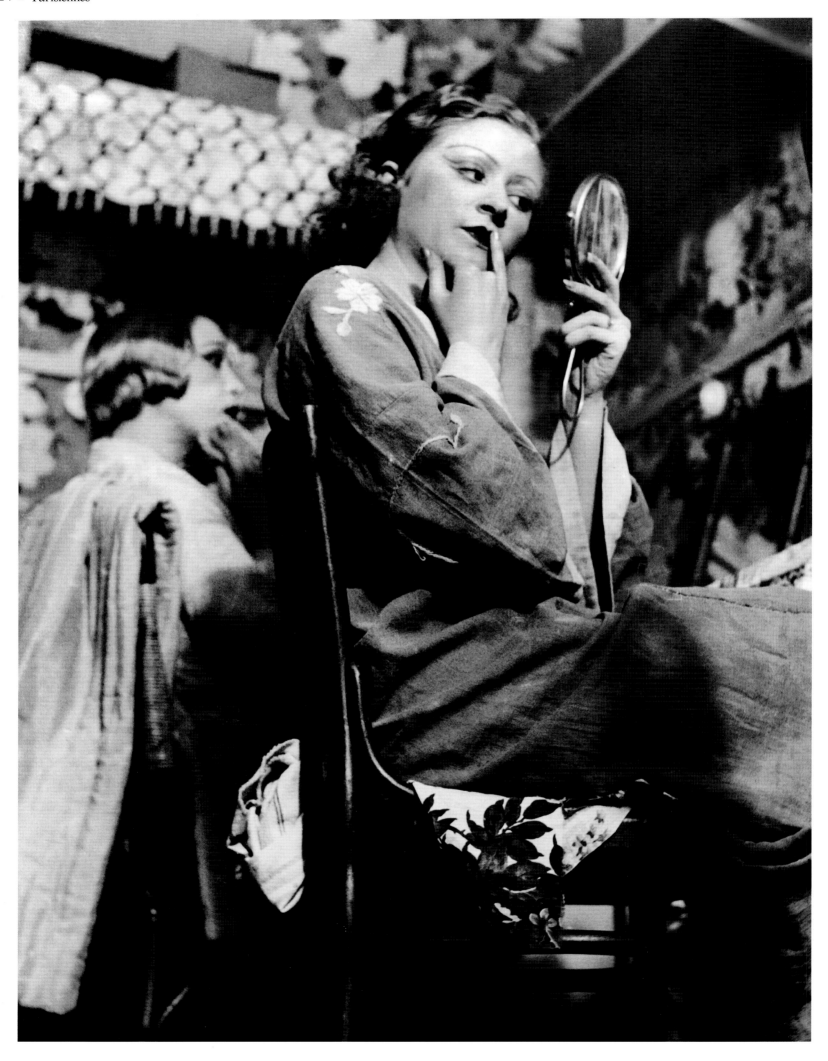

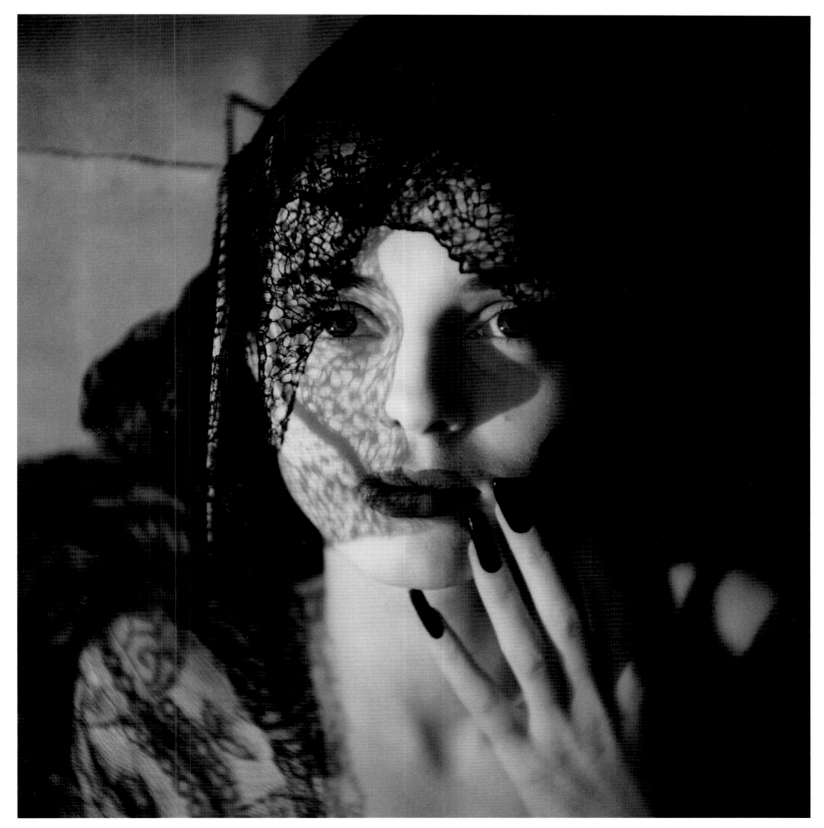

Florette, Paris
JACQUES-HENRI LARTIGUE, **January 1944**

A dressing-room
at the Folies Bergère
ANONYMOUS, C. **1930**

"Really Mademoiselle,… try to take care over
your appearance…study our Parisian ladies!"

ÉMILE ZOLA, *Au Bonheur des dames*

Legs on the metro
ROBERT DOISNEAU, 1971

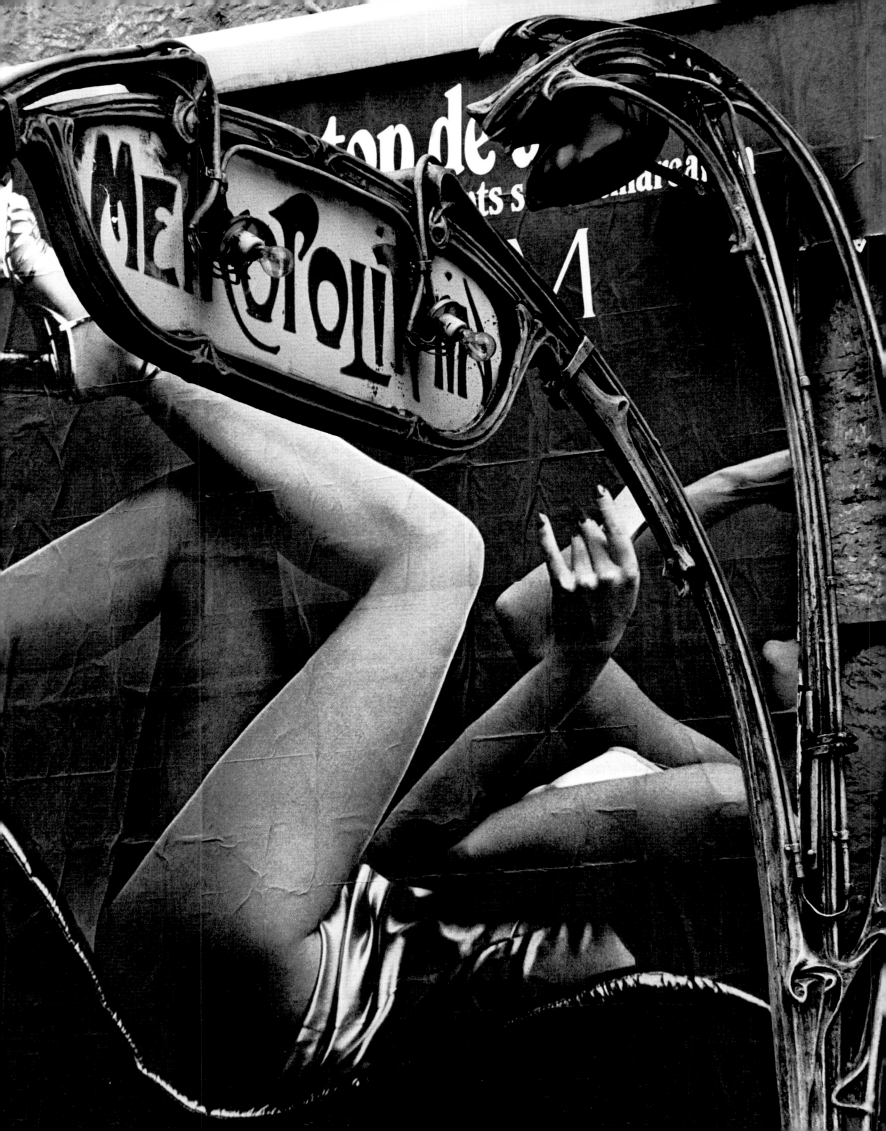

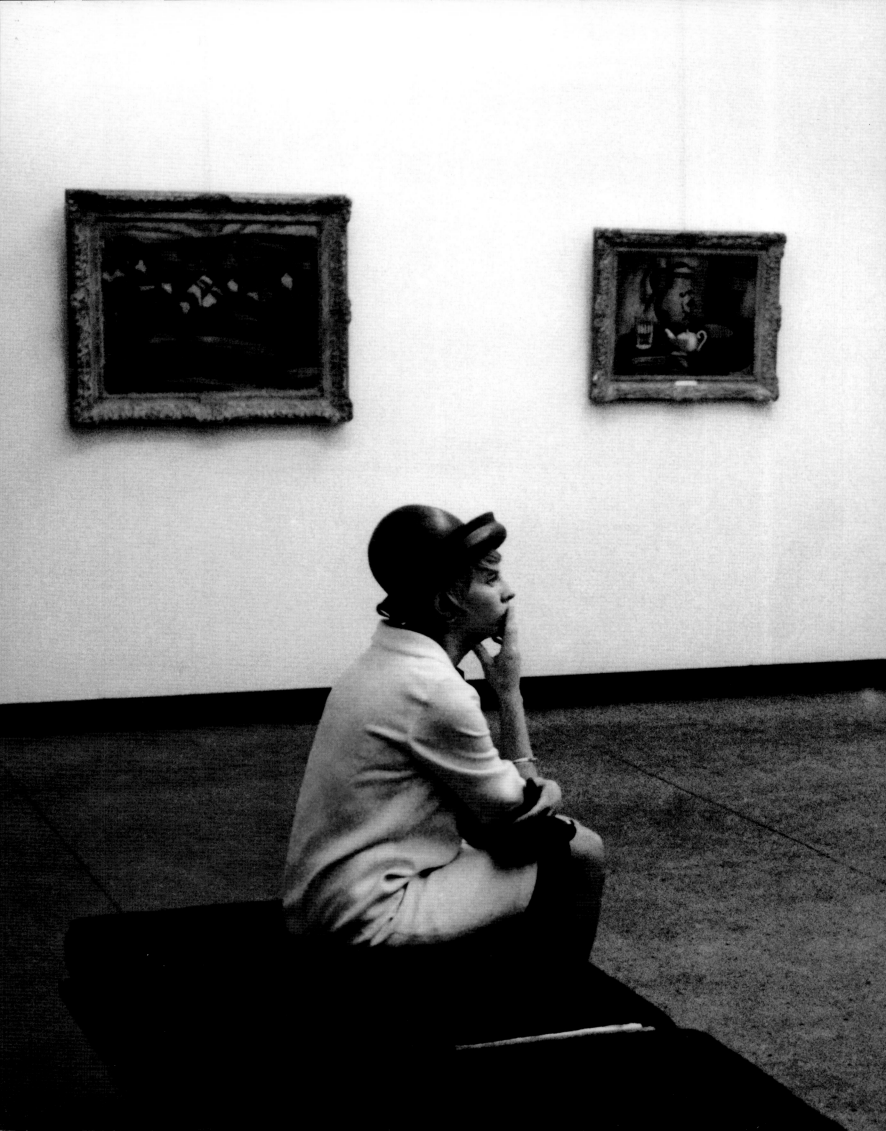

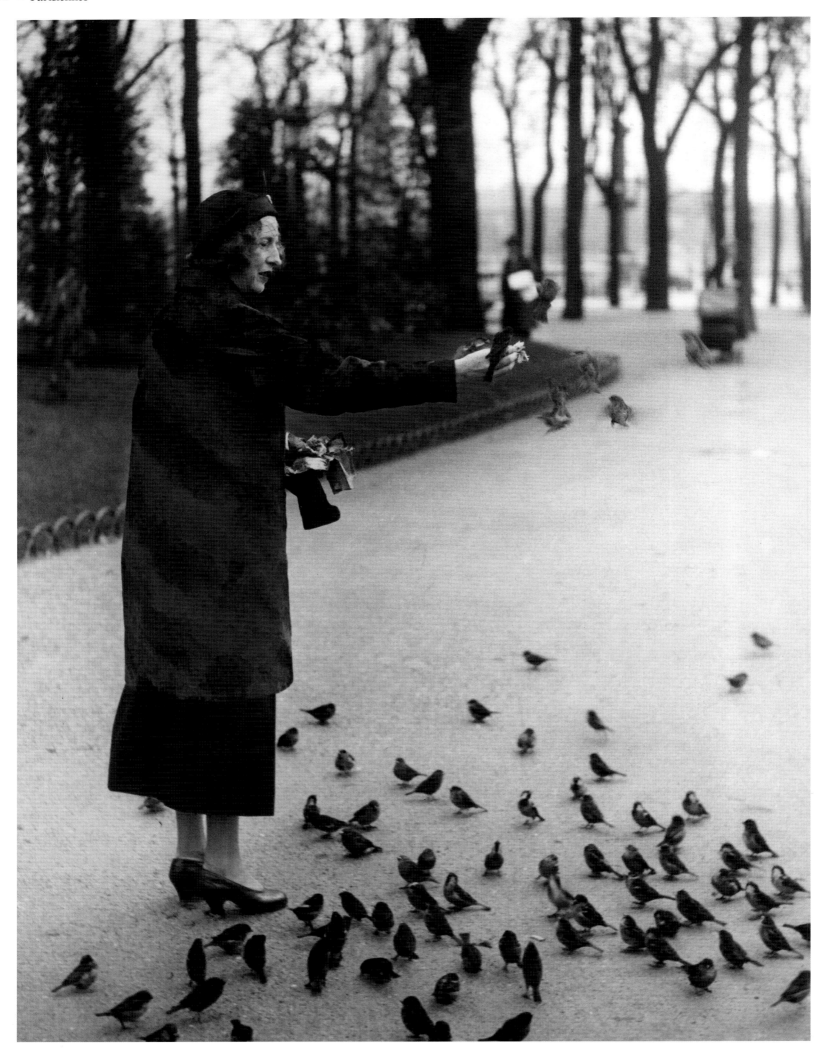

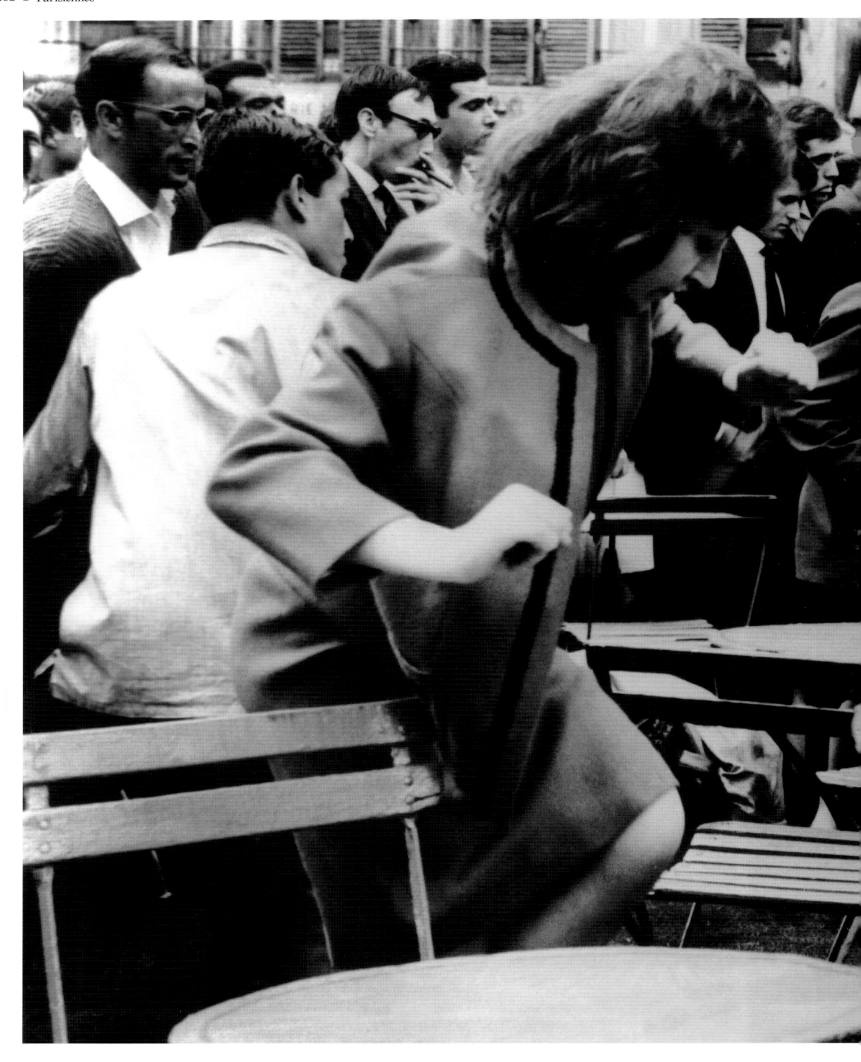

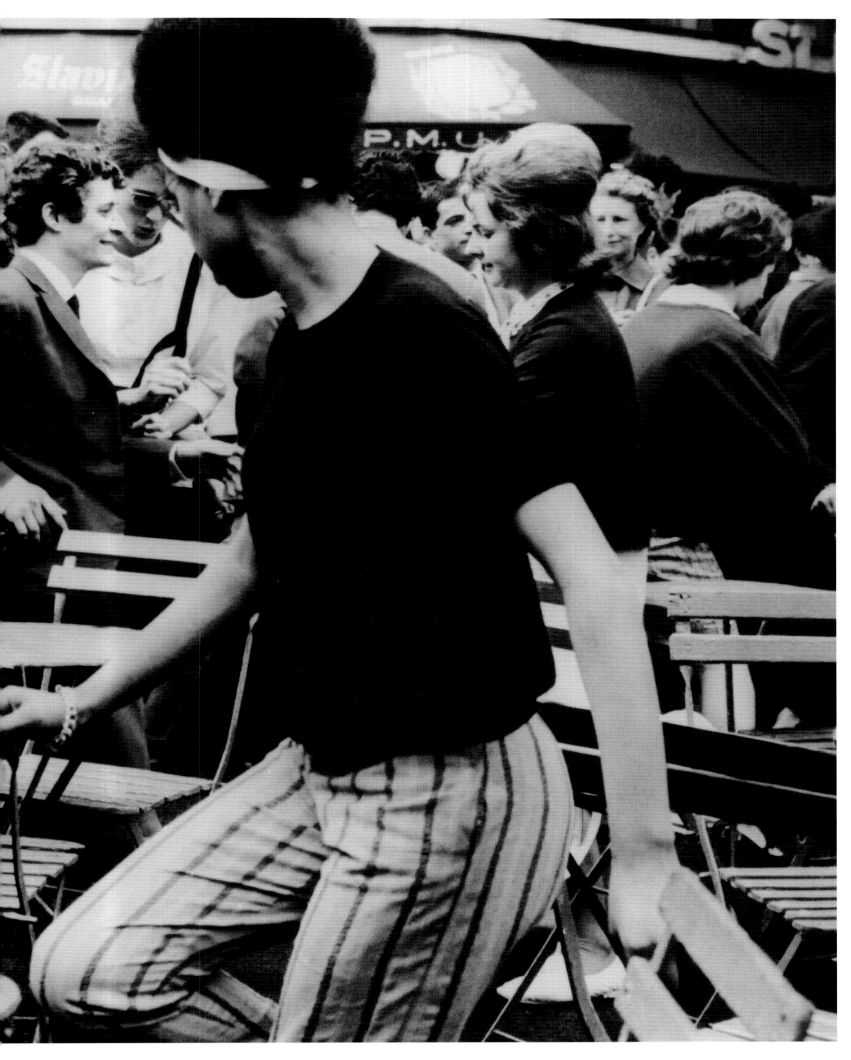

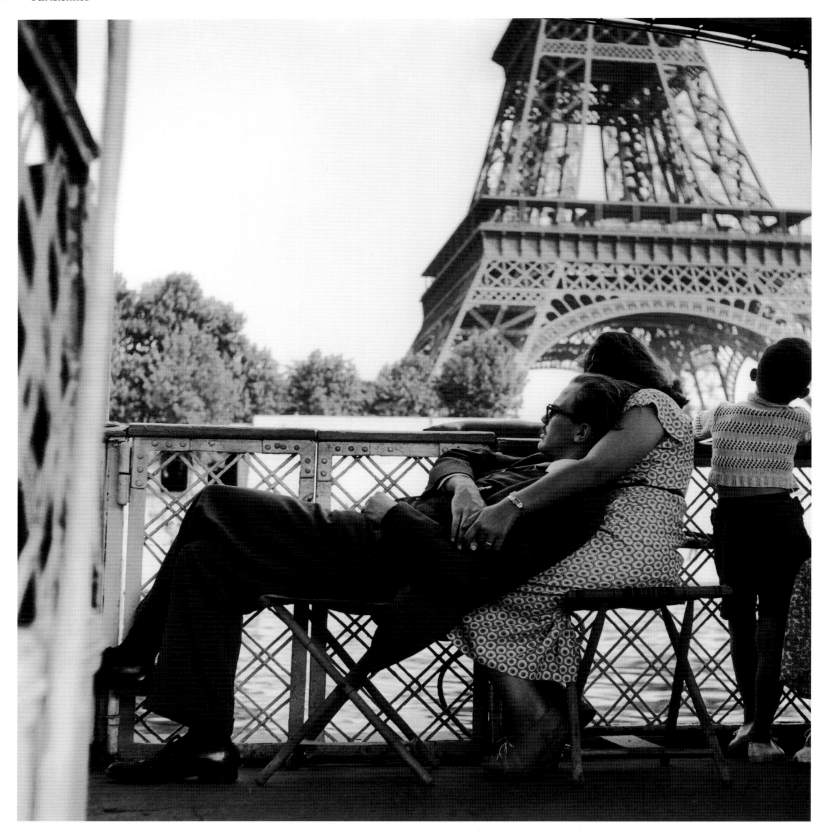

On the bateau-mouche
WILLY RONIS, 1949

BIBLIOGRAPHY

AUDIBERTI, JACQUES *La Poupée*. Paris: Gallimard, 1956

ARDENT, FANNY, quote from *7 à Paris,* May 23, 1990

BACHELARD, GASTON, *The Poetics of Reverie*. Boston: The Beacon Press, 1971

BAUDELAIRE, CHARLES, *Les Fleurs du mal*. Translated by William Aggeler. Fresno, CA: Academy Library Guild, 1954

DE BEAUVOIR, SIMONE, *The Second Sex,* Translated by H. M. Parshley. New York: Vintage, 1989

COHEN, ALBERT, *Le Livre de ma mere*. Paris: Gallimard, coll. Folio, 1974

COLETTE, *La Vagabonde*. Paris: Livre de poche, 1975

DAUDET, ALPHONSE, *Lettres de mon moulin*, Paris, Gallimard, coll. Folio classique, 1999

DURAS, MARGUERITE, *The Lover*. Translated by Barbara Brey: New York: Pantheon, 1998

DURAS, MARGUERITE, *Whole Days in the Trees*. London: Calder Publications 1984

FAULKNER, WILLIAM, *Sartoris*. New York: Random House, 1956

GAUTIER, THÉOPHILE, *Paris and the Parisians*. London: Richard Bentley, 1835

ANNA GAVALDA, *I Wish Someone Were Waiting for Me Somewhere*. Translated by Karen L. Marker. New York and London: Riverhead Books, 2007

GAVALDA, ANNA, *Hunting and Gathering*. Translated by Alison Anderson. New York and London: Riverhead Books, 2007

GIROUD, FRANÇOISE, *Journal d'une Parisienne*. Paris: Éditions du seuil, coll. Points, 1995

GRÉCO, JULIETTE, *Jujube*. Paris: Stock, 1993

HUGO, VICTOR, *Les Miserables*. Translated by Frederick Charles Lascelles Wrawell. London: Hurst & Blacket, 1862.

GRIMOD DE LA REYNIÈRE, *Écrits gastronomiques*, Paris, 10/18, 2006

DE MAUPASSANT, GUY, "Amoureux et primeurs" published in *Le Gaulois*, 30 March, 1881, reprinted in *Lectures « Fins de siècles »*, Paris: Hubert Juin, 10/18, 1999.

MICHEL, LOUISE, *Mémoires*. Brussels: Éditions Tribord, 2004

NIN, ANAÏS, *A Woman Speaks*. Athens, Ohio: Swallow Press, 1975

RILKE, RAINER MARIA, *The Notebooks of Malte Laurids Brigge*. Translated by M.D. Herter Norton. New York: Norton & Co, 1949.

RAMPLING, CHARLOTTE, quote from *http://www.thecontext. com/docs/3197.html*

ROUSSEAU, JEAN-JACQUES, *Julie ou la Nouvelle Héloïse*. Paris: Flammarion, coll. GF, 1999

SAGAN, FRANÇOISE, *Réponses 1954–1974*. Paris: Le Livre de poche, 1976

SCHIFRES, ALAIN, *Les Parisiens*. Paris: Le Livre de Poche, 1997

ENRIQUE VILA-MATAS, *Paris No Se Acaba Nunca ("Paris Never Ends")*. Madrid: Editorial Anagrama, 2003

VIRGIL, *The Eclogues*. Translated by Guy Lee. New York and London: Penguin, 1984

ZOLA, ÉMILE, *Au bonheur des dames*. Paris: Le Livre de poche, 1971

INDEX

INDEX OF NAMES

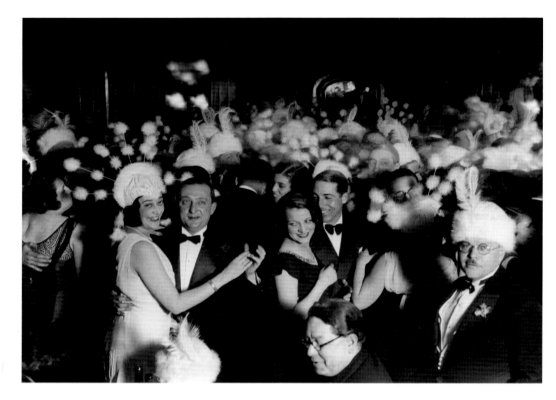

A night-time ball at the Lido
ANONYMOUS, **1932**

INDEX OF PLACES

Terrace at the Deux Magots
Anonymous, 1957

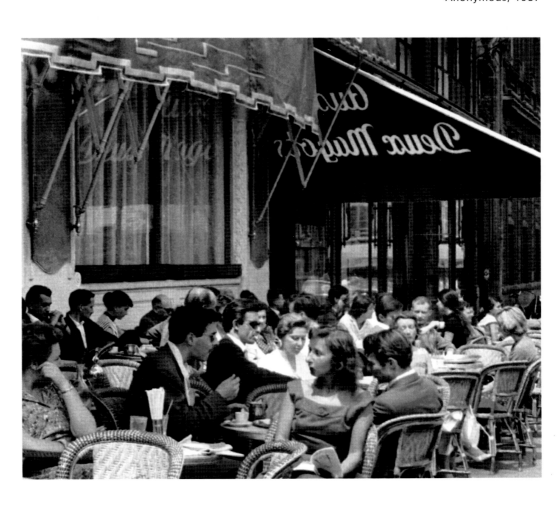

AUTHOR BIOGRAPHIES

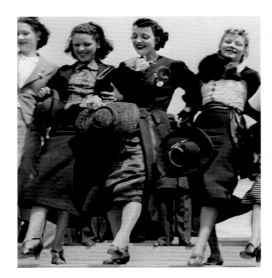

ANONYMOUS, 1938

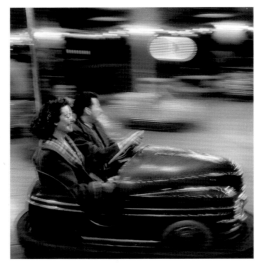

WILLY RONIS, 1953

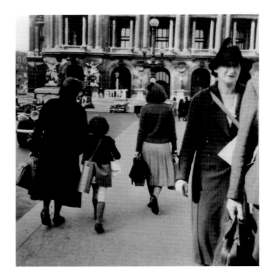

ANONYMOUS, 1939

CAROLE BOUQUET began her film career when the Spanish director Luis Buñuel cast her in his 1977 film *That Obscure Object of Desire*. Although celebrated for her mesmerizing beauty, she refuses to become pigeon-holed and takes on a wide range of different roles on stage and screen. She is closely involved with the not-for-profit organization *La Voix de l'Enfant*, which campaigns against child abuse.

MADELEINE CHAPSAL worked as a journalist on the French news weekly *Les Échos* and later *L'Express*, which she founded with her husband Jean-Jacques Servan-Schreiber. She began her literary career relatively late in life, and achieved widespread success with her novel *La Maison de Jade* ("House of Jade"), published in 1986. She is a prolific author, writing mainly for women. She served on the jury for the Prix Femina from 1981 onwards but was excluded in 2006 after expressing regret and disagreement over the winning titles.

MARIE DARRIEUSSECQ is a prolific writer who achieved worldwide fame with her first novel, *Truismes*, published in 1996. She is a committed atheist, feminist, and pro-European, and her work typifies the young, experimental fringe of the contemporary literary scene.

XAVIÈRE GAUTHIER is a journalist, editor, and academic specializing in women's literature, feminist ideology, and representations of women and feminism in the eighteenth and nineteenth centuries. She founded the artistic and literary review *Sorcières* ("Witches") in 1975, and is the publisher (among others) of the little-known, misunderstood, and often hitherto unpublished writings of the nineteenth-century French anarchist Louise Michel.

DENIS GROZDANOVITCH was France's national junior tennis champion in 1963, but forwent the rigors of a professional tennis career in order to travel, reflect, and keep a series of notebooks, which became the inspiration for his first work, *Le Petit traité de désinvolture* ("Little treatise on Easiness") (José Corti, 2002), published forty years after his early sporting triumphs.

MIREILLE GUILIANO is the international best-selling author of *French Women Don't Get Fat: The Secret of Eating for Pleasure* (Knopf 2004) and *French Women for All Seasons: A Year of Secrets, Recipes and Pleasure* (Knopf 2006). She has written about food, wine, and travel, mostly about France, for a wide range of leading publications.

DOMINIQUE MAINARD is an author and translator, who has translated the works of John Cheever, Janet Frame, and James Lee Burke among others. Her first novel, *Le grand Fakir*, was published in 2001 and was followed the next year by the prize-winning *Leur Histoire*, which was later made into a film. Other titles include *Le ciel des chevaux* (2004) and *Je voudrais tant que tu te souviennes* (2007) as well as a novella, *La Vie en Rose*.

CATHERINE MILLET is founder and editor-in-chief of the magazine *Art Press*. She is also the author of *Contemporary Art in France* (Flammarion, 2006), which has undergone many reprints, and provides a personal examination and scientific analysis of French art of the last few decades. In 2001 she published *The Sexual Life of Catherine M*, a frank account of her personal life. In 2005, she published *Dalí et moi* (Éditions Gallimard).

DELPHINE DE VIGAN is a young writer whose book *Un soir de décembre* (Lattès, 2005) won the Prix Saint Valentin in 2006. Her outspoken stance, incisive insights, and passion for writing evoke the experience of the "fleeting moment," where the past and present intermingle. She has just published her fourth novel, *No et Moi* (Lattès).

PHOTOGRAPHER BIOGRAPHIES

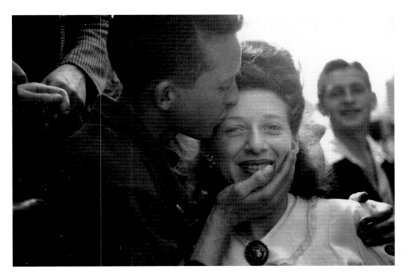

JEAN-PHILIPPE CHARBONNIER, 1945

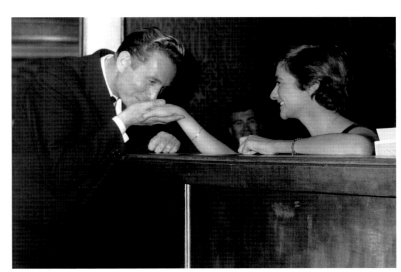

Charles Trenet et Françoise Sagan
ANONYMOUS , 1958

CECIL BEATON (1904–1980) had his first London exhibition in 1926, which enjoyed immediate success, and secured him a contract with *Vogue*, for whom he continued to work until the mid-1950s. He also worked for the women's magazine *Harper's Bazaar*, and photographed numerous portraits of Hollywood stars of the 1930s.

ÉDOUARD BOUBAT (1923–1999) studied at the École Estienne, and subsequently worked in a print shop. He discovered photography in 1946 and won the Prix Kodak in 1947. He traveled widely until his death in 1999, publishing and exhibiting his work worldwide.

BRASSAÏ (GYULA HALASZ) (1899–1984) met the French photographer Eugène Atget in 1925; this meeting had a decisive influence on his early work. His first photographs of Paris were published in a collection entitled *Paris de Nuit* (1932). In 1937, he began working for the women's magazine *Harper's Bazaar*, remaining there until 1962.

JEAN-PHILIPPE CHARBONNIER (b.1921) was editor-in-chief of the French news daily *Libération*, the weekly *France Dimanche*, and *Point de Vue* magazine, and a reporter for the magazine *Réalités*, covering scenes of everyday French life and international events. His works have become valuable historical documents, but remain relatively little-known in France. An

album of his works, *Reporters Sans Frontières*, was published in 2005.

ROBERT DOISNEAU (1913–1994) taught himself photography starting in 1929, recognizing it as the ideal medium through which to capture a changing world, and Parisian life in particular. He worked for *Vogue* from 1949–52. A retrospective of his work was held at the Hôtel de Ville in Paris in 2006 and was extended by popular demand.

ÉLISE HARDY (b. 1962) joined the Rapho Agency in 1993, specializing in political subjects such as student and union demonstrations, and ecological catastrophes. Since 1998, she has focused on realist "urban landscapes," and symbolic, off-beat, poetic images.

JACQUES-HENRI LARTIGUE (1894–1986) was born into a wealthy family, thanks to which he was able to practice photography from the age of six. He was given his own camera at the age of eight. His work expresses a fascination with the challenge of capturing "movement and the moment" on film. In Paris, he photographed courtesans, society ladies, and actresses. In 1915 he took up painting in parallel with his photographic work.

JANINE NIEPCE is a distant relative of Nicéphore Niepce, and was one of the first French women to work as a photojournalist,

with a particular interest in women's history. She has worked with the Rapho Agency since 1955; her work is published in France and worldwide.

WILLY RONIS (b. 1910) was sent in 1938 by the French Communist weekly *Regards* to cover the workers' strike at the Citroën-Javel factory. He has worked for industry, advertising, and fashion, as well as capturing chance scenes of everyday life in the streets of Paris.

SABINE WEISS (b. 1924) began taking photographs when she was still a child, and opened her own studio in Geneva after completing her studies. She settled in Paris in 1946 and was "discovered" by Doisneau in 1952, who introduced her to the Rapho Agency. She has traveled worldwide since 1961, alternating between commissions for press and advertising work, and her own portfolio of pictures, exhibited all over the globe.

PHOTOGRAPHIC CREDITS

BRASSAÏ
© Estate Brassaï—RMN
pp. 22, 34, 68, 192-193

GAMMA / EYEDEA:
Cecil Beaton/Camera Press p.187
Gilbert Uzan p. 14

KEYSTONE FRANCE / EYEDEA:
The Keystone agency was founded in the United States in 1917. In 1918, it became established in Europe, with an office in London, followed by a branch in Berlin and finally Paris in 1927. Today Keystone has over 10 million documents in its archives. The agency's photographs, for the most part by anonymous photographers, are an extraordinary resource for documenting life in the twentieth century.

Front cover, back cover (middle and right), and pp. 8, 9, 10, 11, 12, 13, 15, 28, 29, 31 (right), 36, 37, 38, 48, 51, 52, 54, 55, 57, 58, 59, 60, 61, 62, 63, 64, 70, 71, 72, 73, 74–75, 76, 77, 78, 79, 80, 81, 82, 84, 86, 87, 90, 91, 94, 95, 96, 100, 101, 110, 111, 112, 117, 119, 120, 121, 125, 126, 127, 130-131, 132, 133, 134, 135, 142, 143, 144, 145, 146, 148, 149, 150, 151, 152, 153, 154, 156, 157, 162–163, 166, 168, 180, 181, 182, 184, 188, 189, 190, 191, 194, 195, 196, 197, 199, 200, 201, 214–215, 216, 218, 220, 221, 224, 230, 232, 233, 236, 237, 238, 239 (right).

JACQUES HENRI LARTIGUE
© Ministère de la Culture-France/ AAJHL
pp. 139, 225

RAPHO / EYEDEA:
Édouard Boubat
pp: 20, 21, 30, 33, 43, 44, 47, 49, 93, 116, 136, 179, 208–209, 210, 213, 217
Jean-Philippe Charbonnier
pp: 31 (left), 176, 239 (left)
Robert Doisneau
pp. 18, 27, 89, 99, 105, 107, 108, 155, 160, 165, 167, 198, 204–205, 206, 219, 222, 223, 227
Élise Hardy
pp. 32, 40, 41
Janine Niepce
pp. 4, 6, 66, 67, 109, 123, 124, 129, 169, 170–171, 173, 228–229
Willy Ronis
pp. 26, 35, 42, 50, 83, 102, 103, 111, 140, 144, 174, 203, 211, 234, back cover (left).
Sabine Weiss
pp. 24, 98, 137

ACKNOWLEDGMENTS

Thank you to the authors: Carole Bouquet, Madeleine Chapsal, Marie Darrieussecq, Xavière Gauthier, Denis Grozdanovitch, Mireille Guiliano, Dominique Mainard, Catherine Millet, and Delphine de Vigan.

Thanks also to Farid Abdelouhab, Céline Adida, Érica-Maeva Blasquiz, Gaëlle Boulay, Jacques Boulay, Élisabeth Eulry, Magali Galtier, Élise Hardy, Joëlle Losfeld, Marie-Laure Miranda, Paul Otchakovsky-Laurens, Michèle Perrot, Pascal Ridao, and Isabelle Sadys.